HUNTLY
Capital of Strathbogie

HUNTLY
Capital of Strathbogie

The Town of the Tower and the Linden Tree

*Stories of people and events
in Huntly and Strathbogie, Aberdeenshire,
from the earliest times until the present day*

Cyril A. Barnes

SCOTTISH CULTURAL PRESS
EDINBURGH

CYRIL BARNES has been in the priesthood of the Anglican Church for 47 years, mostly in the Scottish Episcopal Church, but he also spent ten years in the Church of England.

He has considerable experience as a writer and journalist. He was editor of the *Huntly Express* from 1985–90, the *Banffshire Herald* for a period, *The Scottish Episcopalian* (the Church's national monthly newspaper) from 1990–93, and the diocesan newspaper, *Northern See,* since its beginning in 1990, as well as editing a regimental newspaper for several years when he was in the army.

He has also written several booklets and pamphlets, as well as contributing articles to a number of periodicals over the past 40 years – mostly concerned with historical, theological or religious subjects. He has spent most of the past 50 years in North-east Scotland and, although not a native, likes to think of himself as 'a north-east loon'.

First Published 1998 by
Scottish Cultural Press
Unit 14, Leith Walk Business Centre
130 Leith Walk
Edinburgh EH6 5DT
Tel: 0131 555 5950 • Fax: 0131 555 5018
e-mail: scp@sol.co.uk

British Library Cataloguing in Publication Data
A catalogue record for this book is available from the British Library

ISBN: 1 898218 63 3

The publisher acknowledges support received from Huntly Heritage
towards the publication of this volume

Printed and bound by
Redwood Books, Trowbridge, Wiltshire

Contents

*Upon the River of Dovern ar castelis, Touris, palices and
gentil menis places nocht few, in quhilkes or cheif and
Principal, Strathbogie, the principal place of the
Erle of Huntley and Rothemay.*

(John Leslie, Bishop of Ross, 1566–*c*.1576)

Acknowledgements

I would like to acknowledge with grateful thanks the assistance rendered by many people – many of them without their knowledge – sometimes documentary, sometimes verbal, in the research for this book. Other people's research over the years, as well as reports and stories in the columns of the *Huntly Express,* have been invaluable. To them all, I would offer my thanks. Some have a mention in the text if I have quoted them, others too numerous to get a special mention, but their help and encouragement has been beyond measure.

A special thanks goes to two people who have not only proved their undoubted ability by what they have done but have also proved true friends, because only true friends would have put up with the many changes of a not particularly well-organised mind and still have maintained that friendship.

One is Brian Shepherd, who volunteered to prepare the manuscript for press and put it 'on disc', and for deciphering all my many additions and amendments. The other is Jason Masters, who did not exactly volunteer to take all the pictures for the book, but who accepted the job with a certain amount of trepidation. He often has had to put up with hearing 'I think we ought to have a picture of that,' or 'Do you think you could manage one of that from another angle?'

My special thanks, particularly, go to several people who have read the completed work and made many valuable suggestions, most, if not all, having been incorporated. In particular the late Dr Patrick McBoyle whose material for Chapter 22 was invaluable and who read and approved it after it was written.

Finally, to Mary White and the pupils of the then Primaries 4, 5, 6, and 7 at Cairnie Primary School during 1994–5 who have had so much of the book in the form of history talks that, finally (no doubt to see the end of it!) they have asked if it could be launched at the school when it is published. Which, if all goes well, it will be, because my final thanks go to the publisher, Jill Dick of Scottish Cultural Press, who has put up with a great deal of umm-ing and aah-ing, but who, despite the author, has eventually got it off the ground.

Introduction

It is natural happenings which make history, but it is people who shape history. The following 26 chapters are about the people and personalities who have shaped the unfolding events in the towns and villages of Strathbogie through which the river – which gives it its name – flows to its meeting with the River Deveron just downstream from 'The Jewel and Capital of Strathbogie', as Huntly is known. The town lies in a sheltered bowl formed by four hills:

> *The Battlehill, The Ba'hill, The Clashmach and The Binn.*
> *All form a circle, and Huntly lies within.*

A very quick glance at its history will tell you that one family has made and shaped this district more than any other, but it may come as a surprise to many to discover that this family were 'white settlers'! Since their arrival in the fourteenth century, however, few families have had such an influence on the history of the North-east of Scotland for such a long period as the Gordons. Even in this small book they appear time after time.

It is difficult for us, in a period when the influence of the Gordons has declined, to appreciate the impact which they have had on the North-east of Scotland. So strong has been that impact in the past that there can be few, if any, areas of North-east life, until the present century, which have not been either initiated or touched by their influence. They owned the farms and the land and, if not the houses, at least the ground on which they stood, only releasing that grip within the last few years as feu duty was abolished by parliament. They were the landlords, the employers, the law (at one time and for centuries), and the educators, as well as the military recruiters and commanders.

In 1975 a fitting tribute was paid to their achievements during the past six centuries when one division of the old Aberdeenshire was re-named 'Gordon' in the local government reorganisation. Sadly, it seems, the Conservative government of the mid-1990s saw fit to reverse that decision – presumably for some ideological whim of its own, for there was no demand for it – and Aberdeenshire has been resurrected, even if it does now embrace (insensitively, you might think) parts of the old county of Banff, including its former county town!

The Gordons' influence has not always been good – that would be too much to expect of anyone – but it has always had something of a flair and, if they sometimes shaped the course of history outside the confines of Strathbogie, as well as those inside it, it is because of their ambition and single-mindedness which determined where they wanted to go. Had they not been so single-minded, they may well not have achieved as much as they did, nor even made such an

immense contribution to the future of the North-east of Scotland.

So if the history of Huntly is the story of a family it is perhaps even more the story of the house in which they lived out their lives. The early development of the area is centred on the house they built and, more particularly, where they built it, for it was not built because they liked the spot, but because it was an instrument for defence and aggression, built, as it was, to filter traffic passing on the main road to Moray.

When the Gordons arrived on the scene, Strathbogie already had a history, but their coming began the second stage – from the fourteenth to the eighteenth century – of its three-part history.

It was said, 'Ye daur no misca a Gordon in the Rawes o Strathbogie,' and that was probably true anywhere between the Spey and the Bogie because that was Gordon land. Although they still ruled the land, they ceased to occupy the mighty castle at Huntly when the 2nd Marquis backed the wrong horse in the Civil War and was executed in 1649. Slowly, it fell into disuse; its stone and many fixtures being cannibalised to build other dwellings, including Huntly Lodge which became the residence, variously, of the heirs to the Dukedom, or of the Dowager Duchesses.

The Gordons, however, were not the first 'white settlers' who cast their eye on Strathbogie and found it 'a goodly heritage'. Everyone in both Huntly and Strathbogie is an 'incomer' at some point in past history, so it ill-becomes anyone to say they are natives, except by naturalisation!

The first period of this three part history begins with these early 'incomers', because there is evidence that this fertile, sheltered area was populated by people centuries before recorded history. They, too, helped to shape Strathbogie and their blood still runs in the veins of people hereabouts.

This little book is about people who have shaped the history of Strathbogie. Twenty-six individuals have been selected as being typical of their day, or of the contribution their type of work has made to the life of the community, and on that peg I have hung contemporary historical events. Some of them are very substantial figures; others are just ships, passing in the night.

If I have given these a little substance, I shall be well pleased.

Chronology of Strathbogie

BC

*c.*12000	End of last glaciation period.
*c.*6000–4000	The hunter-gatherers arrive in Grampian.
*c.*4000–2500	The farmers replace the hunters and the Garioch has a settled way of life; long cairns and barrows; recumbent stone circles; henges (Neolithic period).
*c.*2500–500	The climate gets wetter; Beaker people; (Bronze Age); Development of bronze technology and burial cairns.
500 BC – AD 900	Iron Age. The Picts. The soldier of Barflat. Tap o Noth, Dunnideer and Bennachie hill forts.

AD

1066	Norman Conquest of England.
*c.*1150–75	The Celts. Duncan the Celt, first 'Norman' Baron of Strathbogie, builds the first (wooden) Peel of Strathbogie.
1203	Duncan de Strathbolgyn dies.
1224	David de Strathbolgyn censured by Pope Honorius.
1307	Robert the Bruce taken ill and brought to the Peel of Strathbogie. Battle of Slioch (Slevach). (Christmas Eve) Battle of Barra.
1314	Battle of Bannockburn. David de Strathbolgyn forfeits the lands of Strathbogie for backing the wrong side at Bannockburn! Bruce gifts them to Adam de Gordon in 1318 – he backed the right side!
1376	The Gordons arrive in Strathbogie. Adam's grandson comes north to claim the lands gifted by Bruce in charter dated 1358.
1408	Elizabeth Seton (nee Gordon) succeeds to the lands, the male line having expired.
1436	Elizabeth's husband, Sir Alexander Seton, created 1st Lord Gordon.
1445 or '49	Alexander Gordon (son of the above) created 1st Earl of Huntly and Lord of Badenoch.
1452	Wooden Castle sacked by Earl Douglas.
1470	2nd Earl builds the Palace of Strathbogie.
1488	(27 March) Royal Charter creates Milntown of Strathbogie ('The Rawes') a free Burgh of Barony (see also entry at 1545 below).

1495	Wedding of Perkin Warbeck and Lady Catherine Gordon in the Chapel at Huntly Castle. 'Huntlie' created by Act of Parliament (cap. James IV).
1506	Alexander, 3rd Earl, changes name to 'Huntly' Castle.
1545	(3 July) 'Huntly' anciently called 'Torrisoule' created Burgh of Barony.
1551–4	George, 4th Earl (Cock o the North) rebuilds Huntly Castle in the grand French style.
1560	Start of Reformation.
1562	Death of 4th Earl from a heart attack at the Battle of Corrichie.
1588	Spanish Armada.
1630	Fire at Frendraught House.
1636	6th Earl, 1st Marquis, dies.
1643	Solemn League and Covenant.
1649	King Charles I and the 2nd Marquis of Huntly executed for treason. From this time, the castle begins to fall into ruins.
1660	Restoration of the Stuart monarchy (King Charles II).
1688	The so-called 'Glorious Revolution'.
1689	Episcopalianism disestablished; Presbyterianism established as the 'official' Church of Scotland.
1715	First Jacobite rising.
1727	First Presbyterian Church opened in Huntly, in what is now Upperkirkgate.
1745	Second Jacobite rising.
1746	Battle of Culloden.
1769	4th Duke of Gordon announces plans to develop Huntly.
1794	4th Duchess of Gordon recruits The Gordon Highlanders.
1801	'Missionar' (Congregational) Church opens in Huntly (closed in 1963).
1805	Present Huntly Parish Church opened.
1815	James Legge born.
1824	George MacDonald born.
1834	St Margaret's Roman Catholic Church opened.
1839	Foundation Stone of The Gordon Schools laid by Elizabeth, Duchess of Gordon, as a memorial to her husband, the 5th and last Duke.
1841	The 'walk-out' from Marnoch Church in protest at having a minister foist upon them. Strathbogie (Free Church) Church in Huntly opened.

1843	The Disruption and start of the Free Church of Scotland.
1849	Mackay of Uganda born.
1850	Christ Church (Episcopal) in Huntly, opened.
1852	James Hastings born.
1854	Great North of Scotland Railway line from Aberdeen to Huntly opened. Huntly Cricket Club formed.
1863	*Huntly Express* launched.
1864	Death of the last Duchess of Gordon.
1888	Huntly Jubilee Hospital opened.
1893	Huntly Golf Club formed.
1905	Death of George MacDonald.
1921	Huntly Football Club formed.
1966–7	Huntly Rugby Club formed.
1975	Last Provost and Huntly Burgh Council bow out. Grampian Region and Gordon District take over local government.
1992	Huntly Jubilee Hospital becomes part of Grampian Health Care – an NHS Trust.
1996	Further re-organisation of local government. The tenants of Downing Street (Conservative) put the clock back and Aberdeenshire was reborn – the child of Grampian Region and its districts.

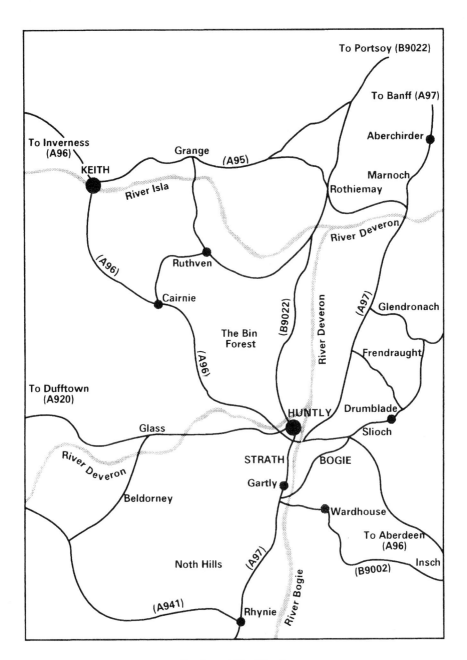

Huntly and Strathbogie

1. Rhynie Man

That day in 1978 was a fairly ordinary one on the farm of Barflat at Rhynie. At least it was until Kevin Alston, who was ploughing, turned up the stone. It was a pretty big stone – about one and three-quarter metres in length and three-quarters of a metre wide. The sort of thing that ruins a day's ploughing because you cannot just toss something that size aside. In fact, far from ruining Kevin's day, it made it, both for him and his father Gavin.

The boulder which Kevin had dug up was no ordinary boulder – it bears the figure of a man, carved in profile. He is wearing a sleeved tunic which falls to just above the knee and is belted at the waist. He is wearing leggings, and pointed shoes on his feet. Over his shoulder he carries an axe. His head has obviously been carved in great detail. He has prominent eyebrows, a large hooked nose, large teeth and a long, pointed beard. He has a very fierce expression on his face which, it is believed, may be a caricature from a long lost legend.

'Rhynie Man', as he has come to be called, is the earliest drawing or carving of a man known in the North-east of Scotland. It may well have been his memorial, that is, his gravestone. It was certainly carved by Pictish masons some 1400 to 1500 years ago, and there are only two other known Pictish stones which have incised single figures. One is also at Rhynie and stands in the Square, but it is so weathered that it is now impossible to discern the figure. The other is at Balblair, Inverness, and it was at this latter site that an early Bronze Age burial cist was unearthed in 1990 while excavations were going on to extend a quarry.

Mr Alston also turned up another stone along with Rhynie Man. This is a fragment of a larger carving: of a Pictish 'beast' – possibly based on a dolphin – and a comb. It is the eighth Pictish stone to have been found in the Rhynie area including the famous Craw Stane, visible on the left from the A97 as one climbs the hill out of the village going south. This also is incised with a fish and a beast. Others are to be found at the entrance to the Rhynie Kirkyard.

It is believed that Rhynie Man may have provided a model for the pictures of men on later monuments carved in relief at Golspie in Sutherland and Glamis in Angus. Which brings us to the importance of this 1400-year-old man from Barflat, because he is not just a pretty picture.

The appearance of so many carved stones in Rhynie, dating from Pictish times, suggests that we had here a community of major significance in the days before recorded history. Or were these stones an early attempt at recording history, because they are almost all that we have on record from those early days nearly two millennia ago.

Of course, we have Tap o Noth. On the top of the Tap lie the remnants of the

1

second highest hill-fort in Scotland, the highest being in Sutherland. The area around the North-east is noted for its hill-forts, among them, locally, Dunnideer at Insch, the Mither Tap o Bennachie, Barra Hill at Oldmeldrum, and Cnoc Cailliche or Wheedlemont, also at Rhynie. They were rather more than 'forts' – fortified settlements might be a better description.

'Rhynie Man'

Pictish Stone (shown rotated by 90°) found at Rhynie, on the farm of Barflat
(photograph courtesy of the Archaeology Service of the Aberdeenshire Council)

The earlier fort at Tap o Noth is 21 hectares (84 acres) in size, enclosed by a stone wall running all round it, except on the steepest side. Inside, 145 platforms were identified, most of them, surprisingly, on the northerly side. The upper fort consists of a vitrified wall – that is, wood was interlaced with the stone and then set on fire. A great deal of dry brushwood must have been hauled to the top to get up sufficient heat.

It is difficult to imagine a community being at home at this altitude, particularly in winter, even in the milder climate which prevailed here up to about 500 years ago and in the winds we get around here. It has been suggested that the site dates from about 1000 BC, but it is formally undated. Perhaps the enclosure found not far from the kirkyard at Rhynie was the winter home of these Tap o Noth dwellers, especially as the climate got wetter and colder.

The Noth Hills showing 'The Tap'

What of these earlier inhabitants of Strathbogie? People have been living off the land in the North-east of Scotland for something like 8000 years, difficult as it is for us to imagine.

The earliest settlers were hunters and they have left behind their hunting tools to prove it. They were nomads, going where the food was, using their surroundings to sustain life. They knew a thing or two about conservation, however, because they were skilled in the art of 'forest-firing' so that the right

3

conditions might be created in which their food could live and breed.

We have no idea what happened to the hunters. Were they pushed out to make way for another way of life, like their descendants in the Highland clearances, or were they absorbed into a new lifestyle and culture, brought by new settlers to the area?

What we do know is that a new way of life was introduced by groups of 'incomers'. They came, largely, from across the sea in Europe. They had no hunting skills because they were farmers, able to clear and till the ground, raise crops and animals to feed themselves.

By 4000 BC there is evidence of a settled way of life in Strathbogie and, within another 1000 years, the land between the River Don on the east and the River Deveron on the west, was a well-populated and probably very important region.

This Neolithic (literally, New Stone Age) way of life has left its traces. This was the age of the recumbent stone circles – and we still have little idea why they were erected. Strathbogie has nothing quite so spectacular as those at Callanish in the Western Isles or Brodgar in Orkney, but we have our share. What was their purpose? Places of worship and sacrifice? Village halls? Community centres? Burial grounds? Crematoria? The placing of the recumbent stone and supporters has led to suggestions of a religious significance, but we still are no nearer to knowing what they really did with them.

By the time another 1000 years had passed, society was becoming more technological and with it, changing its character, hence the development of the hill-forts. Why? Because the whole of Scotland, as of Europe, was gradually coming under the powerful lords whose staying-power depended on the amount of hardware they could display against the other powerful lords. This type of hierarchical (almost feudal) society was to continue for something like another 2000 years, but it constitutes the first of the three periods of Strathbogie's history, even though, apart from a few stones and their inscriptions, nothing was written down. It was going to be a long time before anything of the history of Strathbogie would be recorded.

2. The Norman Barons of Strathbogie

The twelfth century saw Scotland come under the influence of Norman–French culture. England was conquered by William, Duke of Normandy, at the Battle of Hastings in 1066, when he defeated the English King Harold. Harold was the last of the Saxon Kings, the successor to Edward the Confessor. At first, the English accepted defeat with resignation. After all, they had been invaded many times and accepted the new arrivals with a measure of tolerance.

The Normans, however, were interested only in imposing their will and lifestyle on the conquered people, and having it accepted, either voluntarily or compulsorily. Bit by bit, the Norman invaders quelled whatever resistance they found and the crop of Norman castles, which appeared all over the countryside, was evidence they intended it to stay that way.

So this man, who could not speak a word of English when he got here – a descendant of the Norsemen who had settled in Northern France in the tenth century – had a more lasting influence on the country of his conquest than probably any invader since the Romans. Perhaps it was because they were not only best soldiers, led by one of the cleverest generals, but because they were also good colonisers – at least, if you judge them by the skill with which they imposed their law and their culture on the conquered land. They lost little time in doing this. The English noblemen and landowners, as well as the bishops and abbots of the Church, were deposed and replaced by Normans, although even they had to prove that they were loyal and faithful to William – that they would, in fact become his liege men.

Norman William never ruled in Scotland, yet, inevitably, it quickly became fashionable for Scots noble families to adopt Anglo–Norman ways; especially appealing was the fashion of building castles and introducing a Scottish version of the feudal system, although it was never quite so intensive a system as it was in England.

As well as the Norman lifestyles, Christianity had come to Northern Scotland from west and south during the previous five or six centuries. Iona had sent missionaries from the Irish Celtic mission off Scotland's west coast who arrived by way of the great Glen and the plains of Moray. Similarly, missionaries from Ninian's base at Whithorn on the Solway Firth had ventured via the trade routes over the Mounth, the mountain range to the south of Aberdeenshire, and arrived on Deeside and Donside, following then the narrow pass into the Garioch and Strathbogie which was later guarded by the mighty fortress of Kildrummy. Would it not be a feather in Strathbogie's cap to be able to say that Mungo, the first bishop of Glasgow, came to Strathbogie; but 'The Mungo' and 'St Mungo's Well' at Kinnoir, just to the north of Huntly, cannot even claim nodding acquaintance with the saintly Bishop because it is extremely unlikely that they were named because of any connection he might have had.

We are on firmer ground, however, when we say that Wolok settled in Glass and the establishment of the Church there is due to him. His name even survives in the Wallakirk, where there once stood a chapel possibly originally built by him. Any suggestion that Wolok was a Saxon missionary, however, belongs to the realm of fantasy. He was either from Whithorn or Iona and there is no evidence to suggest that the Saxons ever penetrated north of the border: King Oswald, a Saxon king of Northumbria, who sought sanctuary from his enemy with the monks of Iona, invited them to come and Christianise his kingdom when he went back. Which they did, establishing a 'second Iona', so to speak, on the island of Lindisfarne, just off the Northumbrian coast. This lasted until the

5

Synod of Whitby in 664 sounded the death-knell of the Celtic Church and caused the monks to withdraw back to Iona.

Marnan too has left his name indelibly on the parish of Marnoch; he is said to have established a cell on the banks of the River Deveron close by the old kirk of Marnoch and the graveyard. He was undoubtedly one of the Celtic mission from Iona. They kept Marnan's head as a relic after his death and his cell became a place of pilgrimage once a year when they used to wash his head and give the water to the sick people for their healing.

All these people were incomers, not only to the North-east, but also to Scotland; the Celts brought their own language and culture, settling down and calling it home. We have moved on 500 years since the Pictish Barflat Warrior lived in Rhynie and the Pictish settlement at Tap o Noth was abandoned. The year 1066 marked the beginning of the culture change which, as we saw at the beginning of the chapter, was sweeping through Scotland. The Scots kings invited Norman barons to come and settle north of the Border and gave them lands which they held, according to the new fashion, in feudal tenure.

It was not without a great deal of opposition from the Celts, however. Instead of being a tribal kingdom, as they had been before, they now became a feudal one. One of the main areas of opposition to the Norman lifestyle was Moravia, roughly the modern Moray, which also happened to be one of the most fertile, and much-coveted areas of Scotland. The Scots kings had long appreciated the

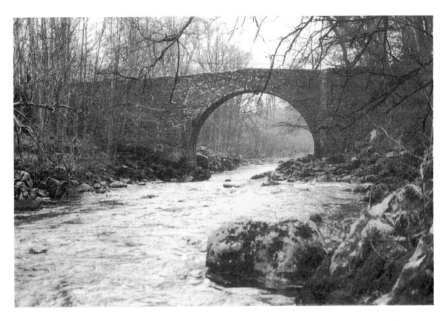

'The Elgin Bridge', close by the castle, which used to carry the main road into Moravia (Moray) and which, after the castle fell into disuse, was the main access to Huntly Lodge, now the Castle Hotel

delights of Moravia and owned large tracts of land there, and the only way they could get there to look after the estates and maintain the royal garrisons was by way of the main route through Deeside, Donside and into Strathbogie. It was therefore imperative that they had loyal barons at strategic points on the route, one of them being the crossing of the Deveron at Huntly. By the end of the thirteenth century, the route through narrow Glenkindie and westward was guarded by impressive castles – Kildrummy, Strathbogie, Boharm, Balvenie and Rothes. They were all occupied by Norman or Normanised barons – Mar, Fife, Comyn, de Moravais and de Pollacs.

It was in the latter part of the twelfth century that Duncan, Earl of Fife, although a Celt (probably out-Normaning the Normans, and enjoying playing at Norman barons), was given 'the lands of Strathbogie' by King William the Lion. In the style of all the Normans – real and converted – Duncan chose a well-protected piece of ground on which to build his castle. It lay just above the joining of the two rivers, with a natural protection from the north side. Its occupants were in a strategic position to notice anyone going into Moravia, on the other side of the Deveron, because this was, for a long time, the main road. The bridge over the Deveron, just beside the castle, is still called 'The Elgin Bridge'.

Taking possession of his new lands, Duncan immediately began to use his territorial title in the Norman style, calling himself 'Duncan de Strathbolgyn'. He built the Peel of Strathbogie in the typical Norman style – an earth and timber motte and bailey (like the first castle at Kildrummy). The wooden castle was built on the motte or mound (still to be seen today) and surrounded by a ditch or moat, topped by a palisade which guarded the buildings forming the castle. There might have been another enclosure, also with a palisade and ditch. This would have contained the chapel, stables, smithy and all the other buildings of the baron's establishment. The palisade (*palus,* meaning a stake) enclosures gave the derivation of the proper name for the fortification – 'The Peel of Strathbogie'.

The Earls of Fife did not have the occupancy of the Peel of Strathbogie for very long, however. Duncan died in 1203, leaving the lands of Dunbennan and Kinnoir to his third son, also Duncan. David de Strathbolgyn (Duncan's son?) seems to have made himself thoroughly unpopular with the Bishop of Moray. He had the nerve to raid the Bishop's lands at Spynie Palace, the Bishop's residence. It may quite possibly have been a regular occurrence because the Bishop's lands were noted for their 'good pickings' and he may not have been the only one to raid them! However, Bishop Andrew de Moravia could get no satisfaction from the local justices; justice being of a somewhat arbitrary nature in those days. He therefore took his case to higher authority and appealed to Pope Honorius who, in an Apostolic Letter dated 12 May 1224, 'Censured David de Strathbolgyn and his followers out of Strathbogie'. He is said to have planted himself in the Peel of Strathbogie, described in the Moray Diocesan records as being in 'The Aucht and Forty Davoch of Strathbogie'. The intervention of Pope Honorius may not

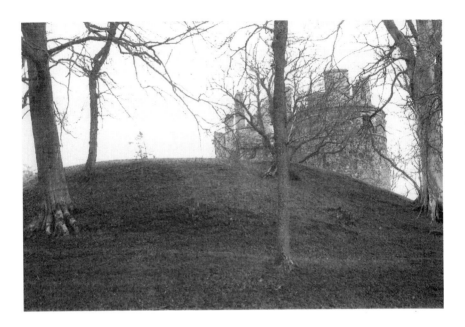

Huntly Castle and the motte on which the first castle was built

have been quite 'the sledgehammer to crack a nut' that it seems at first sight. David did submit to the Church's power, no doubt under threat of excommunication, which, in this age, we no doubt find slightly amusing – a bit like the old wifie down the road putting a curse on small boys who ring her door bell and then run away. In the thirteenth century, however, it meant loss of citizenship, sometimes even inheritance, and certainly ostracism from society. Some, like the Wolf of Badenoch (Alexander Stewart, son of King Robert II) who burned down Elgin Cathedral in 1390, taking his revenge on the Bishop of Moray who brought about his excommunication, could hardly have cared less; others trembled.

In 1307 King Robert the Bruce embarked on a punitive mission to the North-east of Scotland. The Earls of Buchan – another branch of the Comyn family – were a thorn in the flesh to the King, and whether he intended to destroy them, or simply bring them to heel, we shall never know. His mission ended in destroying them. During the campaign, he was taken ill at Inverurie and carried to the stronghold of David de Strathbolgyn so that he might be safe until he recovered.

> Therefor in litter they him lay,
> And till the Sleuach held their way.

8

> And thocht here in that strength to lie
> Till passit were his maladie.

Sleuach, the old name for Slioch, just half an hour's walk from the Peel of Strathbogie, was part of Bruce's Earldom of the Garioch. When he was well again, he went back to Inverurie, where he was again taken ill and his enemies, thinking he was too ill to do anything, took advantage of the situation and attacked him. He was not so ill that he could not fight, however, and he promptly defeated them at the Battle of Barra on Christmas Eve, 1307.

The end was nearing for David de Strathbolgyn as well as the Earl of Buchan. Despite his Norman conditioning, the leopard often has difficulty in changing his spots. David de Strathbolgyn forgot that Norman barons were supposed to turn in behind their King when he needed them. Like the Earl of Buchan, he had made up his mind that Robert the Bruce was finished and so he decided to look after Number One and back the other side just before the decisive Battle of Bannockburn in 1314.

He was wrong; King Robert won!

For his pains, he forfeited the Peel and lands of Strathbogie and, in the manner of the times, they were given as a reward to one of those who were loyal to Bruce and had joined themselves to his Standard at Bannockburn. So Strathbogie got a new owner whose name was destined to be remembered many centuries after he was dead because it was given to the area in which Strathbogie stood.

The castle was renamed, too, and the still-young fourteenth century ushered in the second (and, arguably, the greatest) of the three periods which make up the history of Strathbogie.

3. A Genuine 'White Settler' from Normandy, via The Borders

To begin the second period in the history of Strathbogie, we journey to the unlikely country of upland and valley which divides the two countries of Scotland and England and which has seen so many dramas played out in the course of two or three millennia. This is the country of the Cheviot – a land which breeds its people just as hardy as its sheep. It is here that we will find the people who are going to concern us for the next few hundred years of our story. This is where Huntly was established – long before it was even heard of in Strathbogie – and not only the first Huntly, but the first Gordon. Both are still there, even if they do realise that the new Huntly and the new Gordons have achieved a fame which they never looked for.

Enough riddles; we are talking about the village of Gordon in Berwickshire – a few miles from the border and within sight of the Cheviot Hills on the other side, in Northumberland. Today, the village is on the road from Lauder to Kelso. A mile or so from the village, on the Earlston road (Gordon stands on a crossroads), stands the house and farm of Huntlywood, once the home of the Gordon family, who gave their name to the village.

Unlike David de Strathbolgyn and his forebears, the Gordons were real Normans who came from Normandy. There they went back to the time of Julius Caesar, 1300 years before, because he mentioned a branch of the famous Nervii, under the name of Gordimi, which he came across when he was busy conquering Gaul in 53 BC. There was also an emperor called Gordinius, who could possibly have been one of the Gordimi. Possibly!

On firmer ground, there is a record of a Sir John Gordon, Constable of France, in the time of Charlemagne in 790 AD, which at least supports the idea that the Gordons had Anglo–Norman connections. In a manuscript belonging to Gordon of Prony(ie?) there is a mention of a Sir Adam de Gordon who came with King Malcolm III on his return to Scotland. As a 'thank you' for his services to the king, he got a grant of lands in Berwickshire to which he gave the name of Gordon – also known as Huntly – near to which was a large forest. In this forest lived a tremendous old boar which Sir Adam killed by his own hand and there is a tradition that King Malcolm thereupon insisted that Sir Adam make his heraldic device three boars' heads. These can still be seen on the Gordon escutcheon over the entrance door of Huntly Castle (Aberdeenshire, not Berwickshire) and also at the Nunnery at the Gordon house of Auchanachie at Ruthven. The tradition is, however, disputed on the grounds that heraldry had not then been born in Scotland.

However, among those who rallied to the standard of King Robert the Bruce at Bannockburn was the then head of the Gordon family, (the fifth) Sir Adam de Gordon. He was well-placed to guard the Border against the English marauders as they foraged over the Cheviot in search of whatever they could find. Gordon commanded one of the main crossings of the Cheviots from south to north. The Border was no longer guarded by Hadrian's Wall which was built between Tyne and Solway during the Roman occupation, the remains of which are a tourist attraction today. It had been an effective barrier in its time, but in later days, when the Border could move either way, virtually overnight, other eyes kept watch to see who was entering or leaving the kingdom under cover of darkness or mist. Adam de Gordon, well-placed at his Huntly stronghold, could make sure that the Border did not move without his knowing. He was a powerful feudal lord, with a considerable company of fighting men and others under his command, and it was on the Border that the Gordons would have gained a fair amount of practice developing the aggressive tendencies which characterised them for centuries. Such a man as Adam de Gordon would have been popular with King Robert, as he would be with any sovereign whose cause he backed so keenly. Because of this, he seems to have been one of Bruce's great favourites

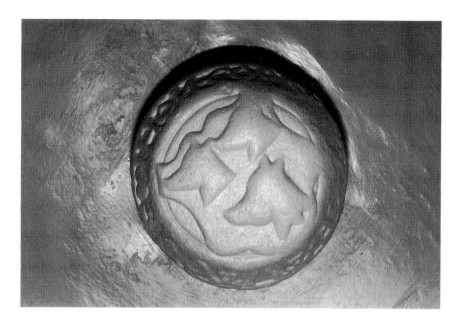

*The three boars' heads which have formed part of the
Gordon Coat of Arms since the fourteenth century*

and was rewarded accordingly. To this already well-heeled Border laird, Bruce gave the lands nearly 200 miles away in the North-east which had belonged to the turncoat, de Strathbolgyn. Yet why did neither Adam de Gordon, nor his son, ever come to Strathbogie to rule over their new lands? Why was it left to grandson, Adam, to be the first to come? Was it the continual harrying by the invaders from across the Border which kept Adam de Gordon at home? Was the fortress at Huntly so insecure that it would have been imprudent to have left it in the hands of a few, given that he would have needed a considerable force of both armed as well as domestic retainers, in addition to the vast array of skilled workmen – craftsmen, labourers, and so on – for the expedition to Strathbogie? Or was he so comfortably placed in the Borders that he did not relish the thought of being uprooted to go where few (Bordermen, at any rate) had gone before? It is unlikely that we shall ever know the answers to these questions, however, we do know that Adam's son, John, was confirmed in the Lordship in 1358, although it was not until 1376 that young Adam, John's son, came north.

After that they never looked back on their Berwickshire past. The Gordons had arrived!

We hear nothing about them for another 40 years. Presumably they were rather

busy settling down to life in what must have been a very different place from the Huntly in the Borders. When the Gordons arrived in the area where the greater part of Huntly is now situated, it was barren heath and marshy swamp. They also had to get used to the strange northern weather, to say nothing of the strange northern folk!

Sir John de Strathbogie received the charter confirming him in his lands and castle on 20 March 1358, at which time he also received the lands of Enzie and Boyne, but in 1406, his son, Adam, the last of the male line of the Gordons of Huntly (Berwickshire) and Strathbogie, died. He was succeeded by his sister Elizabeth.

Elizabeth had just married a local landowner with a proud North-east name, Sir Alexander Seton, and so the first of many North-east families was united with the Gordon blood.

Although the Gordon name had been changed for that of Seton, it soon reappeared when Sir Alexander was created first Lord Gordon in 1436. Alexander and Elizabeth were known locally as 'The Bow o Meal Gordons'. This title arose from the habit of the castle family of taking a bowl of oatmeal to the poorer of their retainers. They did it so regularly that the title seems to have stuck! This served the purpose of distinguishing them from 'The Jock and Tam Gordons' – one based in Rhynie, the other in Ruthven. Adam and Elizabeth Gordon had a brother called John who predeceased them in either 1388 or 1394. Jock and Tam were his illegitimate sons. Tam distinguished himself for posterity by fighting a battle (duel?) with John, the Abbot of Grange, ostensibly over boundaries. Tam had the lands of Daugh in Ruthven which no doubt bordered on the lands of St Mary's Abbey at Grange, which was a monastic foundation from the great Abbey at Kinloss. A cairn allegedly marks the spot on the Balloch where the duel was fought. Tam killed Abbot John in the duel but was so badly wounded himself that he just made it home to Little Daugh before he, too, died. History does not record where Abbot John was buried, but it was presumably in the Abbey burial ground, no doubt adjacent to the Abbey which was built on the hill where the parish church of Grange stands today, overlooked by the Balloch. Tam was buried near the north wall in St Cyril's Church at Ruthven, where his recumbent effigy can still be seen today. However, it is a bit weathered as it is open to the elements – the church roof having long gone.

From Tam's brother, Jock o Scurdargue (near Rhynie), is descended Sir John Gordon of Pitlurg (on the county boundary near Newtack, between Cairnie and Drummuir). It was Sir John who built the 'Pitlurg Aisle' in St Martin's Kirk, Cairnie, to house the very snooty and dispossessed congregation of St Peter's Kirk (near the so-called 'Red Bridge' over the Deveron) after it was burnt down (see Chapter 9). The inscription in the Pitlurg Aisle – what remains of it – is supposedly the oldest written record of a Gordon in the district. The Gordons held property at Pitlurg until 1724. In 1815, General Gordon, a descendant of this branch, took the name of 'Pitlurg' to his new estate of Leask and Birness, which lies between Newburgh and Cruden in Formartine.

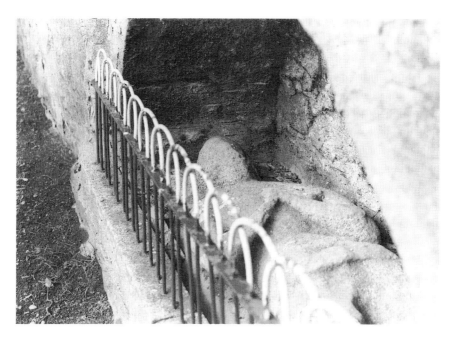

*The effigy of Sir Thomas Gordon (Tam o Riven)
in the wall of St Cyril's Church, Ruthven*

Sir Alexander's son, also Alexander, succeeded his father as Lord Gordon and was created the 1st Earl of Huntly and Lord of Badenoch in either 1445 or 1449.

Not only had the Gordons arrived in Strathbogie but, well within a century, had managed to make their presence felt, as incomers to a place so often do. They always say that it is the incomers who get things done, and it was certainly true in the Gordons' case; a trend which was to characterise their progress through the centuries and the generations.

The arrival of the title of 'Earl of Huntly' put Alexander in a bit of a quandary. It may have been all right for a Lord Gordon to have lived in an old wooden castle, but not for an earl. So we see the first 'L-plan' tower house being erected on the north side of the bailey. 'The greate olde tower', as it was known later, was blown up by William Shaw on the orders of King James VI in 1594 after a revolt by the 5th Earl and Lord Errol. Its existence was unknown until excavations in the twentieth century uncovered the ruins. It was built in stone and lime, alongside the old fortifications, both of which were destroyed when the castle was sacked in 1452.

The sacking was the Earl's own fault, however. He went off to join the civil war which started after the murder of Earl Douglas by James II in Stirling Castle

on 22 February 1452. On the way to support King James, Huntly had to fight the Earl of Crawford – known as 'The Tiger' – at the Battle of Brechin on 18 May. The Earl of Moray, a relative of Douglas, took advantage of Huntly's absence and, together with a small force, sacked Strathbogie Castle, burning down the 300-year-old Norman Castle. When he returned from Stirling, the Earl of Huntly lost no time in getting even with Moray because he went off and fought him at Darnaway itself.

The need for a new castle was now even more acute. Not only did the Earl of Huntly need something more in keeping with his new status, but now he had no home. Rebuilding, therefore, went on apace but, sadly, he died in 1470 before it was completed. His son, who succeeded him as 2nd Earl, supervised the completion of the rectangular building with its tower standing at its south-west corner. The cellars and the dungeon remained – a legacy from a ruthless age.

Without a doubt, it was now the 'Palace of Strathbogie'; but it is worth pointing out that *palatium* in Latin (which translates as 'palace' in English) simply meant 'hall' in medieval times, to distinguish it from that other popular type of residence of the time, a 'tower house'. Spynie Palace, home of the Bishops of Moray between Elgin and Lossiemouth, was likewise a 'hall'. *Palatium* or palace suggests that it was a good deal grander and more luxurious than it was. In point of fact, there was little comfort and scant luxury in the Palace of Strathbogie at the end of the fifteenth century and any resemblance to the European palaces of more recent times would have been entirely coincidental.

One of the other important events, not entirely overshadowed by the re-building of the castle, was the elevation of the Milntown of Strathbogie to the status of a (free) trading burgh of Barony. It gave the go-ahead to sell wine, wax, woollen cloth, broad and narrow linen cloth; to have bakers, brewers, butchers, etc.; to choose bailies and other officers; to hold weekly markets on a Monday and a public fair at Lammastide (1 August) yearly for eight days; and to put up a cross. When they 'put up a cross', they are referring to a 'preaching cross' where the townspeople would gather to listen to the Christian Gospel being preached, because this was the age of the itinerant preaching friars. If they did erect one, where was it? It is often referred to as 'the market cross' because it was usually erected in the market place; so did they erect one in what is now the Square, or was it nearer the castle, bearing in mind that the centre of the village was probably there.

The Royal Charter of King James III granting this freedom was apparently among the Duke of Gordon's papers but is now lost. Nor was it ever recorded in the Register of the Great Seal of Scotland, which is the record of Crown grants. It should be said, however, that there was nothing unusual at that time about it not being recorded. The evidence which shows the Charter did, in fact, exist is found in the catalogue of Gordon papers compiled when they were still in the Gordon family possession at Gordon Castle, Fochabers, and which is now in the Scottish Records Office in Edinburgh.

The catalogue entry reads:

Charter of King James III in favour of George, Earl of Huntly, erecting the town of Milntown of Strathbogie in a free burgh of Barony, dated the 27th March 1488, and the 28th of the King's reign, under the Great Seal.

It is evident that the Milntown mentioned is 'The Rawes' on the west bank of the River Bogie. The eastern end of The Rawes was probably entered by the road (then just a track) which came down Strathbogie from Rhynie and Gartly via Cocklarachy and crossed the Bogie at the spot, or fairly near, where the bridge (by the former level crossing) is at present. The road followed the river and the first houses were probably encountered at the foot of the present Old Road. The Old Road traced its present route (roughly) into what is now Castle Street. The houses may well have petered out at the Castle Park, and the main road out of The Rawes continued down the Avenue, past the Palace and over the Elgin Bridge. This embryo town was probably a rather small place in 1488, but it kept its title of 'The Rawes o Strathbogie' until 1727 at least, and probably until the Duke of Gordon announced in 1769 that he was re-planning and expanding the town to bring more trade.

Jumping slightly ahead, it is worth noting here that, during the time of George, 4th Earl (see Chapter 4), Mary, Queen of Scots, granted a charter 'for the erection of the town of Torrisoule into a free burgh'. This carries the date of 1545 which was deemed by Gordon District Council to be the one which founded the Burgh of Huntly. It is difficult to support this view.

Torrisoule is a corruption of an earlier 'Tillysoul', 'tilly' meaning 'a knoll'. The knoll known locally as 'The Torry' is obviously the one referred to and where the original hamlet referred to in the 1545 Charter grew up. Whether you can take Torrisoule instead of The Rawes as the parent and forerunner of the town of Huntly, is very doubtful. The evidence for the latter does seem to be stronger. In the first place, The Rawes, or the Milntown of Strathbogie, is still there, even if it does look a bit different 500 years later.

Torrisoule or Tillysoul disappeared completely in the course of time, and is unlikely to have been transplanted, even in the Duke of Gordon's re-planning of the town in the eighteenth century. It left behind a stretch of open country to the north-west of the town growing up around the present Square. It was only in this century that the housing north-west of what is now King Street was built.

It is worthwhile spending a little time over this as it is the subject of continual dispute. In fact, a former parochial schoolmaster, the Reverend John Macdonald did just that in a lecture which he gave in 1872 and which was printed verbatim in the *Huntly Express* of 23 March 1872. He does not appear to have been aware of the Charter of 1488 in favour of the Milntown of Strathbogie, as readers will see. This is what he said:

"Let me now turn your attention to the history of the rise and progress of the town of Huntly. The farthest back record we have of it is the Charter (of 1545) a copy of which was got some time ago by Mr Dunbar, of the *Huntly Express,* from the Register Office in Edinburgh, which was published some weeks ago.

There must at this early period have been a village in these parts named Torriesoul, and the name has not yet been altogether lost. We have still the 'Near Torrie' and the 'Far Torrie', and we have got a Torrie Street. The date in the Charter carries us far back – carries us back to the period when Mary, the beautiful and ill-fated Queen of Scots, was an infant of only a few years old. Notwithstanding the ambitious wording of the Charter, which evidently looked forward to the future prosperity of our burgh, it must have been at that time simply a collection of what we would now call thatched hovels, with perhaps one rather imposing house in it, or in its neighbourhood, the hostelry of Torriesoul. It took its name, I believe – but here, of course, I admit myself liable to correction – from the slight eminence, or eminences to the west of the town still called the near and far Torry (or the big and little Torry). I shall give you my reasons for this conclusion. In the written documents, in which I have been able to find the name, it is spelt in four or five different ways. Spalding, in his history of the troubles, mentions it twice. As an episode of his account of the raid on the lands of Frendraught, to which I have referred before, he says, 'Some of thir gentlemen happened to be drinking in Tilliesoul'. Again, in speaking of a deputation sent up to Edinburgh in regard to the difficulties into which the Marquis of Huntly got as to the feud with Crichton of Frendraught, he gives among the names of the deputation, James Gordon, ostler of Turriesoul.

Now, in the Presbytery record the name is mentioned twice, and it is there spelt 'Torriesoyle'. In the Charter, which is the oldest document, and the one we must go by, it is spelt as in the Presbytery Record 'Torriesoul'. Now, in the meaning of the word quoted in the *Huntly Express* – with the high authority of Jamieson and Dr Stewart to back it – they both went upon the supposition that 'Tilliesoul' was the proper spelling of the name. But here we have, as I have pointed out, the word spelt only once 'Tillie' by Spalding; and I may say he spells 'Kirriemuir', Killiemuir making the same mistake. But against this we have the record of Presbytery, almost the only educated men in the district at the time; the name Torrie still remaining among us; and last, but most conclusive evidence of all, the Charter spelling the name almost exactly as the Presbytery Record does. If Tilliesoul be the name, I give in at once to the authority of Jamieson and Dr Stewart that it meant a hostelry attached to a nobleman's mansion. If Torriesoul is the proper name, as I think written evidence proves it to be, it means – and here I am not speaking on my own authority, but on that of some of the best Celtic scholars in Scotland

– it means the height of view; the height from which a watch might be kept. Now, just look at the position of the Torrie, and say whether or not the name is not applicable.

There is no name more common in Scotland, and especially in the Highlands of Scotland than that of 'Tor'. It always means a height just like our own Torry. You have it in 'Torrybean' or the Tor of a hill, in this parish in Kinnoir perhaps – in Kintore, in the county – and in many other instances I might quote.

But what of the Rawes of Strathbogie, or the Rawes of Huntly? Was it the same place as Torriesoul? Now, here we must go on tradition to a very great extent. I have heard it repeatedly said by old men, who have been born and brought up in Huntly, that the hostelry of Torriesoul lay somewhere about what we now call the Meadow Stile; and it is clear, from the written documents I have examined, that between the Torrie-height and the Mill of Castleton there must have been a hamlet. The name Torriesoul appears to have been gradually lost. I can find no mention of it in the parish records, which extend as far back as 1689. The Rawes of Strathbogie or the Rawes of Huntly, are frequently mentioned by Spalding, and in the Presbytery Record; and in the two instances in which they are mentioned in the Presbytery Record, separate individuals are spoken of as living in 'Torriesoyle', and in 'Rawes' – showing that there was a separate hamlet which went by the 'Rawes', and that of these the Lord of the Manor gradually succeeding in forming the town of Huntly.

The late Rev. Peter Merson of Elgin Academy, than whom there can be no better authority, from the long connection of his family with the town of Huntly, told me that the Rawes extended from the Old Road, along the side of the road which ran across the Castle Park by the little bridge which still remains to the Bridge of Deveron. The Old Road formed a part of them; but as the site of Huntly began to be feued on a definite plan, the tenementers – for the holder in the Rawes appear to have been only tenementers – were gradually transferred to Huntly just as those of Torriesoyle were.

The name of Rawes of Huntly appears to have been almost invariably applied to the village down to the time of the junction of the parishes in 1727, when it was gradually dropped. We have probably, in the name Old Road, the last remaining witness to the time when Huntly was known to the common people by the not very euphonious name of the Rawes. The population of the village, towards the end of the seventeenth century, seems to have been from three to four hundred."

The reader may therefore choose between 1488 or 1545 as the date of the founding of the Burgh of Huntly.

Among the regular visitors to the newly re-built Palace of Strathbogie was King James IV. The Earl was known to be fairly lavish with his table, even if the

The Gordons

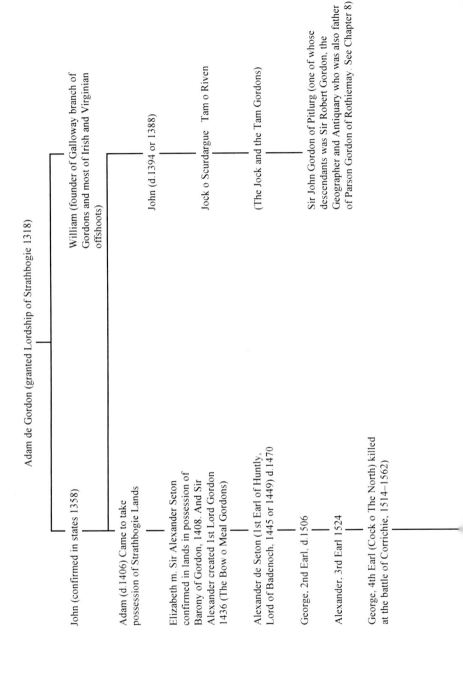

Adam de Gordon (granted Lordship of Strathbogie 1318)

William (founder of Galloway branch of Gordons and most of Irish and Virginian offshoots)

John (d.1394 or 1388)

Jock o Scurdargue Tam o Riven

(The Jock and the Tam Gordons)

Sir John Gordon of Pitlurg (one of whose descendants was Sir Robert Gordon, the Geographer and Antiquary who was also father of Parson Gordon of Rothiemay. See Chapter 8)

John (confirmed in states 1358)

Adam (d.1406) Came to take possession of Strathbogie Lands

Elizabeth m. Sir Alexander Seton confirmed in lands in possession of Barony of Gordon, 1408. And Sir Alexander created 1st Lord Gordon 1436 (The Bow o Meal Gordons)

Alexander de Seton (1st Earl of Huntly. Lord of Badenoch. 1445 or 1449) d.1470

George, 2nd Earl, d.1506

Alexander, 3rd Earl 1524

George, 4th Earl (Cock o The North) killed at the battle of Corrichie, 1514–1562)

George, 5th Earl restored to forfeited Earldom in 1565, d.1576

George 6th Earl (1562–1636) Created 1st Marquis, 1599

George 2nd Marquis, executed for treason, 1649

George 3rd Marquis

George, 4th Marquis, created 1st Duke 1684 (1650–1716)

Alexander, 2nd Duke, (m. Henrietta Mordaunt 1678–1728)

Cosmo, 3rd Duke, 1720–1752 (m. Katherine Gordon of Haddo)

Alexander, 4th Duke 1743–1827 (m. Jane Maxwell, d 1812) (m.2 Jean Christie 1820, d.1824)

George, 5th Duke 1770–1836 (m. Elizabeth Brodie d 1864) no children

Having no heir, the title, with the Earldom of Norwich, lapsed. The Marquisette of Huntly, which the eldest son held, passed to the 5th Earl of Aboyne, Lady Charlotte Gordon, daughter of the Duchess Jane and the 5th Duke's sister, had married the 4th Duke of Richmond, Charles Lennox, and in 1876 the title of the Duke of Gordon was vested in him and he became Duke of Richmond and Gordon. More than 150 branches of the Gordon family have been traced, all descended from Adam de Gordon's grandchildren, either Elizabeth, mother of the 1st Earl, or John's two illegitimate sons, Jock and Tam, many of them still continuing to live in the North-east of Scotland.

home comforts of the Palace left a lot to be desired, and the King was noted for indulging himself with food.

The King was certainly known to have been at Strathbogie in 1495 for the wedding in the Palace Chapel of Perkin Warbeck, the Pretender to the English throne, and Lady Catherine Gordon, the White Rose of Scotland, so-called because of her beauty.

The King visited again on his way to the shrine of St Duthac in Tain, on at least two occasions. It was one of the 'in-things' in the fifteenth and sixteenth centuries to make pilgrimage to St Duthac's shrine – apparently more benefits could be received from him than from any other saint, and all the best people in Scotland did it. Seriously, however, we must remember that this was an age of faith and people were more ready to believe then, than now, in the benefits of going on pilgrimage to one's material as well as spiritual health.

Besides good food the pleasure-loving James IV enjoyed gambling, minstrels and jugglers, and items in his accounts refer to payments for them, along with 'drink silver' to masons at Strathbogie Castle, which seems to indicate that, on his visits, work was still going on at the Palace, even at the end of the century.

Earl George died in 1506, having just managed to complete the building work. He was succeeded by his son, Alexander, who was the first of the Gordons to remember where they came from and who decided to change the name of his new castle from Strathbogie to Huntly – the name of his ancestral home in Berwickshire.

A Charter under the Great Seal of Scotland confirmed him in his lands at Strathbogie, as well as laying down that, in all future times, Strathbogie should be called the Castle of Huntly.

As in horticulture, in so many graftings, it did not 'take'. Nearly 40 years later, 'the Earl had recourse to an Act of Parliament which established that the castle should be known as Huntlie.' What the Charter under the Great Seal did not accomplish, he hoped that an Act of Parliament would! It does not seem to have worked completely, however, because by the seventeenth century, the historian Spalding was still calling the castle both Huntly and Strathbogie as the fancy took him.

Were Earl Alexander here today, however, he would no doubt be delighted to notice that the name 'Strathbogie' had completely disappeared as a title for the castle and no-one ever thinks of it now as anything but Huntly Castle.

4. *The Cock o the North*

George, the 4th Earl of Huntly, enjoyed nothing better than showing off his property, possessions and himself to anyone whom he thought would be impressed. Unfortunately, although he had spent a long time building up his life-style, his boasting and showing off were his undoing. Perhaps he thought that, being a cousin of the Queen, he could live like a king. He did, but the Queen felt that there was room only for one on the throne of Scotland, and had no intention of allowing George Gordon to share it with her.

His grandfather and great-grandfather had built up Huntly Castle a century before, but it was not quite grand enough for him. Good enough if he had been like all the rough and ready noblemen he saw round about him in Scotland, but he considered himself a cut above them: he was the Queen's cousin, after all. He was also well travelled. He had undertaken a French tour in 1550/51 and admired the style, dress and beautiful chateaux of the French aristocracy, as well as their opulent style of living. He was converted and wanted to live like them.

When he returned to Huntly, he set about creating a chateau in the grand manner of the French. No longer would it be the gloomy Palace of Strathbogie; Earl George set about making it a castle fit for a king – or a queen, in his case. In only three years, between 1551 and 1554, he practically rebuilt it. The only things he left were the thirteenth-century dungeon and underground vaults. Although the 1st Marquis refashioned the castle slightly in the seventeenth century, it is substantially the same today as it was when the 4th Earl left it in 1562, following his death at the Battle of Corrichie. He did not enjoy his opulence for long.

George Gordon was proud of his castle. He and his wife, Elizabeth Keith, have left their intertwined initials on a spurstone on the corbel-stepped gable, but there was nothing romantic about it. It was not a pair of lovers carving their initials on a tree. Rather, it was putting his name on his property, even in a place which can only be seen with difficulty. Only the best would do for Earl George, with his endless power-seeking and delusions of grandeur. He even imported a French architect to design and oversee the re-building, but that in itself was no use unless he could show off the castle. To do that, he went to the top. He invited no less a person than the Queen Regent, Mary of Guise – mother of the infant future Queen Mary – and her court, including (sadly for him) the French Ambassador; an influential person at the Court, for Mary herself was French.

Nothing was too good for the Royal party. He laid on a thousand men as guard of honour; every day had its own new entertainment; they played games and indulged in other pastimes, and the Queen Mother was said to be in raptures at this beautiful and elegant house, in its delightful setting, and all the wonderful

21

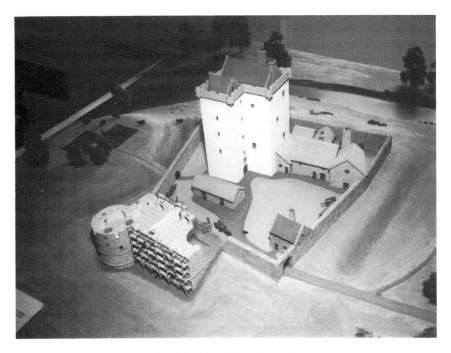

Model of the 4th Earl's castle

things which their so-attentive and charming host arranged for their pleasure. Not wishing to outstay her welcome, the Queen Mother announced they would be leaving, but the Earl protested that they could never outstay their welcome, and they would never be a burden on the castle's finances.

To prove it, he took the French Ambassador on a conducted tour. It was the wrong thing to do. They visited the storehouses and cellars, the bakehouse and the brewhouse, as well as the cold store where they hung the venison. By this time the Ambassador was completely astonished and, casually, the Earl remark-ed that he got fresh supplies in season from all parts of the estate every day!

When they got back to the Royal palace, the Ambassador took the opportunity of remarking on the magnificence of Huntly's lifestyle and his wonderful castle. In fact, he said this 'Cock o the North' was getting too big for his boots, his power outstripped that of the Crown and it was time that he had his wings clipped. The name went round the Scottish Court like wildfire and, because Huntly was fairly unpopular and so boastful, it stuck, although, in all fairness, no one was perhaps more delighted than the Cock o the North himself. He did, however lose the Earldom of Moray which he had somehow acquired not very long before, although this did little to lessen the Cock's strutting, nor

his crowing. Maybe the Court was not sorry to see this happen because his boasting had caused him to be known, somewhat sarcastically, as 'the wisest and wealthiest subject in Scotland'. Certainly the second part was true, but the first part was not, and in the later part of his life it became very apparent that he was a very unwise subject.

One of the most disgraceful and horrendous incidents in the history of the castle serves to show the Earl's lack of wisdom. This was the murder of a young man called William Mackintosh, nephew of the Earl of Moray, and head of various tribes known collectively as 'Clan Chattan'. Huntly had tried, unsuccessfully, to get Clan Chattan to acknowledge his lordship. When that failed, he captured Mackintosh and threw him into the dungeon at the castle. No one ever emerged from the dungeon alive. Suffice it to say that the whole North-east was aghast at Huntly's action. It was an act which might be seen to lie at the root of subsequent events.

Another contributory factor in mighty Huntly's downfall was the fact that he backed the wrong side at the Reformation and stuck with the old faith. It cannot be said to have been bad judgement in this case because, after all, Queen Mary was not only his cousin but she had been brought up in the Catholic tradition. What could be more natural than that he elected himself her champion and went all-out to oppose the Reformation and support the Counter Reformation.

When Parliament met in 1560, the leading principles of the extreme Reformers were accepted, and at one stroke a revolution was completed in the Church of Scotland. The old Church of Scotland was overturned; its possessions confiscated; its creed changed; the jurisdiction of the Pope in Scotland abolished; all Statutes not in accord with the new principles repealed; and the saying of Mass banned under pain of confiscation of goods – banishment for the second offence and death for the third.

So Huntly, thinking he was doing the Queen a service, turned Huntly Castle into a Catholic stronghold and a repository for church treasures removed from places like St Machar's Cathedral in Aberdeen, lest they fall into the Reformers' hands. There were 140 lbs of gold and silver plate, statues, candlesticks, altar cloths and vestments – including the cloth of gold set which had been a treasure at St Machar's – and a silk tent which Robert the Bruce had captured from the English King Edward III, and in which he slept the night before the battle of Bannockburn.

It was not so much that Huntly was leader of the Catholic opposition to Calvinism and the reformers which led to his undoing. It was that, no matter what he did, he believed he had the right to do it because he was related to the Queen. He was the greatest Scottish nobleman – a Catholic nobleman serving a Catholic Queen.

Unfortunately, Queen Mary did not see it exactly like that. The first indication Huntly had that his Queen did not approve of what he was doing was in September 1562 when she made her first journey to the north. She bypassed

Huntly Castle completely and went to stay at Rothiemay House with Lord and Lady Saltoun. The snub must have come as a great blow to Huntly, so much so that Lady Huntly wrote pleading with the Queen to come, saying that her husband was not as bad as his reputation. The Queen also added insult to injury by going to Darnaway and staying with Lord James whom she created Earl of Moray during the visit.

Dr William Cramond, in a paper to the Banffshire Field Society in 1900, described the story of the Queen's visit to Rothiemay in 1562, which had been recorded by the sixteenth-century Scottish historian, George Buchanan. Having spent the night of 2 September at Balquhain, instead of going to Huntly Castle, the Queen spent a peaceful night with the Abernethys (Saltouns) at Rothiemay. Her bedroom, according to Dr Cramond, was apparently still being shown to visitors in 1900, although a bed, supposedly in which she slept, was sold in 1888 to a Mrs Reid in Aberdeen for £6.15s, and two 'Queen Mary chairs' were also disposed of at the same sale.

Lord Saltoun subsequently supported the cause of the Queen against Huntly at the Battle of Corrichie a month later – something he and other northern barons lived to regret. In a letter to the Privy Council in 1566, the barons complained that 'thair landis, rowmes and possessions wer and ar in utteer perrell and dangier to be invaidit and persewit with fyre, swerd, and all uther kynd of hostilities be George Erll of Huntlie, is assistaris and complices'. (This obviously refers to the 5th Earl and not the 4th, who had died on the battlefield.)

The Queen may have been a Catholic at heart, but she now ruled a country whose Parliament had opted to change the form of Church government to Presbyterianism, even though a large number of the people of Scotland did not agree with Parliament's decision. It was more than their life was worth to say so, of course, and Huntly, by his ostentatious embracing of the Catholic cause was indulging in rebellion against the will of Parliament and, hence, the Queen herself. By supporting the Catholic cause openly, Huntly had, in the Queen's eyes, committed an act of treason. The fact that she was his cousin did not give him immunity from the force of the law, even though, in Strathbogie, he *was* the law! So Mary prepared to teach Huntly a lesson. She sent her troops to do battle with him and, at Corrichie, on Deeside, at the Hill o Fare, the two armies met on 28 October 1562.

The Earl went in command of his troops, but he never went into battle. He died before he could even get near it, but not from wounds. His rich living and lack of exercise had resulted in his becoming too fat and overweight and, when they got him into his armour, it proved too tight and he collapsed and died before he even drew his sword, always assuming that he could have done so in such a tight suit of armour.

The battle did not stop because the Earl was dead, however, and the Queen's army very quickly gained a decisive victory. Earl George's two sons were taken prisoner to Aberdeen where the elder, John, who would have succeeded his father and become the 5th Earl, was beheaded in the presence of Queen Mary.

This was the second of Earl George's sons whom she had executed. The other was put to death in Inverness, when he would not let her into the castle – where he was keeper – when she was on a visit to the town. (It is hardly surprising that she, herself, met death by execution when she, and everyone else at that time, treated life so cheaply.)

The Earl of Moray took speedy advantage of Huntly's death and disgrace. He came and plundered Huntly Castle and then set it on fire, a task which, although he may have arranged it for the Queen, he no doubt carried out with a certain amount of glee because, being auld enemies, there was no love lost between Moray and Huntly.

Huntly's lands were forfeit to the Crown, of course, as all traitor's lands were, but the Queen had the Church treasures removed to Edinburgh and it is interesting to read the list in Queen Mary's Inventories: 'Ten caippes, chassubles and tunics, all of cloth of gold from Strathbogie Castle', and 'I delivert three of the fairest, quilk the Queen gave to the Lord Darnley'.

The rooms of the house in which Darnley was murdered were furnished with things brought from Huntly Castle. These included 'tapestries, a leather chair of state, a black velvet dais fringed in black silk, a velvet high chair and a table covered in green velvet'. It was said that the copes, chasubles and tunicles of

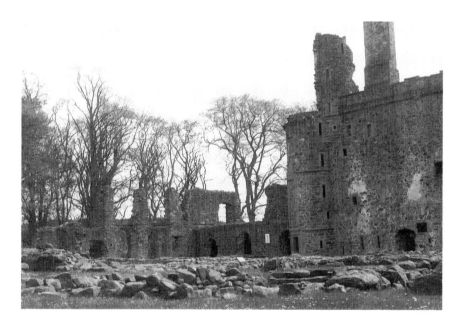

Huntly Castle: a view of outbuildings, kitchens and other quarters needed to support a household of considerable size, and in the grand manner expected, during the heyday of the castle following its refurbishment in the French style by George, the 4th Earl

25

gold, which the Queen profaned for secular use, were 'relics of the proudest triumph ever gained by Scottish arms'. So much for her being a Catholic Queen!

The work of restoring the castle after its plundering and firing was started fairly quickly – in 1569 – but very little of it can be dated from that time, so very likely only the woodwork, roof and furnishings were the victims of the fire of 1562. The work was still going on 30 years later when an even greater blow struck during the time of the 6th Earl. He also had dreams of being the greatest nobleman in Scotland, even though they never materialised. At least the 4th Earl carried out his dreams!

Meanwhile, the Strathbogie lands were restored to George, the new 5th Earl, as a result of something which can only be described as an act of Royal blackmail, much less justified and far more despicable than the overthrow of the 4th Earl. But then, Queen Mary had been brought up in a hard school and was not above believing that the end justified any means!

This story concerned the 5th Earl's sister, the Lady Jean Gordon, who was married to the Earl of Bothwell. Queen Mary said that the Earl would get the lands of Strathbogie back again if he consented to the divorce of his sister and the Earl of Bothwell whom she (the Queen) fancied (although presumably she did not tell Earl George that until afterwards) and who was footloose and fancy free at the time, her former husband Lord Darnley having conveniently been murdered by person or persons unknown. Well, you don't refuse a Queen, especially when your lands – and hence your livelihood – are at stake, so he agreed to the divorce. Jean, the erstwhile Countess of Bothwell, was dumped, the Earl of Bothwell married Queen Mary, and Huntly got his lands back. What happened to Jean? She married the Earl of Sutherland in the newly-restored Chapel at Huntly Castle on 13 December 1573. She was described, rather condescendingly, as 'a vertuos and comlie ladie, judicious, of excellent memorie, above the capacity of her sex.' Sounds rather a snip, or was that just a reference to get her married?

5. *The Earl and the Rewards of Treason*

There have always been men who would gamble everything on one hope. One of those who did was George, 6th Earl of Huntly.

He was not the first Lord Huntly to be looked on as the leader of Scotland's Roman Catholics in the face of the new Calvinistic Presbyterianism, which had swept the country in the wake of John Knox's reforms. It was as difficult, however, to separate politics and religion in sixteenth- and seventeenth-century Scotland as it has been in twentieth-century Ireland.

The Counter Reformation, as it was called, suffered something of a set back

when the Earl of Huntly was defeated and discredited, and his castle sacked, by the Catholic Queen Mary. Catholic though she was, Mary showed an almost Presbyterian disregard for the treasures of St Machar's Cathedral, Aberdeen (which were being stored at Huntly until they could be returned to the Cathedral), carrying them off and applying them to secular use.

As the Spanish Armada sailed into the English Channel on 21 July 1588, Earl George married Henrietta Stewart, daughter of the Duke of Lennox. He had staked everything on the Armada defeating the British Navy, and the Spaniards landing in Britain and taking the throne away from the Protestant Elizabeth of England. It must have been a sad day for George, therefore, when the news reached Huntly that the Armada had not only been unsuccessful, but had not even got there! George's dream of becoming the greatest nobleman in Scotland was blown away by the same summer Channel gale which took the Armada off its course.

But George Gordon led a double life. In the year of the Armada, he signed the Presbyterian Confession of Faith while, at the same time, continuing to engage in plots for the Spanish invasion of Scotland. On 28 November, his duplicity caught up with him. When he was captain of the guard at Holyrood Palace, certain treasonable letters came to light. King James VI gave him a Royal Pardon for this, probably because he had been instrumental in delivering the King from the Ruthven raiders in 1583.

Huntly's 'clean sheet' did not stay clean for long, however. The following year he led a rebellion in the North which came to nothing, and for this he was imprisoned for a short time in Borthwick Castle. He still had not learned his lesson and the next escapade in which he got involved was a private war with the Grants and the Mackintoshes. They enlisted the help of the Earls of Atholl and Moray and in February, 1582, Huntly set fire to Moray's castle at Donibristle in Fife and stabbed the Earl to death by his own hand. This outrage produced the ballad, 'The Bonnie Earl of Moray', and brought Huntly's enemies down on him to ravage and plunder the lands of Strathbogie.

It was after this that the real blow fell. Murder he could get away with: the law being what it was at the time, each laird managed to settle his own differences and exact revenge. Treason was quite another thing. The 'Spanish Blanks', as they came to be called, were intercepted. These amounted to treasonable plots to overthrow Elizabeth of England and James of Scotland and establish Spanish rule in Britain. Two of the 'Blanks' bore Huntly's signature, and both he, and the Earl of Errol, whose name also appeared on them, were charged with high treason.

On 26 November, however, the rebel lords were released from jail, and the charges were dropped on condition that they renounced their Roman Catholicism or left the kingdom. Both refused, and it was certainly unlike George Gordon to do so; he would have been more likely to say yes and then just let things drift, doing nothing. In this case, however, he was so far up to his neck that it must have been pointless to recant yet again. Instead he played for time. He returned

to Strathbogie and got on with building his castle, on which work had been going on for a long time. The French Ambassador paid him a visit in 1595 and reported to the Court when he got back that, 'Huntly hastens the building of his hall and gallery at Strathbogy'. One wonders if he was the same ambassador who had visited the 4th Earl some years before and had been instrumental in getting the Earl's 'wings clipped' by the Queen Regent. If not, perhaps French Ambassadors to the Court of Scotland were renowned for telling tales!

Only a fool would have done what George did next. In October of that same year – 1595 – along with his friend and accomplice, Lord Errol, and joined by Lord Bothwell, he led a revolt against King James VI, conspiring to imprison him. James, who no doubt partly sympathised with Huntly and his Catholic views, and was certainly well-disposed towards him, could hardly allow such a rebellion to go unchallenged. An army, commanded by the Earl of Argyll, was sent out to put down the revolt but it was defeated by Huntly at the battle of Glenlivet (or Balrinnes).

King James arrived in person, accompanied by the arch champion of the Protestant cause, Andrew Melville. No doubt Melville insisted on going with James to prevent the King relenting when he arrived in Huntly. The King had something of a reputation for doing just that, and Melville is on record as saying that there ought to be a witness of dealings with 'the followers of the beast' – that is, Roman Catholics. They blew up Errol's castle at Slains; the original one (which is still a ruin) is seven miles to the south of the new one, which was begun in 1597 but remodelled in 1836 and which is also now a ruin. Slains Castle has become better known more recently because it is said to be the inspiration for Bram Stoker's *Dracula* stories; Stoker actually lived in, and later retired to, Whinnyfold, close by the 1597 Slains Castle.

When they moved on to Huntly, Melville no doubt intended to blow up the castle there, too. James did exactly what Melville had feared he would – he saw the beautiful building which Huntly Castle now was, and relented. 'It was Melville,' says his nephew James, 'who reasoned and bore out the matter by the assistance of Lord Lindsay, so... that at the last, the King takes upon him, contrair to the greater part of the council, to conclude the demolishing of the House, and gave command to the master of the wark (William Shaw) to that effect, which was not long in executing by the soldiers... When all was done, little sound mining and small effect fader was produced.'

They used gunpowder, lent (!) for the occasion, surprisingly, by the Lord Provost and Bailies of Aberdeen. The Privy Council Register records that 20 stone weight of powder was lent, but if James Melville is correct, it did little damage. About 20 feet of the north wall seems to have been blown up because it has been repaired with different materials. The date and the arms over the door on the north-east tower entrance give the date of this as 1602. A complete wing or tower on the north side seems to have been completely demolished, and the 'greate olde tower' on the north side of the courtyard was also blown up, along with a number of buildings on that side whose foundations are still to be seen.

George Gordon left Scotland about March 1599, but returned secretly and submitted to the Kirk, which held a great deal more power in the sixteenth and seventeenth centuries than it did later. James was delighted, and restored him to his estates, forgave him his treason (yet again), and after a decent interval, created him 1st Marquis of Huntly. King James did not hold the reins of government completely, however. The Kirk ruled – and the General Assembly of the Church of Scotland decided – that Gordon's submission to the Kirk might have a better chance of 'taking' if ministers of the new faith stayed at Huntly Castle in succession to instruct the Marquis in the faith. They would also have a better chance of keeping away 'mass priests' and all the other nonsense and idolatry of the old faith. They cannot have made much headway, however, because when autumn came, George announced that he was closing up the castle and moving his household to Edinburgh.

He returned in 1602 – with or without his Presbyterian 'instructors' is not clear. Part of the castle, despite the destruction of 1595, must have been fairly habitable, and now the Marquis set about the rebuilding and refurbishment with a new vigour. It was a far more magnificent restoration than anything done by his predecessors, and to it belongs most of the beauties still seen today, despite its ruinous state. The stately oriel windows, for instance, which imitated the style of those at the Chateau of Blois, of which the Marquis was said to be governor, are an example.

The windows bear the carved inscription:

GEORGE GORDON, MARQVIS OF HU(NTLY)
HENRIETTA GORDON, MARQVISSE OF HU(NTLY)

The last four letters have either disappeared or were never there in the first place. Probably it was intended to extend the south front eastward, and the corner stones were certainly left so that it could be. The Marquis's original intention, apparently, was to have a large quadrangular block of buildings, but only a small part of the original design was ever carried out, due no doubt to the family's religious leanings. They were constantly being harassed because of their Catholicism and they found that their house at Bogs o Gight at Fochabers, which later became the family's only home, was farther removed from Aberdeen and provided a retreat from all the constant sources of annoyance.

Although Huntly was back in favour with the King for a further time after his latest 'lapse', the Kirk was not quite so sure about his 'conversion' to Presbyterianism as the King. On 7 March 1607, he was summoned to appear before the Privy Council. Immediately, Huntly went to London and appealed to King James – who by now was King James I of England as well – but to no avail. He was excommunicated by the Kirk in 1608 and imprisoned in Stirling Castle until 10 December 1610, when he again signed the Confession of Faith and was released.

When Charles I came to the throne, he did not have the same regard for

*Huntly Castle as it is today showing the restoration and rebuilding
work carried out by George, the 6th Earl and 1st Marquis*

Huntly, and the Marquis turned to waging a private war again – this time with
the Crichtons of Frendraught – from 1630. Again the Privy Council summoned
him to appear and this time he was jailed in Edinburgh Castle in 1635. He died at
Dundee on 13 June 1636, renouncing (positively for the last time!)
Presbyterianism, and declaring himself what everyone had known he was in any
case, a Roman Catholic.

The 1st Marquis was 74 when he died. On 25 June his friends gathered in
mourning weeds and carried his coffin – covered in black taffeta, in a horse litter
or hearse – from Dundee to the Chapel of Strathbogie in Huntly Castle, his lady
staying with the coffin throughout the journey. She then went to the Bogs o
Gight. The Marquis was taken from Strathbogie to Bellie Kirk, and then on to
Elgin Cathedral, where he was buried at night, with more than 300 men with
lighted torches filling the Cathedral aisles.

6. A Lady worse than Lady Macbeth

The position of 'First Lady' in this collection of local personalities must inevitably go in historical order to one who would certainly prove Shakespeare's words in the mouth of Mark Anthony on the death of Julius Caesar:

> The evil that men do lives after them,
> The good is oft interred with their bones.

It is difficult, now, to imagine that Frendraught House, in its peaceful wooded tranquillity at the head of Glendronach, could have such a history of bloody feuds, killings, burnings and subsequent hauntings by guilt-ridden ghosts. Yet that was the picture at least in the fifteenth century after it came into the possession of the powerful Crichton family through Janet, grand-daughter of the Earl of Huntly, who married the 2nd Lord Crichton.

The Crichtons, Gordons, Leslies and Dunbars were all intermarried – where else could they look for marriage partners without jeopardising their privileged

Frendraught House, Forgue, as it is today

position and endangering their precious estates and property if not among 'their own kind?' (Remnants of this protective policy still exist today, though to a lesser extent, among the land-owning classes and 'suitable' marriages are still made with the same end in view.) There was, therefore, precious little territory in the north and west of Grampian which was not controlled by them through one of their branches.

The fact that they were all inter-related did not stop them feuding among themselves. One of the seventeenth-century Crichton Lairds of Frendraught had a well-deserved reputation for scrapping with any and every one of his neighbours, and in his fights he was ably supported by his wife who had an equally deserved reputation for quarrelling. Lady Elizabeth Crichton was a Gordon, the eldest daughter of the Earl of Sutherland and, if the accusations which were made against her have any truth in them, as they certainly seem to have, 'both the Medusa of Euripides and Lady Macbeth,' to quote an unknown nineteenth-century historian, 'pale into insignificance beside her.'

Our tale begins in 1630 with a fairly normal boundary dispute between Sir James Crichton and one of his neighbours, Gordon of Rothiemay. Crichton wasted little time over disputes of this nature; he chose the quickest and most effective way of settling the argument – he simply shot Gordon! Because these inter-related families owned all the land hereabouts, they owned everything and everybody on it, which meant that they were the local law and what they said went. One of them had to be the chief administrator of justice and this fell to the Marquis of Huntly as befitted his rank. In every case, when dealing with his fellow landowners, he was related to both sides in the argument, but this did not stop him from fining Crichton the sum of 50,000 merks, the 'blood money' to be paid to Gordon's son, John, who, earlier than he thought, had become the new Laird of Rothiemay!

Crichton did not learn his lesson, however, because sometime later that year he took a shot at another of his neighbours, also a relative, Leslie of Pitcaple. He was lucky that he used an arrow and not a pistol and merely wounded Leslie. Again Crichton appeared before the Marquis of Huntly and having heard the evidence, the Marquis found in favour of Crichton this time. Leslie, fuming, stormed out, vowing that if he could not get justice in law, he would settle the matter with Crichton his own way. Crichton was obviously afraid that Leslie would lie in wait for him and exact vengeance on the way home, so he set about fixing a 'get you home safely' service. Naturally, all the kinsfolk and neighbours had been to the sitting of the court at Huntly Castle and were no doubt all refreshing themselves afterwards, before the arduous journey to their respective homes, so it was not a difficult task for Crichton. Yet they were an unlikely group who escorted the Laird of Frendraught that night and included Viscount Aboyne, Huntly's son and heir, and the John Gordon whose father Crichton had killed earlier that year. No doubt he told them he would make it worth their while with an offer of plenty of food and drink when they arrived at Frendraught.

It is unlikely that he planned mischief when the party got there because impulsive men like Crichton usually acted on the spur of the moment. Lady Crichton could have planned something, however she had no idea they were coming. One can only conclude, therefore, that she was an opportunist and grasped the occasion to get even with their auld enemies. We shall never know, but she seems to have been lavish with her hospitality and they retired to bed replete with both food and drink. It was probably Lady Crichton's idea to put them up for the night, but judging by the amount of liquor which men of their ilk consumed, they would be in no fit state even to get on a horse, let alone ride it home!

Viscount Aboyne (or Melgum, as he was also known) was put in the old tower, separated from the rest by a wooden staircase. According to Father Blackhall's *Brief Narrative*, his room had a vault underneath it with a round hole under the bed, the purpose of which can only be a matter for speculation! John Gordon, the young Laird of Rothiemay, and other guests, including Colonel Ivat and English Will, as well as the servants, were on the floor above, and, on a floor above that, another guest, a Captain Rollock.

A fire seems to have started about midnight, reportedly in a single explosion. It raged so furiously that the noble Viscount, the Laird of Rothiemay, English Will, Colonel Ivat and some of the servants, perished. They tried to get help by calling to those in the close, below the tower window, but no help was forthcoming. The writer of a contemporary ballad, which was very popular in Forgue and district, and which was never refuted, put the blame for the death of the people in the tower fairly and squarely on Lady Crichton.

> When he stood at the wire window
> Most doleful to be seen,
> He did espy the Lady Frendraught,
> Who stood upon the green.
>
> And mercy, mercy, Lady Frendraught,
> Will ye not sink with sin?
> For first yr husband did kill my father
> And now you burn his son.
>
> And then it spake Lady Frendraught,
> And loudly she did cry:
> It was great pity for good Lord John,
> But none for Rothiemay;
> But the keys are sunk in the deep draw well,
> Ye cannot get away.

What seems to be indisputable is that the fire was started deliberately, which suggests that something immediately combustible was used. It is also indisputable that the keys were dropped down the well, as the balladeer said, because enormous keys were, in fact, found at the bottom in 1840, when the well

33

was being cleaned out. It has now been beautifully restored by the present owner, Mr Alexander Morison. The Marquis of Huntly, who had lost an heir, and recalling the fine he had ordered Crichton to pay to Rothiemay, suspected him of starting the fire and applied to the Privy Council in Edinburgh to mount an enquiry. They agreed, and appointed the Bishops of Moray and Aberdeen and others to meet at Frendraught on 13 April 1631. When they heard the evidence, their opinion was that the fire 'could not have happened accidentally, but designedly', which did nothing to clear the Crichtons, but rather made it worse. Sir James, in a vain attempt to clear his name, held a kangaroo court and had three of his servants, John Meldrum, John Tosch and a girl, examined under torture. Tosch and the girl confessed nothing, but Meldrum lied and, on evidence

The 'deep, dark well' down which Lady Crichton dropped the keys to the old wooden tower, and which were found in the nineteenth century. The well has been restored in recent times

that would not now even send anyone to jail, was found guilty of starting the fire and was sentenced to be hanged and quartered.

All of which failed to impress Huntly, who decided that the only way to make Crichton pay for the deed was to hurt his pocket. So he resorted to hiring a group of malcontent Macgregors, Camerons and broken men of Clan Gordon, to descend on Frendraught and carry away as much of Crichton's property as they could. One raid resulted in 60 cattle being carried off, another netted sheep and cattle which they promptly sold extremely cheaply at the Byack Fair: a dollar for the cows and a groat for the sheep. Everyone knew where they had come from and would have been unwilling to pay more. More than Crichton suffered from this rent-a-mob, however, because apparently they also robbed the Parsons of both Rothiemay and Marnoch!

The raids turned the tables in Crichton's favour, at least temporarily. He appealed to the Privy Council and 'the Marquis was ordered to appear before them in Edinburgh, and was bound, under a penalty of 100,000 merks, to abstain from injuring Frendraught'. Crichton also managed to get 200,000 merks compensation from the Marquis.

Lady Crichton was not so fortunate as her husband. Soon after the fire, she went to stay with her daughters at Kinnairdy Castle in Marnoch and while there, she began to absent herself from the Kirk of a Sabbath. This proved too much for the Presbytery of Strathbogie who wanted to know the reason for this absence, and also why she would not conform to the established order. When the elders took her to task, she asked them for time for deliberation, presumably because she pleaded that she was still suffering the effects of that October night when the tower went on fire. Still, later, 'wilfully refusing to hear the Word', Lady Crichton was summoned before the Presbytery, admonished the first time, the second time and the third time; received the first prayer, the second prayer and the third prayer – all serious admonishments. Excommunication lurked. It was Master Reidford of Marnoch Kirk, who interceded and reported that 'Lady Frendraught had promised to hear the Word occasionally'. That was not good enough for the Presbytery. It was the days of the Solemn League and Covenant, and the Presbytery told her she must sign it, or else! It was hard – staunch Catholic that she was – but she signed, and it got the Presbytery off her back for the time being. She soon repented of repenting, albeit, and told a Presbytery delegation that 'she regretted nothing so much as the signing of the Solemn League and Covenant'. This was like a red rag to a bull and the 'Lady Elizabeth Crichton of Frendraught, for apostasie and perjurie' was excommunicated by the Presbytery.

There was more. Lady Crichton asked Father Blackhall to be her confessor on the death of her previous priest. He refused even to see her, let alone be her confessor, for the simple reason that she was suspected of being guilty of the death of Lord Aboyne. Suspected by the world – and condemned – as a murderess, excommunicated by the Kirk, and cold-shouldered by a priest of her own faith, she had no one else to turn to. In desperation, you might think, and as

a guilt-offering, some believe, Sir John and Lady Crichton presented two chalices to the Kirk at Forgue in 1633 for use at the Communion. One of these is the oldest piece of hallmarked silver known in Scotland and is still in use at communion services in Forgue Kirk. Yet this does not appear to have laid the guilt. It would seem that her spirit, according to legend, still walks in Frendraught House. Sightings of a dark-haired woman in a white dress have been recorded from the eighteenth century, ever since a clergyman/writer claimed that she had been seen in the house and also among the beech trees which surround it. In 1938, when the late William Thomas – a former manager of Glendronach distillery – was in his early teens, he remembered seeing the dark-haired woman with a pale face when he was out shooting crows in the grounds. The house at that time was shut up and empty, but he saw her clearly standing at a window looking out over the close and the well. He drew a gamekeeper's attention to it and he, too, saw the face. Others have experienced footsteps on the stairs and the dark-haired lady in a white dress with gold trimmings has been seen on a number of occasions. Curiously, though, she is always on the stairs, as if condemned perpetually to walk them as a penance.

7. Cavalier and Covenanter

If George Gordon, 1st Marquis of Huntly, was a gambler, ready to stake everything he possessed for a cause in which he believed, his son, George, was a chip off the old block – but of a very different guise. The 2nd Marquis, through a sense of loyalty, backed the wrong horse. Unlike his father, however, he was not prepared to say one thing and do another. And that was his undoing.

Huntly Castle, which was unfinished on the 1st Marquis's death, was not only destined never to be finished, but also within 11 short years, was to be left a ruin to fall into decay, never to be rebuilt. On Monday, 5 July 1640, Major General Munro, Commanding the Army of the Covenant, arrived in Strathbogie to occupy the castle. Parson Gordon of Rothiemay (see Chapter 8) recorded that he came to Strathbogie and camped with the whole regiment beside the meeting of the two rivers – Deveron and Bogie. The keys of the castle were handed to him but he prevented his troops from defacing the building and rifling the contents, with the exception of some items which appeared to be popish and superstitious. Parson Gordon's reference here is to the carvings over the entrance door. These consisted of the arms of the Gordon family with the date 1602, when the 1st Marquis began the rebuilding of the castle, and the initials G.M.H. (George, Marquis of Huntly) and H.S.M.H. (Henrietta Stewart, Marquisse of Huntly – she was the daughter of the Duke of Lennox and they were married on 21 July 1588). Above these, the Royal Arms, with J.R.S. (Jacobus Rex Sextus)

and A.R.S. (Anne Regina Sestorum). Above the Royal Arms there is an inscription, probably defaced by Captain Wallace – one of Munro's foot captains – which appears to begin: *Non nobis Domine gloria...*. At the top of the carvings is a large circular stone inscribed with a sun, and in the centre, a crucifix. This was probably defaced at the same time as the other by Captain Wallace and his merry men.

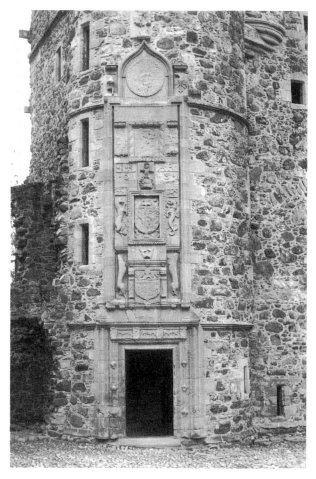

The main door of Huntly Castle at the present time

That was not the only thing they did. They cut down the trees around the castle to build barrack huts for the soldiers and plundered the storehouses, baking, brewing and making free with the larders and using their beef, mutton and poultry to feed the troops. Not only that, they went off with the castle

armaments, armour, muskets, pikes and swords, as well as exacting heavy fines on the staff and servants. When he had finished, General Munro managed to leave the castle and its environs something of a wilderness, devoid of people, horses, arms and money.

Two years later, Huntly was setting out on his treasonable path – backing the King instead of the Covenanters – which ended in his death. He was entertaining at the castle the Earl of Irvine 'who was taking up a regiment from France'. The Marquis 'weill intertaynde (him) in Strathbogie' and the Earl of Irvine 'gat 40 souldiers fra (Huntly) to help his regiment'.

In 1644, Strathbogie was again sacked, this time by the Duke of Argyll at the head of an army marching to pursue the Duke of Montrose, the head of the King's party in Scotland. On 25 September, the Duke of Argyll marched from Aberdeen and destroyed the whole Rawes of Strathbogie – crops, lands, horses, sheep and anything else the troops could lay their hands on. After a fierce little battle, on the Sunday, Montrose left Strathbogie and took to the hills. Argyll, seeing him depart, went to Strathbogie Castle and made camp there, living off the countryside.

Montrose and his victorious army returned to Huntly in May 1645, after the battle of Auldearn, but only stayed a few days. After the battle of Alford, the Covenanting Generals Leslie and Middleton were sent to Strathbogie with a large army to besiege the castle. Lord Charles Gordon and James Gordon of Newton defended it for a time, but they had to surrender when their provisions ran out and they could see no sign of any rescue.

The officers were beheaded and its so-called 'Irish' garrison all hanged. A price of £12,000 Scots was put on the Marquis's head. General Middleton caught up with him in December 1647, in the house of John Grant of Delnabo, and he was brought back to Strathbogie along with his 'Irish' escort. When they got to Huntly, the escort were all taken out to the castle park and shot and the Marquis was despatched to Edinburgh for trial. He just missed the Sovereign whom he tried to serve and on whose success against the Puritans and Covenanters he had gambled. Both of them lost – King Charles I was executed on 30 January 1649, two months before the Marquis of Huntly. He just missed Charles's successor as well. Charles II paid a visit to Huntly Castle, though why is not known, just before he went off to the battle of Worcester to be defeated.

The 2nd Marquis was the last of the Gordon line to occupy the castle at Huntly, but although it was not quite the end of its complete occupation, the heart had gone out of it and the glory had departed.

All that remained for the noble Palace of Strathbogie was ruin and decay.

8. *The Cartographer of Rothiemay*

The middle of the seventeenth century was a troubled time for the Church in Scotland. James I (of England, VI of Scotland) had succeeded to the English throne, following the death of Elizabeth. James believed in the Divine Right of Kings – that kings should not be criticised like lesser mortals, and should not be answerable to lesser mortals for their actions – although he knew how far to go in dealing with his Privy Council. His son Charles I, who also believed in the Divine Right, and who succeeded him in 1625, did not. He was politically incompetent. One of his aims was to increase the Church's wealth and status, and to strengthen the role of bishops as the Church's form of government. To help him, he enlisted the aid of the tidy-minded Archbishop of Canterbury, William Laud. King and Archbishop set out on the road to get everyone to conform to the same religion, and they wanted the same uniformity in Scotland as in England. Which is where they became unstuck, largely because Charles was mixing religion with politics. The Scottish landowners were aggrieved because of Charles's high taxes and the nobles were aggrieved because he was appointing churchmen to political offices – notably Archbishop Spottiswoode as Chancellor. The Scottish parliament presented a list of their grievances to the King in 1634 and invited him to accommodate them. Charles would not, and in 1637 a heated controversy over the introduction of a new Prayer Book broke out. Charles and Laud wanted the Scottish Church to fall into line with that in England.

Remembering the obstinacy which greeted the 'supplication' in 1634, it was now the turn of Scotland and the Scottish Church to be obstinate. Their answer was the National Covenant. Those who signed it bound themselves to maintain the form of church government most in accord with God's will – and that, in their book, did not mean government by bishops, but by presbytery. It was signed in February 1638 and those who signed it were quite determined to use force to get their way; the result was the Bishops' Wars of 1639–40. Charles had asked the English Parliament for money to fight Scotland in these wars; the Parliament saw their opportunity to give him money on certain conditions – the result being the English Civil War that began in 1642. Scotland was eventually drawn into it and the National Covenant Party gave support to the Parliamentary side on the condition that, if they won, they would support the establishment of Presbyterianism in Scotland and impose it on England and Ireland as well. This pact was known as the 'Solemn League and Covenant'.

Not everyone in Scotland could sign the National Covenant of 1638. One of these was Alexander Innes, the minister of Rothiemay, who was accordingly deposed. Presumably his successor was able in conscience to do so, and was

admitted as minister of St Drostan's, Rothiemay, in 1641. His name was James Gordon, the fifth of 11 sons of Sir Robert Gordon of Straloch and Pitlurg, the geographer and antiquary.

James, who is forever remembered as 'Parson Gordon', was educated at King's College, Aberdeen, and assisted his father in his geographical studies and in the preparation of the first ever Scottish maps for an atlas being compiled by a Dutchman called Bleau. It is unlikely that many people in Scotland now do not know what shape their country is. It is difficult, therefore, for us to appreciate the impact it must have had – admittedly, on a small section of the seventeenth-century community – when they saw the outline of their country on paper for the first time. That is what Bleau's *Atlas* did, and some of it was due to the skill of Parson Gordon of Rothiemay.

In 1646–7 James Gordon made a large map of Edinburgh and some of the earliest known views of Edinburgh's historical buildings were sketched by him, including Holyrood Palace and the castle, as well as other buildings throughout Scotland. For the large map of Edinburgh, engraved by De Witt, the magistrates of the city gave him 500 merks, made him a burgess, and 'treated him to a collation'.

It is interesting to speculate that he must have sketched many of the local buildings during his 45 years as minister of Rothiemay. Maybe these included Rothiemay House and Huntly Castle although none survive that we know of.

One spectacular item which did survive is the earliest map of the city of Aberdeen, along with a detailed verbal description which gives a delightful and unique insight into the appearance of the city as it was in 1661. A grateful Town Council, not to be outdone by Edinburgh, presented him with a silver piece or cup which weighed 20 ounces, 'ane silk hat an' ane silk goon to his bedfellow.' Unfortunately, his wife did not live long after that to enjoy her 'silk goon'.

On 1 September 1647, the General Assembly gave him permission to travel to Stirlingshire 'for drawing the mappe thereof'. Yet cartography was not his only occupation – apart from being parish minister, that is. He was a competent historian as well. Between 1659 and 1661, Parson Gordon found the time to write the *Memoirs of Scots Affairs*, which throws a clear light on many of the events of the time such as the period of the Covenanters, so called because they supported the Solemn League and Covenant, and the wars of the Marquis of Montrose, through which Gordon lived.

As a parish minister, it seems he was conscientious, as the records of the Kirk Session testify. His position, however, seems always to have been precarious because, like his predecessor, he found it difficult to discipline those whose loyalty to the National Covenant left a lot to be desired. Perhaps his sympathies lay with them.

A theological problem of a different kind had to be dealt with on another occasion when we find him remonstrating with parishioners who tried to offer up fires at the midsummer solstice – a long-standing pre-Christian religious tradition which 2000 years of Christianity have even today failed to break. A

number of references to local witchcraft are found during Parson Gordon's time, while he also had to condemn others who played football on the Sabbath!

Unfortunately, he suffered from an inefficient parish clerk who left the kirk records in such a state that it was said that 'a rhapsody, so confused, never came out of any clerk's hand'.

Most of these problems must have paled into insignificance with the arrival in Rothiemay of a troop of English soldiers who 'dallied with the village girls and gambled in the ale-house with the drunken dominie who lost all his money and his verie shirt'. Not only that, they vandalised the church – Cromwell's troops left a trail of damaged churches in their wake, approved, of course, by Parliament. At Rothiemay they threw down the stool of repentance and refused to move out of their quarters in the Manse.

James Gordon died on 26 September 1686 – still minister of Rothiemay – at the age of 71. He believed his life had been fairly uneventful, being more a man of study and research than any thing else. So many clergy in this period of Scottish Church history were more interested in ecclesiastical politics than in the care of the souls of their parish. Not so James Gordon; his life sounds pretty eventful, looking at it from a distance. His memorial, however, is in his writing and his map-making, for even his burial place is unmarked and unknown.

9. The Man who would not pray for King George

For nearly 200 years, from 1560, the history of Scotland's church is often so confusing, even for the people who sit in today's pews, that they find it completely incomprehensible.

It is generally believed that, prior to 1560, the Scottish Church was Roman Catholic and suffered from terminal decay; that John Knox came along, completely revived it and reorganised it along Presbyterian lines and the Church of Scotland was born; that some of the Roman Catholics survived and that is why they are there today alongside 'The English Church', the Methodists, the Congregationalists – all of whom came from England – and all sorts of other people like 'Free Kirkers', 'Wee Frees' and 'United Frees', who probably came from the Western Isles (which is one of those historical myths which we pick up in school).

In the first place, it is doubtful if Scotland was ever, in the accepted sense, a 'Roman' Catholic country. An attempt was made at the Synod of Whitby in 664 AD to bring the Celtic Church into line with the rest of the Western (i.e. Roman) Church under the pretext of ironing out one or two rather footling anomalies: namely, the date of Easter (which the Celtic Church kept on the same day as the Eastern Church, not surprisingly, since they derived their beginnings from them,

rather than from Rome); and the shape of the monks' tonsure. (The monks of the Roman tradition had a shaven circle on the crown of the head, whilst the Celtic monks in the Eastern tradition shaved the front of the head and let the hair grow long at the back.) Both these things were so trivial that they could easily have been settled over a pint of monastery-brewed ale.

So what was the point of bringing bishops and priests from Ireland, Scotland and all over Northumbria, if not to discuss these. The real point was that they were to be brought under the Roman steam-roller and made to submit to the rule of the Bishop of Rome. Which they did. In a fashion. It took something like four centuries to make it happen because, rather than submit and lose their independence, the bishops of the Celtic Church just returned home and refused to play any more with – in particular – Bishop Wilfred of York, who was the chief negotiator for Rome. Yet it was an accident of history which finally extinguished the Celtic Church. The Saxon Princess Margaret of England – grand-daughter of King Edmund Ironside and great-niece of Edward the Confessor – who had been brought up in Hungary, was fleeing with her sister and brother from the Norman Conquest of England, when a freak storm washed their ship ashore in the River Forth. They were rescued and taken to the court of the Scots king, Malcolm III (known as Canmore, or 'Bighead') at Dunfermline. In due course, Margaret and he were married, and she was obviously the power behind the throne. Far from being 'a frail English princess', which she pretended to be, she was a very dominating woman who organised the court (and the Kingdom!) in the way she believed it should go. Which was Rome-wards. Her first job was reforming the existing Celtic Church on Roman lines and bringing it into subjection to the Bishop of Rome. Fortunately or unfortunately, whichever way you look at it, the transformation was only partial, because her son, David I (1124–53), known as 'The Saint', was still arguing with the Pope about the Scottish Church being independent of both Canterbury and York as late as the mid-twelfth century (he obviously did not share all his mother's views); and even a Scottish archbishop did not materialise until 1472, the senior Scottish bishop – the *Primus inter pares* – always exerting a sturdy independence. In effect, *Ecclesia Scoticana* – Church of Scotland – never really was, nor wanted to be, run from outside the country. The Declaration of Arbroath on Scottish independence to Pope John in 1320 was the work of the Scottish Church, and its echoes can be heard down the following centuries – none more than in our own time – from both spiritual and political sides.

In the second place, although it could be said to be Catholic if not exactly 'Roman', *Ecclesia Scoticana* did not move from being Catholic to being Presbyterian with the Confession of Faith called for by the Reformation Parliament of 1560. There was a kind of see-saw movement: the old bishops either left the country or joined the Reformers, and the Church was both Episcopalian (having bishops) and Presbyterian (having elders, the minister being, properly, the teaching elder). Then James VI restored the rule of Bishops and the Church became Episcopalian. A national uprising in Charles I's time

resulted in the signing of the National Covenant and, eventually, the deposing of the bishops, and the Solemn League and Covenant of 1643 and Presbyterian rule. In turn, the bishops were reinstated at the Restoration of Charles II in 1660. For part of this 100 years, the bishops were often just bishops in name – 'titular' or 'tulchan' bishops (a tulchan is a straw-filled calf's skin, set beside a cow to encourage her to let down her milk).

It must have come as something of a relief, at least to those who supported the Presbyterian side, when William, Prince of Orange, became King. Scotland may well have settled down, had not the attempt of James VII to restore bishops not renewed lingering fears in the mind of Scotsfolk. The trial of seven English bishops led to the Revolution of 1688 and they, and all of the Scottish bishops, were reluctant to break their oath of allegiance to King James and refused to take the oath to William. Consequently, they were deprived of their dioceses and William gave his support to the Presbyterians. Episcopalianism was disestablished by the Scottish Parliament in July 1689, and *Ecclesia Scoticana* became Presbyterian. The following year, all the Presbyterian ministers who had been deprived since 1661 were restored and the Episcopalians were ordered to leave their manses, glebes and churches forthwith.

That was the theory of it; in practice, as the history of the Huntly area shows, things were never quite as simple as that. Huntly is a combination of two ancient parishes, Dunbennan and Kinnoir, the two being united in 1727. In 1690, it appears that the two congregations came to some kind of amicable arrangement to suit everyone. Those of a Presbyterian persuasion seem to have gathered at Dunbennan, those of a Catholic or Episcopalian persuasion at Kinnoir, where the minister was a Reverend Lewis Gordon, son of the map-maker of Rothiemay. He had been turned out of his church at Kirkcaldy in 1690 and came to Kinnoir where he continued to minister until 1715. Had it not been for the Jacobite Rising of 1715, which was supported by the Episcopalians – who wanted the Stuart monarchy and the Catholic cause restored to Scotland – Mr Gordon may well have stayed until age or infirmity rendered him incapable. As it was, he was evicted from Kinnoir and summoned to appear, as were so many other Episcopalian priests, before a Judiciary Court in Aberdeen. He was deprived, but as late as 1737, the Presbyterian minister had to call in the Bailie of Regality (the local law man) to enforce his discipline at Kinnoir because they would not give up their Episcopalian ways! The penalty was banishment from the parish but often the law had recourse to close the church in question. Mr Gordon's reply to all this was to open a meeting-house at The Rawes where he was certainly officiating in 1720!

It has taken rather a long time to find 'the man who would not pray for King George'.

The Reverend Adam Harper had been Minister of Boharm, the next door parish to Cairnie, since 1686 and continued there until he was forced to quit in 1716; like Mr Gordon, a casualty of the 1715 Rising. Apparently, Mrs Harper was a strong Jacobite and when Government papers arrived at the Boharm

Manse, to be read in church, the lady burned them!

Leaving Boharm, Mr Harper retired to Cairnie and took up residence at Cairnwhelp where he, too, opened a meeting-house. The Presbytery of Strathbogie took exception to this because many people – presumably Episcopalians – went there. In 1720, a court met at Cairnie and found Mr Harper 'resolved to persevere in his duty', in which he was doubtless encouraged by his son, the Chaplain to the Duke of Gordon at Gordon Castle, Fochabers, the Duke being a strong Episcopalian. Accordingly they informed the Sheriffs of Aberdeen and Banff but were apparently not too hopeful of any results because they added in their Minute: 'If the Sheriff fail in what is Duty, the Presbytery will apply to others for redress'. Obviously the Sheriff did fail, because the Presbytery record of 1724 noted that there was still 'an Episcopal meeting-house kept at Cairnwhelp by Mr Adam Harper, who prays not for King George, etc.'!

Mr Harper died at Cairnwhelp on 14 May 1726, aged 67, having been a priest for 40 years. The Episcopalian cause was still very much alive, however, since in the account of a Presbytery visitation of Cairnie in 1736, there 'was a Jacobite meeting-house in the parish, wherein is worship publickly every Lord's Day'. Mr Harper seems to have been succeeded by the Reverend John Irvine, who, in 1744, was described as 'Presbyter (priest or elder) at Cairnwhelp' – a clear case of accepting what you cannot change.

Not for long, however. When the Episcopalians again backed Prince Charles Edward Stuart in the ill-prepared, if courageous, Second Jacobite Rising of 1745 – culminating in his defeat and the extermination of the Highland clans by the Government forces at the Battle of Culloden in the spring of 1746 – they ruined any immediate future for themselves. The size of tolerated congregations was reduced, under Penal Laws passed after the '45, to such an extent that they resorted to all kinds of ruses to worship. Many adopted the practice of the priest and four or five people holding the service in the central hall of a house with four or five people in each of the rooms off the hall. Others, like the ones at Marnoch, worshipped in the woods at Ardmeallie with the estate workers keeping watch in case the Red Coats (soldiers) came upon them suddenly. Many Episcopalians – both clergy and lay people – from the North-east were transported to Barbados as undesirables under the Penal Laws.

By 1760, King George III was beginning to see Episcopalians as less of a threat and when Prince Charles Edward died in 1788, the only Stuart 'pretender' left was a Roman Catholic cardinal! Episcopalians gradually accepted that the Jacobite cause was dead, and the draconian Penal Laws were repealed in 1792 since the Jacobites were no longer a threat to the House of Hanover. It may well stand as a salutary warning to any church group who identify themselves with the state. Episcopalians were reduced, in Sir Walter Scott's immortal phrase, 'to the shadow of a shade', and although they made a 'come back' in the nineteenth century, it was at a price.

Following the Industrial Revolution, large numbers of English people came to work in Scotland. These people set up their own Church of England

congregations and brought their own priests with them. Coming from England, their priests were able to take the oath to King George. Eventually after many years, they and the Episcopalian congregations merged (the last one to merge being in 1922), but it has left the Episcopal Church saddled with a title they detest – that of 'THE ENGLISH CHURCH'.

Following the Repeal of the Penal Laws in 1792, the Huntly Episcopalians were invited by the Duchess of Gordon, Elizabeth Brodie, to worship in the private chapel of Huntly Lodge, called the Duchess Chapel, in Meadow Street, until 1850. This in more recent times has been the local Scout headquarters and is now used as a store by R. Barron & Sons, Nurserymen. The present building in Provost Street was consecrated and opened for worship in 1850. It is now linked with the neighbouring congregations at Aberchirder and Keith. A number of other places of worship in the Huntly area are now extinct, the need for them having disappeared, or their congregations having been absorbed into other buildings. These include:

Wallakirk at Glass – only the peaceful graveyard now remains of the Kirk on the banks of the Deveron, said to have been the first built by St Wolock at Beldorney in the eighth century. Wolock is said by James Godsman to have been a missionary from Candida Casa at Whithorn in Galloway, founded by St Ninian in the fifth century.

Peter Kirk, Drumdelgie – also on the banks of the Deveron, near to where the so-called 'Red Bridge' is today. Built before the thirteenth century, it is also known as the Burnt Kirk because it was burned down by a fire allegedly caused by a kae or jackdaw. The bird is said to have carried a burning stick or cinder from a neighbouring cottage and dropped it into the thatch of the kirk roof. The congregation were ordered to go to the 'Reformed Kirk of St Martin' at Cairnie. Everyone except 'the Guidman o Hacklebirnie' agreed, provided a larger church was built. Apparently, St Martin's was too small. Eventually it was enlarged by the building of the so-called Pitlurg Aisle by Sir John Gordon of Pitlurg. Sir John was a descendant of Jock o Scurdargue (see Chapter 3). These Gordons were known as the 'Jock and Tam Gordons' to distinguish them from the Gordons of Huntly. They were two of four 'natural' (illegitimate) sons of Sir John of Gordon who fell at the battle of Otterburn in 1388, brother of Adam de Gordon and uncle of Elizabeth who married Sir Alexander Seton, who later became the first Earl of Huntly. To distinguish them from the 'Jock and Tams', as we saw in Chapter 3, they were known as the 'Bow o Meal' Gordons.

The Pitlurg Aisle was restored in 1868 by Charles Elphinstone Dalrymple, of Kinellar Lodge – who married a descendent of Sir John Gordon – the then Minister of Cairnie, the Reverend John Annand, supervising the work of restoration.

The Aisle contains a weathered statue which for many years stood in an ivy-covered niche in the garden wall at the school house. Locals believe it to be a statue of St Martin, the Patron of Cairnie. Martin, one of the most popular saints

45

in medieval times, became Bishop of Tours in 372 AD. He was a bishop for 25 years, much of his popularity being that, although a bishop, he lived as a monk under monastic discipline. The statue at Cairnie, shows the subject holding a pastoral staff in his left hand, the right, in repose, resting on his chest, ready to bless the faithful. However, there are those who agree with Ian B.D. Bryce and Alistair Roberts when they claim that the effigy is a pre-reformation statue of the Sacred Heart of Jesus. The position of the right hand is in the act of tearing open the breast to reveal the heart (*Proceedings of the Society of Antiquaries of Scotland,* Vol. 23, 1993).

The oldest written 'Gordon record' from the Pitlurg Aisle, Cairnie

St Carol or Cyril, Ruthven – joined with Cairnie and Botary about 1721, the parish church of Ruthven, or Riven, was allowed to fall into ruin. The most famous feature is the bell, the 'Wow o Riven', which bears the inscription, OMNE REGNUM IN SEIPSUM DIVISUM DESOLABITUR 1643: Every kingdom divided against itself shall be brought to desolation. George MacDonald immortalised 'the Wow' in a story originally called *The Bell*, but later renamed *The Wow o Riven*. Below the ruined belltower, a stone is erected to the memory of John McBey, also known as 'Feel Jock' or 'The Colonel' whose story MacDonald also told in *The Wow o Riven*. McBey was a foundling, discovered

in a moss some miles from Huntly, and could give no account of his origins. The memorial stone was erected by the people of Huntly who recorded that McBey thought the bell now above his body always said, 'Come hame, come hame'.

In the early nineteenth century, it was proposed to remove the bell to Cairnie Church, when it was built. The Ruthven folk did not agree and they decided that, should it be attempted, one John Wilson, a brogue maker, should ring it. An attempt by the Cairnie Schoolmaster, Mr Leslie, and a party of workmen employed by Cairnie Church, was made, but no sooner were they seen than Wilson sounded the alarm and a crowd armed with sticks, pitchforks and other weapons descended on them, smashing the cart which was to carry the bell. They took the bell down themselves and locked it in the Mill of Riven for two weeks! The Duke of Gordon, who had given permission for the bell's removal provided the Ruthven folk agreed, was said to be highly amused by the incident and commended them for their pluck.

The Wow o Riven, immortalised by George MacDonald in the novel of the same name

Little Daugh, or Daach – there was a small Episcopal chapel – a chamber, even – for the use of Mrs James Black, whose husband was the valet to both the 3rd and 4th Dukes of Gordon. He was placed at Little Daugh on his retirement and became the first and last resident factor at Ruthven for the Duke. Apparently there were about 100 Episcopalians at this chapel, renewed and coom-ceiled by Elizabeth, the last Duchess of Gordon who was an Episcopalian until becoming a member of the Free Kirk in Huntly (Strathbogie) after the disruption of 1843.

Mortlach – not much is known about the chapel at Mortlach (in Cairnie, and nothing to do with the other Mortlach at Dufftown). Part of the walls are said to have been visible at one time in the Bin Forest, south of Ruthven, where, according to an old rhyme, 'now gangs mair dead than livin'. No doubt true!

Little is known about a church which once stood at *Haddoch* and where the last recorded burial was apparently at the end of the eighteenth century.

10. A Thief and a Dutch–American with the same thought

The only thing we know about John Meldrum is what is contained in a brief reference in the Royalty Books in Register House, Edinburgh. A Minute of 1 April 1725 reads: 'At the Tolbooth of Huntly, the 1st April 1725, which day Henry Gordon at Miln o Huntly, Procurator Physcal, sued John Meldrum in Sandieston for £20 Scots of fine, and £6 damage from the said John Meldrum, for his carrying away from the Castle of Huntly six timber beams which had been a sclate roof... and two flake bars belonging to the Duke of Gordon.'

It was no April Fool joke, despite the date, however, and one wonders if John Meldrum was doing what a Dutch–American did sometime later. Both of them were concerned with Sandieston and it might be fanciful to suppose that they were both going to use the same materials for the same building! Be that as it may, it was typical of what was happening to Huntly's abandoned castle in the early eighteenth century.

In 1684, only 30 years after the 2nd Marquis of Huntly had been executed by the Covenanters for treason for supporting King Charles I, the Gordon Marquises were raised to the status of Duke, following the restoration of the Stuart monarchy, as a reward for their services to the Royalist cause during the period of the Commonwealth. They became perilously near to losing it again, however, when the 1st Duke held Edinburgh Castle during the early years of King William III's first Scots Parliament, only a year after the so-called Glorious Revolution of 1688. This was the first of four attempts by the Jacobites (supporters of the Stuart Cause) to bring James VII – father of the Young

Pretender, Prince Charles Edward, better know as Bonnie Prince Charlie – from his exile and restore the Stuart line to the Scottish throne. The Duke of Gordon did not prove to be a very ardent defender of Edinburgh Castle – nor perhaps, a very ardent supporter of the Jacobite cause – and, luckily for him, he handed over the keys of the castle to King Billy on 13 June 1689 – in the nick of time!

From that time onward, the Dukes of Gordon took no active part in the Jacobite cause, although the 1st Duke's son was to the fore in the Jacobite Rising of 1715 and the 3rd Duke's youngest brother, Lord Lewis Gordon, commanded a battalion for Prince Charles Edward at Culloden, escaping after the defeat of the Prince's army and spending the rest of his life in exile in France.

The second half of the eighteenth century and the first half of the nineteenth century saw vast changes in the social and economic life of Scotland; machinery appeared on the farm, the railways were beginning to shorten the distance between two places, gas began to be the means of lighting up the dark hours, while at sea, steamships were speeding up communications between countries and continents. The Gordons, who had by now made their home permanently at Bogs o Gight beside the Spey at Fochabers, had, at the same time, 'gone up in the world'. They had become the premier noble house in Scotland, with estates stretching from East to West coasts, encompassing Lochaber, Badenoch, Moray, Banff and Aberdeenshire. They owned great wealth and had great privilege. The move westward, however, meant the abandonment of Huntly Castle, which had been the Gordon home for close on 500 years, and it was now allowed to fall into ruin. Hence John Meldrum's action in 'liberating' some of the materials before beetle and rot rendered them useless; and Meldrum was not alone – only he was caught!

It was, however, a foreigner – the Dutch–American – who not only cannibalised the castle but also dragged Huntly into the modern age. Had it not been for him, the 4th Duke of Gordon might not have been so ready to transform the squalid Rawes of Strathbogie into a well-planned, modern residential town – pleasant both to live and work in.

The 3rd Duke died suddenly in France in 1752, leaving a 33-year-old widow, Katherine, three sons and three daughters, the eldest of whom was only nine and the youngest just a few months old. What Katherine most missed was a man about the house and, after unsuccessfully trying to hook a young Pole, 14 years her junior – and later to become the last King of Poland – she eventually landed a wealthy American colonial whose mother was Dutch. Staats Long Morris was only ten years younger than the Duchess. The young Mr Morris seems to have enjoyed being consort to the Duchess of Gordon. She set him up as commanding officer of his own regiment, with her son, the 4th Duke, commanding a company.

It was when the Duke was 21, and all set to marry the attractive and vivacious Border girl, Jane Maxwell, that his mother and stepfather decided it was time to move out of Gordon Castle. For some time they had been getting ready a house at Huntly, Sandston (or Sandieston), doing to Huntly Castle what

John Meldrum had done. The difference was that it belonged to the Duchess and not to John Meldrum. Having used materials from the castle, they renamed it Huntly Lodge, which name it kept until it was renamed again, this time to be called Huntly Castle Hotel.

Not long after they moved into Huntly Lodge – and no doubt because a Gordon 'presence' was again in Huntly – the Duke, in January 1769, announced that he was enlarging Huntly in an effort to bring in more trade. He gave off a number of feus to build both houses and factories and, 21 years later, in 1790, one of the Huntly residents was able to send his impressions to the *Caledonian Magazine*. 'Even in this place there exists ample proof of improvement. Many of the inhabitants in the course of 20 years have raised themselves to a state of what might be called opulence, in consequence of the advance of trade, greatly increased its population, and very considerable improvements have taken place in and about it'.

This is in sharp contrast to the picture we get in 1767, two years before the start of the Duke's initiative. Then the Duke had to open a meal market in Huntly, which he supplied from his own granaries, to ease the shortages in Strathbogie.

Another indication of Huntly's new found prosperity was an improvement introduced by Col. Morris. He was responsible for starting a post-runner three times a week between Huntly and Keith. Previously, the south mail, to and from Huntly, went to Old Meldrum and then on to the coast at Banff, and so inland again, taking several days in both directions.

Unfortunately, this was also the time that the situation in the American colonies (as they were then) was giving cause for anxiety in London. The Government began a recruiting campaign for the Army, which resulted in a form of conscription. The Navy had long had its dreaded 'press gangs' but the Comprehending Act of 1777 was designed to round up both petty criminals (like beggars and smugglers) as well as the work-shy. Unfortunately, the recruiters in the north east, who were charged with raising two new battalions, in addition to the usual on-going recruiting for the regular ones, spread their net rather widely. Quite a lot of young lads in the Huntly area were worried that they might fall foul of the press gangs and find themselves in uniform before they knew what was happening. William Bell, the Duke of Gordon's factor at Cocklarachy, told the Duke that many young men were almost in a panic at the thought that they might find themselves in the army. Part of the trouble was that Captain Leith of Leith Hall and Gordon of Wardhouse were recruiting in Huntly for William Gordon of Fyvie, who was the Duke's cousin. The Duke had warned the Huntly lads to beware of them and not to fall for their enticements, which were considerable: 25 guineas apiece – more than the Duke was able to offer. However, the Duke had little success with his recruiting in Strathbogie. How many could resist the bribe, which Fyvie was offering? At any time it would have been difficult to find enough recruits in the area for one battalion, never mind two, and the Duke had to go to Aberdeen to find enough to complete the

muster. They went first to Fort George and then, in full Highland Dress, to their battalion headquarters at Ayr.

On 10 December 1778 Duchess Katherine died in London and her body was brought back for burial in the family vault in Elgin Cathedral. With her death, another era in Huntly's history came to an end, and the scene was set for the beginning of the third period in its history – the period which brings it right up to our own time.

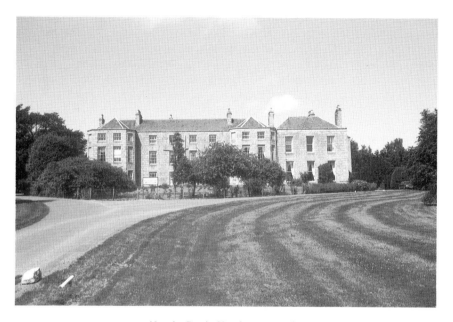

Huntly Castle Hotel as it is today

11. The Flower of Galloway

Jane Maxwell was a highly intelligent, well-educated, beautiful woman. She is probably the most fascinating, and certainly one of the most colourful people to influence the history of Strathbogie.

Jane was the first wife of Alexander, 4th Duke of Gordon. She was given to saying what she thought, one who did not stand on the dignity of a duchess, even though she was not above 'pulling rank', if the occasion demanded. To those who did not like her or were jealous of her, especially in the London and

51

Edinburgh society in which she mixed, she was 'rude and uneducated'. This was no doubt because there was less difference between the laird and his staff in Scotland than there was in England. The laird and his lady spoke with their servants in Scots, as they did at home among themselves, something which their English, English-influenced and educated 'friends' in London or Edinburgh found difficult to understand. No doubt this can be traced back to the Norman conquest when the Conqueror gave Anglo–Saxon lands to his barons who then 'lorded it' over their peasant serfs. This did not happen in Scotland and certainly the 4th Duke of Gordon demonstrated in ample measure the narrowness of the social differences.

Jane was the second daughter of Sir William and Lady Maxwell of Monreith in Wigtownshire, and socially no match for the young Duke. Alexander for his part, was certainly attracted to this lovely, lively 18-year-old, who completely bowled him over. He was no callow youth, however, wet behind the ears. Already he was the father of a year-old son by one of the Gordon Castle housemaids, Bathia Largue – the first of nine (known) children born to his many 'girl-friends'. One of these, Jean Christie, the daughter of the castle housekeeper, he met in 1784 when she was 17, and a housemaid at the castle. She was perhaps the only real love of his life, bearing him five children – all before she became his second Duchess in 1820, eight years after Jane's death.

All the Duke's nine 'natural' sons and daughters (as those born to unmarried parents were called) were brought up alongside his others in the castle household. This was not always the treatment which 'natural' children received when fathered by men whose family could often be callous. Victorians later were much less tolerant of this practice and the narrowness of their attitude has persisted for a century and a half, only being relaxed in our own day with a change in the way a birth certificate is now issued. The present day one-parent family is, however, a very different animal from the extended family of the seventeenth century. The Duke would never have dreamed of not acknowledging all his children, nor would he have dreamed of having the girls who bore them 'put away privily' for their confinement. They were given every attention during their pregnancy and at the birth, and the Duke would never have disgraced his good name by doing otherwise and all the children but one were born at the castle. They were all subsequently brought up there and all bore the name of Gordon. So it is curious that, only some 50 years later, a man would have had a better name for doing the exact opposite of what the Duke did, by denying paternity (at least publicly), and packing the girl off to relatives far away and leaving her to bring up the infant herself. Such was Victorian hypocrisy.

When Jane Maxwell was 17, before she met the Duke at a party in Edinburgh, she had fallen in love with a young army officer. His regiment was ordered abroad and soon afterwards Jane got word that he was dead. She was heartbroken, and it was due to her apathy in the face of family pressure that she accepted the Duke of Gordon's proposal of marriage, even though she was probably never really in love with him, something born out by subsequent events.

They say that truth is stranger than fiction, and it was on her honeymoon that Jane's story took on the quality of a Mills & Boon romance. She received news from which she never recovered. A letter arrived from her lover in the army whom she thought was dead. He was well, he said, and would be home soon, anxious to marry the girl he loved.

She was devastated. The newly-weds were staying with Jane's sister at Ayton House when the letter arrived. Immediately she fled the house and was later – much later, and only after a long search – found lying beside a burn, sobbing her heart out. Eventually, and very characteristically, the young Duchess set about repairing her shattered life. Always the wild one – she lost a finger in a youthful caper 'jumping carts' in Edinburgh's Royal Mile – her parties became noisier and more exciting, and invitations were greatly sought after in Edinburgh. To those who were invited, the Duchess of Gordon was the most brilliant and gifted hostess in the city; to those who were not, she was a common little show-off.

Among her friends, because this was the period of the enlightenment, she numbered such notables as Joseph Hume, the philosopher, Walter (later Sir Walter) Scott, the writer, and Professor James Beatie, who was a lifelong friend and confidant. And Robert Burns. The Gordons met the poet when they were on a visit to the capital, where he was already living, in 1786. The Duchess, apparently, was swept off her feet by the good-looking, exciseman-poet from Ayrshire. It was the entry into Scottish society which Burns needed when Jane Maxwell became not only his admirer, but also his patron, so it might be said that it was the Duchess of Gordon who made Burns famous!

The Gordons also moved in royal circles, having a house in London and being constantly both at Court and in Parliamentary society, Scotland's premier Duke regularly taking his seat in the House of Lords. As well as all this, the Duchess was raising two sons and five daughters, the first five at two-yearly intervals. Charlotte, the eldest of the family, married Charles Lennox, 4th Duke of Richmond, which was the route taken by the Gordon title when George, the 5th Duke, died without an heir. (His younger brother, Alexander, who would have inherited, had died, unmarried, at the age of 23, some years before the death of his older brother.)

Alexander and Jane's marriage was certainly no love-match, but it could well have survived despite this, as many marriages do, had it not been for the rest of the Duke's love-life. Although Jean Christie was his only true love, he was not even faithful to her. While she was bearing him children – five in all – he was also fathering a son and two daughters by other women, as well as the ones which were being borne by Jane Maxwell.

Perhaps the incident which comes most readily to mind when the name of Jane Maxwell is mentioned is the legendary tale of how she helped recruit The Gordon Highlanders in Huntly Square with a shilling and a kiss. It has to be said, however, that although it is quite in character for the Duchess to have made such a gesture, there is no *real* proof that the legend is any more than that.

It seems that it first saw the light of day in print in the 1860s. That,

apparently, was all it needed for it to acquire the nature of fact instead of legend. The Duchess did ride to country fairs dressed in her Highland bonnet (now in the Regimental Museum in Aberdeen) and her regimental jacket. This is not really surprising because women often wore the uniform of their husband's regiment. Whether she did in fact give the recruits a coin – of whatever denomination – and accompanied it with a kiss is now pure speculation. J.M. Bulloch – historian of the Gordon Highlanders – believes that the Duchess never kissed any of the recruits, although he quotes Colonel Greenhill Gardyne as believing that she did. The Gordons have certainly absorbed it into their regimental lore.

Nothing could touch this way-out, vivacious girl, after the tragedy which had struck in the early days of her marriage to Alexander; she would probably have done anything to be able to break up the marriage and had she lived in a later age, she would probably have done this. In the eighteenth century, she could not. So she set out to carve a way of life separate from that of the Duke. Yet she was the Duchess, and under this cover she was determined to live her own life – which she did, even if she was never happy, and even if this unhappiness was not of the Duke's making.

The Gordon Highlanders exercising their 'freedom' of the burgh of Huntly

12. *Textile Tycoons who wove a New Pattern*

It is doubtful if the 3rd Duke of Gordon could have foreseen the immense changes which would result from inviting an Irishman to come to Huntly.

When Hugh McVeagh, a linen manufacturer, came from Belfast in 1737 with a commission from the Duke to oversee the production of fine yarn in the town, Huntly could not have had a population much above 500 folk. It would seem that, at this time, although linen manufacture was established as a cottage industry in Huntly, the end product was of a fairly coarse nature. Obviously the Duke sought to remedy this by inviting Hugh McVeagh to come and set up a proper manufacturing business. Apparently, McVeagh's skill was not confined to linen manufacturing, as he later produced silk stockings. These would no doubt find a ready market in the intellectual and cultural Edinburgh which was emerging during the period of 'The Enlightenment' side by side with the trade and industry revolution which was happening in the industrial cities and towns of Scotland.

Huntly was long noted for its cottage woollen and worsted industry. The spinning was originally done by 'rock and spindle' then, from about the middle of the eighteenth century, by a spinning wheel. This was propelled by either hand or foot and there were few homes without one – usually in the kitchen where the women combined both spinning and household tasks. The thread was then woven on a handloom, usually by the men. All this was a spare-time occupation and paid for on the basis of production rather than time. The manufacturers handed out wool which the women spun. Then they collected the yarn and delivered it for the men to weave into cloth.

One of those who went to work for McVeagh was Charles Edward MacDonald, whose father was a survivor of the Battle of Culloden and whose grandson was the writer, George MacDonald. Charles Edward started work for McVeagh as a clerk but soon became manager and, when McVeagh died, owner of the linen manufacturing business. It was a thriving business and yarn was sent as far afield as London, Nottingham, Manchester, Glasgow and Paisley.

Not only did MacDonald fall heir to McVeagh's business, he also inherited his house and farm of Upper Piriesmill, which both McVeagh and the MacDonalds referred to as 'The Farm'. The MacDonald sons built a new house in 1826 on the farm, detached from the steading, which they called 'Bleachfield Cottage', as it stood near the bleach fields. The house is known today as Greenkirtle and the farm by its original name of Upper Piriesmill, and both are now separately owned.

When the linen business went into recession the factory had to be closed, but with a foresight which characterised much of the MacDonald family's business

transactions, Charles Edward started a thread factory in what is now MacDonald Street. This too, thrived, and with his former connections, Charles Edward built up a sturdy export business with outlets even in South America. Eventually, it had to close due to competition from the West of Scotland spinning mills, but the MacDonalds' three sons went into the bleaching business – turning their hands to using one of Huntly's natural resources, the River Bogie, which was ideally suited for developing the bleaching trade. The area on the east side of the Bogie housed the bleach fields and dye-house and Bleachfield Street ended in a ford of the river – there is a bridge today – and gave access to The Farm, Cocklarachy and so on. All traffic – both foot and horse-drawn – from Gartly and Rhynie as well as from Donside and Deeside and places further south, used this road and the ford to get into the town in the eighteenth and early nineteenth centuries.

When, in turn, the bleaching business failed, due to the discovery of calcium chloride for bleaching, George and James MacDonald, with their customary resourcefulness, turned the factory over to producing starch and flour from potatoes (until the failure of the potato crop in 1846) and milling meal and flour from grain.

Another textile manufacturer in Huntly was a William Forsyth, who is believed to have had a large property on the western side of the new Square (roughly where James Cruickshank, Denim Plus and TV Services are at the time of writing). Born about 1687, Forsyth had gone abroad in his youth to seek his fortune. For a long time no one heard of him, even though he did secure his fortune. Before he left Huntly, he had given instructions for the building of a modest, one-storey house, but after he became wealthy, he sent home plans for a new three-storey house to be built in the new Dutch style, having a simulated gable or 'frontispiece' over the entrance. It is not known when William Forsyth returned to Huntly, but in 1731 he was in business in the town and had been married for some time. He died in 1759, seven years after the 3rd Duke of Gordon, and was survived by two sons, William and Alexander. In time, Alexander acquired a group of properties at the north-west corner of the Square and extended down to the east end of a little street known then as Forsyth's Lane. Fronting the Square, he built a substantial property, which was later either converted into, or replaced by, the Post Office. The elder brother continued to live in the house built by his father on the opposite side of the Square.

The brothers' business was mainly in linen, but cotton, silk and wool were also worked up. It seems likely that a large part of the wealth made by the family came through army contracts, although these may not necessarily have been for textile fabrics. One of the secrets of their wealth was that they could turn their hand to anything, and mention is certainly made of a contract for saddles for the army horses. Efficient labour was abundant and only too cheap, and there was word of one such Forsyth worker, around 1785, who received the handsome wage of eight pence a day! It is easy to see where the Forsyth wealth came from if – even at the end of the eighteenth century – they were paying what were in effect starvation wages. As the young man wanted to get married he felt obliged

to look for other work because he could not support a wife on 8 pence a day!

It might be worthwhile here to briefly take a look at what were known as 'poor folk'. In Victorian times, they tended to take a dim view of any who lost 'respectability' by being paupers (that is those who were either unwilling or unable to secure independence by pulling up themselves by their own bootlaces). They were classed – by the self-righteous and hypocritical society of the later nineteenth century – along with women of the streets, 'mistresses', cripples and imbeciles. In the late eighteenth and early nineteenth centuries, the 'poor folk' were looked after by the Kirk. There were a few orphans who received support from the millworkers. A 'pock' was hung in the mills into which contributions were put. Those in work willingly contributed to the support of their fellow workers who were either disabled or sick, and few went hungry. The Kirk (in the shape of the Parochial Board) was instrumental in caring for cripples, mentally handicapped and blind people, and they probably fared rather better in the eighteenth than in the later nineteenth century. The Beveridge Report and the Welfare State would have been welcome a century before it arrived but it could never have happened in a Victorian climate.

The second William Forsyth had ten sons and a daughter (no wonder he could only afford to pay his workforce 8 pence a day!) and even if they did not all go into business – one went into the army and another became parish minister at Mortlach (Dufftown) – there were enough with energy and talent to make the many Forsyth enterprises pay handsomely.

It was in the Forsyth factory that the tartan of The Gordon Highlanders was designed and made; appropriately enough, since they were raised in Huntly Square (see Chapter 11).

The Seton-Gordons, from whom the Dukes of Gordon were descended, were, of course, not a Highland clan, but were true Sassenachs in the real meaning of the word: English-speaking, *not* English; normally referred to as Lowlanders as opposed to Highlanders – having come from the Borders following the gift of land by King Robert the Bruce to Adam de Gordon following the Battle of Bannockburn (see Chapter 3). As Lowlanders, they naturally had no clan tartan, so one had to be created for the new regiment, probably as an aid to recruiting.

George, Marquis of Huntly, elder son of Alexander, 4th Duke (see Chapter 11) had joined the 42nd Regiment in 1791. Subsequently, when the 92nd was raised in 1794, the Duke approached Forsyth for a tartan like that of the 42nd, but with a yellow stripe interwoven. Forsyth had three patterns prepared and sent them to the factor at Fochabers. In the covering letter, he expressed a hope that the Duke would fix on one of the three, adding that he imagined the yellow stripe would appear 'very lively'. In course of time, he had a letter informing him that the Duke had chosen pattern number two – that's to say, the same as the 42nd Regiment with the addition of the yellow stripe 'properly placed'. The 'Gordons' wear the same tartan to the present day.

The cultivation and making of linen, although one of Huntly's textile enterprises, suffered a decline after the Napoleonic War. Better quality fabric

57

could be imported from Holland at a lower price than it could be grown and manufactured here. That was not the only reason for the industry's decline, however. The American cotton trade was gathering momentum and cotton fabrics were being substituted for linen. It was a time of great depression and few people had capital to invest in linen. 'Hecklers', a highly-skilled class of textile worker, who had once been fairly numerous in Huntly, began to decline, but spinning carried on, though not with the same enthusiasm, and being the complimentary skill to heckling, soon also went into decline. Spinning was the main female industry and the town was famed for its fine yarns. All the adult women, married or single, were 'spinsters' and every house, even to the humblest cottage, had one or two spinning wheels – many of them of expensive and of beautiful workmanship. All the time the women could spare from household chores, they devoted to spinning, and there was a keen rivalry, which is why Huntly produced such good yarns, because they used to vie with one another to produce the best. Those who were good earned good wages, but even average ones could command a pretty good wage.

The weavers also began to get rather thin on the ground, even though they were the most numerous of textile workers. A lot of them found work weaving a kind of cloth known as 'Dowlas' for Aberdeen firms. Despite the depression, there was still a fair amount of work for the weavers. It is thought that, from the Bogie Bridge to McVeagh Street (via the Old Road, of course, Bogie Street not then being there) there were nine or ten weaving shops with anything from two to four looms apiece. If this was repeated throughout the town, a considerable number were in work, despite the fact that the shops were unhealthy places in which to work the normal shift of 12 hours a day. It was not only in the big cities that Blake's 'dark, Satanic mills' were to be found!

About the time that George MacDonald was born in 1824 (see Chapter 16), another man was seeing the potential of the cottage weaving industry and the skills which these part-time workers possessed. His name was William Spence, later one of the foremost names in the textile trade in Scotland – and a Member of Parliament. Spence perhaps started as a 'shanks merchant', one of those who organised the stocking weaving industry. We do not know enough about the beginning of his business to know that, but some of the 'shanks merchants' had several hundred home knitters working for them, such was the demand for knitted stockings. No doubt Spence followed the same principle when it came to other knitted garments. He would buy the wool wholesale, send it to the 'outworkers', as they were called, then collect and sell the finished garments. No precise records were kept at this period, so it is difficult to know what was knitted or how many worked for him, but by 1872, when he formed the company of William Spence & Son, he had a regular contract with knitters of gloves and socks on a self-employed basis.

At the time he was forming the company there is a record of the first investigations into machine knitting and in 1878, he bought his first machines from Harrison's of Manchester. The manufacturers said they would send, along

with the machines, a 'young lady' to teach Mr Spence's workers how to use them, 'provided she got her train fare, lodgings and 10/- a week'. The young lady in question turned out to be Miss Harrison – the owner's daughter!

By the end of the nineteenth century, Spence's was a firm fixture, and the present, imposing granite building which dominates the skyline at the southern end of the town was built in 1910, the remaining 35,000 square feet of the factory being added at various times in the following 80 years as the firm grew. Throughout those 80 years, the name of Spence acquired a reputation for excellence which – thanks to a famous wholesale and retail outlet whose name was a household word – resulted in many of its products being bought by famous people in both public life and the entertainment world.

Around 1880, as Spence's was beginning to build its reputation, a man called Lewis Tomalin got hold of a book in German entitled *Health Culture* by Dr Gustav Jaeger of Stuttgart. The book detailed a result of his researches and a theory which he called his 'Sanitary Woollen System'. He claimed that people would be much healthier if they wore clothing made only from pure animal fibres, such as wool, cashmere or silk. The idea was not new; 80 years before, Napoleon asked for woollen uniforms to safeguard the health of his troops after the Battle of Jena. Mr Tomalin became fanatical about Dr Jaeger's theories. The story goes that he threw all the family's bed linen out of the window and made a bonfire of it, replacing it with woollen sheets! He even had his suits lined with wool and had a woollen pocket handkerchief. He got a concession from Dr Jaeger to manufacture woollen garments to his theories and formed a company called Dr Jaeger's Sanitary Woollen System Co. Ltd. He opened a shop in Fore Street in the City of London in 1884 to which the wealthy, titled and famous – including George Bernard Shaw and Oscar Wilde – flocked to buy their clothes after a glowing article in *The Times* extolled the virtues of the new system. After the First World War, the company shed its clumsy Victorian title, and became the Jaeger Company Ltd. and, as the demand changed, so did the garments which the company produced.

Meanwhile, William Spence & Son were turning out their own garments until a slump in the textile business came in 1956 and the 150 operatives found their jobs at risk. It was then that Jaeger came to the rescue and bought the business from the then owner, Major H.R. Spence and his mother. Five years later they opened the Turriff factory and used this for finishing and making-up garments made in Huntly. In May, 1967, the Jaeger and Country Casuals chain sold out to Coats Paton, providing the Group with a valuable addition to their retail operation. They in turn merged with the Pringle Knitwear group, Dawson International. In 1989, Jaeger decided to run down their operation in Huntly and, following a rescue bid by Grampian Regional Council and Gordon District Council, it was bought by an East Kilbride firm, Laird Portch, and a new company, William Spence Knitwear Ltd, was formed. Its life was, however, short. Ten days before Christmas 1990, the receiver was called in to manage the affairs both of Laird Portch and William Spence Knitwear, and immediately the

management team went into action to save the jobs of the workers and continue the long tradition of the firm which had been developed over something like 170 years. Many famous names like Aquascutum, Burberrys, and Chris Clyne, as well as Jaeger and Country Casuals, had been supplied by Spence's and the management were reluctant to let the expertise go.

With the help of a Peterhead business man, Mr John Grugeon, the former management team formed a company called William Spence Huntly and reopened the factory in April 1991, with a workforce of 50 people. Huntly's 250-year-old textile industry, started by the man from Belfast, was nearing the end of its life, however, and finally had to close down in 1993.

'Spence's' as it was when it closed (1993)

Another well-known local textile business which survived into very recent memory (it closed in 1979) was Brander's Mill. The Brander family occupied a prominent place in Huntly's story for something like a century and a half and, although Brander's Mill has gone, the Brander Library looks set to continue. (We are only concerned here with Brander's Mill; the story of the library is told in Chapter 25.)

The Old Bone Mill came into being on the banks of the Bogie in the mid-nineteenth century. It then became Stephen's Mill in the 1880s and then the Richmond Mills and began producing blankets (it was later often called the

Blanket Mill) as well as tweeds, knitting yarns and carpet thread, although these were probably not all manufactured at the same time. One of the last surviving members of the family, Mr Jack Brander, died in 1995 at the age of 101.

13. An Enterprising Farmer and an Estimable Man

James Edward Ransome, whose name must surely have been as familiar to the Strathbogie farming folk in the nineteenth century, as Massey–Harris and Ferguson are in the twentieth, described the plough as 'the most useful and most general of all agricultural implements'.

So it is to the land, and what the farmers have made of it, that we turn our thoughts in this chapter. We shall also see how one 'farmtoun' developed in modern times following the agricultural revolution of the eighteenth century and leading up to the even greater revolution which followed the mechanisation of agriculture.

The plough had developed according to the jobs it was required to do, so it is hardly surprising that there was a wide variety of local ploughs, each fashioned to the type of soil and kind of work in a particular area or on a particular farm or croft. Despite this, the 'Old Scotch' ploo, as it was known, evolved as the form mostly in use up to the nineteenth century. It was long, without wheels in front, had two handles and an almost flat, wooden mouldboard. A heavy job, if the soil was wet or solid clay, or even formerly pasture, it required a mixed team of oxen and horses, certainly of six and sometimes twelve, as well as two men, to turn over the field. One man handled the plough, the other the mixed team – usually two horses in front and four oxen behind, yoked two by two.

Following the Union of 1707, however, English farming methods began to be copied in Scotland and, gradually, the face of agriculture changed. It was the day of 'The Improvers', as those who adopted the new methods were known. When Dr Johnson was visiting North-east Scotland with Boswell in 1773, he remarked on the scarcity of trees in the landscape. He had seen only one tree which was older than he was! There were no forestry grants for tree planting then as there were in the 1980s and 1990s.

Many of the progressive lairds were willing to try out both new ways and new equipment on their estates. It is worthwhile noting that the majority of lairds are supremely good at estate management. In fact, as Dorothy-Grace Elder pointed out in her column in *Scotland on Sunday* on 18 July 1993, this is the one thing at which peers of the realm excel – not at attending, debating and voting in the House of Lords! For 'peers' read 'lairds', as so often they have been and are one and the same.

A Borderman, James Small, went to Yorkshire and studied the 'Rotherham'

plough, a swing-plough like the Old Scotch, but much lighter. He patented a new version in 1767, combining features of both, and, in fact, it was another invention in which Scotland led the world. In 1780, Small's curved mouldboard was produced in iron by the Carron Ironworks and it was not long before the whole plough was being turned out in iron. In consequence, ploughwrights and foundries sprang up all over the country, among them George Sellar and Son of Huntly, which remains at the forefront of agricultural machinery and equipment sales.

It was not the day of the tractor, though, and it was not until the second half of the twentieth century before the modern giants of agriculture roamed the fields, and names like Massey–Ferguson, John Deere and Fordson were household words in the farmhouse kitchen. It was the day of the Clydesdales and the Shires, and both master and men took a great pride in the welfare and turnout of their horses, for they represented not only a considerable part of the farmtoun's capital outlay – and no one treats a valuable asset carelessly – but were also a matter of pride. Those who cared for them vied with one another to get the best 'turnout', particularly later in the nineteenth century when shows and ploughing competitions became a popular and important part of the farming calendar. Naturally therefore, both saddler and farrier – as well as the veterinarian – were vital members of this farmtoun community. This was particularly true in the nineteenth century rather than the eighteenth when – in the lowland areas of the North-east, where Strathbogie lay – they were still using straw for collars, and ropes made from horse-hair or rushes. It was, in fact, the use of leather harness and the new, lighter versions of the plough, which hastened the day of the Clydesdale and the Shire and consigned the use of oxen to milk and meat production.

Most of the land around Huntly was owned by the Duke of Gordon and farmed by his tenants, as it had been ever since King Robert the Bruce conferred the land upon the Duke's ancestor, Sir Adam de Gordon, in the fourteenth century. Known as the 'Aucht-an-Forty', the lordship of Huntly farm leases were taken for 19 years, and the Huntly 'acres' on a verbal lease of 12 years.

The notice of letting was announced by 'tuck of drum', and all feuars who wished to have 'acres' had thereupon to make application. The last occasion for the letting of all the farms in the acred land in the lordship was believed to be in 1821, when Alexander, the 4th Duke of Gordon, and his estate officials, attended at the Gordon Arms. It was not yet common to do away with small holdings and join them to larger units, except on the death of the tenant, or where there was no son to take over. The supply of holdings was limited, however, and some portion had to be taken from those who had more than their fair share. Only the feuars were involved, and most of the allotments were 2–4 acres, or thereabouts.

Looking at the changes which were taking place at the time, I am indebted to Anne Forbes for pointing out many of the improvements to both agriculture and communications that developed during the late-eighteenth/early-nineteenth century.

It was the farms near the coast which were improved first, because the ships which brought in the lime for the land took out the grain as well. Farmers and land owners away from the coast were responsible for much of the road building in the north-east – 449 miles of turnpike roads were built between 1798 and 1850 – as they were very anxious to share these benefits. The government contributed 50 percent of the cost of building river bridges. In addition, the canal from Aberdeen to Port Elphinstone (Inverurie) allowed lime to be carried nearer to the land where it would be used, and the grain also had less distance to travel by road to the ports.

Steamships were in general use by the 1820s, and farmers used them to transport their cattle. The day of the drover quickly disappeared, because the use of the steam engine on farms was, by this time, almost universal. Farmers also quickly realised the potential which the railways offered for marketing their produce to a far wider area than had previously been available to them.

Despite the fact that the Duke of Gordon was reluctant to put out tenants so that farms and crofts could be made bigger, there was a gradual exodus from the land. The displaced people from the farmtouns moved to the towns and villages and the new industries – spinning, weaving, knitting – absorbed them, although many kept on going back to the land as seasonal casual labour. So the later half of the eighteenth century saw the rise of planned towns and villages, Huntly being one of them. Again it was the Duke of Gordon who not only designed, planned and built the new Huntly, but he also introduced the linen industry to the town (see Chapter 12). His water-powered linen mills provided stiff competition for those farmers who were looking for help on their farmtouns and, therefore, feeing markets sprang up where labour could be hired on a six-monthly term, and 'alms' would be handed out to those who were in any way needing financial help. The tenant farmers with improving leases worked incredibly hard and it is well worth taking a look at one of them, who is fairly typical of the rest. We have remarkably good documentation for this particular one, who died in 1892. He was described in a tribute to him on his death 'as enterprising a farmer and as estimable a man as ever lived in these parts'.

William Grant was born on the farm of Drumdelgie. His father had come to Drumdelgie in the early years of the nineteenth century and when he retired, William succeeded him, retiring himself in 1877. Like most, if not all, the farms in Strathbogie, Drumdelgie was rented from the Duke of Gordon for the sum of £75 a year. When the Duke died, it was leased from his successor, the Duke of Richmond and Gordon. Mr Grant takes up the story:

"At the expiry of the lease, in 1840, the farm was made considerably larger by the addition of several small holdings. These contained a considerable breadth of bog-land, covered with alder bushes, which he at once began to reclaim. It was rather a stiff job. The soil was good, but contained a great number of earth-fast stones, which made the

improvement difficult and expensive. For the completion of the improvement, arrangements were made to expend about £800 under the provisions of the Government Drainage Act, and for which the tenant was to pay 5%. To give some idea of the difficulties to be encountered in carrying out this improvement, I may state that considerable portions of it cost – at the rate of five shillings a day for a man and a horse – from £15–£20 an acre to clear off the stones after being trenched. I kept a note of that, for at the time I was taking the lead in the work, and wrought among the stones for ten years; and so hard, when evening came, I was often scarcely able to put my hands on the top of my head. The transformation, however, which each day's work produced pleased me so much, that I was as ready to begin next morning as ever. The drainage of this, and a considerable portion of the old improved land, amounted to over 100 acres. In addition to this, my late father built a large steading, embracing something over 50 roods of mason work, and to which the proprietor afforded only the wood and the price of the slates.

In 1851, my father retired in my favour, going to another district. There was still a large tract of marshy land on the west side of the farm, of upwards of 300 acres, which I resolved to improve. But as my lease was within seven years of expiry, before commencing, I applied to the late Duke of Richmond – who was a prince among noblemen – for a new lease, which he with great pleasure granted on very favourable terms. And never shall I forget – when he came to see how the improvements were getting on – the kind manner in which he expressed his gratification at seeing what I had done, and, I may add, the fatherly interest he took in me and my work, When that lease was within five years of its expiry, additional steading accommodation had become necessary, and much had still to be done to the land. The present Duke, in 1866, very kindly gave me an additional five years of extension of the lease on the same terms, without any rise, and this is the lease which is now about to expire. In carrying out these improvements, there has been reclaimed by my late father and myself upwards of 450 acres of waste land. Of the whole 660 acres which was lately advertised as the extent of arable land on the farm, there is not much more than 200 acres which was arable land when my father became a tenant on it.

There are about 11 miles of substantial stone dykes finished, and with what is laid in for additional fencing there are as many stones driven off in the clearing of the land as surplus as would finish other four additional miles. The number of loads of stones lifted in connection with the improvements would not be less than 150,000. The number of acres drained would be somewhere about 450, and for which not less than 1100 loads of tiles were carted. The steading now contains between 80 and 90 roods of mason work executed by the tenant, and which would have required a good many thousand loads of building materials, in stone,

lime, sand, wood and slates. To effect all this, there has been a considerable expenditure by both parties. The tenant has performed all the carriages free of charge and paid the landlord 5% on his outlay, apart altogether from the building of stone dykes and the value of the wood and slates for the erection of the steading. In addition to that, there is the erection of three pairs of double and one single cottage. The carriages were afforded free by the tenant and the cost by the landlord, who charged the very reasonable rent of £2.10 shillings for each cottage. These cottages are a great boon to the working classes, and add greatly to the comfort, happiness and prosperity of their families. Although there is still not a little to do in some of the departments, yet a gentleman connected with the estate lately paid me a complement by saying that, taking the steading, fencing and draining into account, it was the most complete thing they had on the property."

Mr Grant went on to say that thorough improvement and cultivation is the first duty, and it stands at the top of all professions because the very existence of man is bound up with it. He said that those who endeavour to increase the productiveness of the land so as to make 'two blades of grass grow where only one grew before', will not only be benefactors to the community at large, but will benefit themselves.

Drumdelgie House, showing the original farmhouse
before its nineteenth-century extension

No account of local agriculture would be complete without mention of the local markets.

Early in the nineteenth century, from when we have specific details, there were nine cattle markets, two sheep markets and two feeing markets in the farming year. The feeing markets were more social occasions than the livestock markets. They were also used as recruiting occasions for the army, and the recruiting parties used to parade the street in full dress, complete with fife and drum band, and followed by the young lads of the town and district sporting the regimental ribbon in their caps. Many of them, no doubt, were eager to take the King's shilling and join the ranks. The cattle markets were the occasion for the sale of other goods apart from livestock and two of Huntly's markets were called 'Fit (Foot) Markets' because of the footwear which was brought by the local traders in addition to the foodstuffs and other articles (see also Chapter 25).

Local farmer and writer, Charlie Allan, writing in the *Press & Journal* in July 1993, said that when the history of North-east farming in the second half of the twentieth century came to be written, the historian would be puzzled by what happened to livestock auctioneering in Huntly.

The farmers originally formed a co-operative which ran a number of marts for many years, as they still do, and called the company Aberdeen & Northern Marts. They brought their livestock to be sold in Huntly as they did to all the other marts throughout the North-east area. Eventually, Aberdeen & Northern Marts directors decided that, in the best interests of the farmers, and because of the development of electronic selling and the direct consignment of livestock to abattoirs, they would close a number of the smaller marts and build an entirely new mart at Thainstone, Inverurie. However, the Huntly farmers decided that Inverurie was too far to take their livestock and they set about establishing another company and raising the money to open a mart again in Huntly. Not in the old premises beside the railway station, however, but a brand new mart on a new site at The Ward Farm on the south side of Huntly, just where the land begins to rise to Clashmach Hill. Which is the situation at the present time.

The agricultural depression hit Strathbogie, as everywhere else, from around 1870, lasting until the start of the First World War. It signalled the end of the small farmer and crofter and encouraged the growth of larger farms, mainly because the small farmer could not compete with the rise of mechanisation. It was increasingly the day of the milking parlour and the cattle court, the combine harvester and the grain dryer.

The guid man's craft

It was customary, apparently, on some of the larger farms, to set aside a small circle of the best ground for all time as an offering to the 'guid man', who would then leave the rest of the farm alone to grow its crops. The guid man was, of course, the Devil and was only referred to as the guid man because it might have brought bad luck to refer to him as the Devil. This was perhaps the same spirit in

which the theatre world refer to Shakespeare's *Macbeth* as 'The Scottish Play'. It is often thought to bring bad luck to mention Macbeth's name!

A circular dry stone wall, with no gate, was erected around the plot. Circular, so that the Devil could have no hiding place; no gate so that, once in, he could not get out. Sometimes the croft was watered regularly, presumably so that it would remain fertile and attractive all the time and the Devil would not be lured into taking the rest of the farm!

The Ballad of Drumdelgie

One version of this Bothy Ballad – of which there are many – giving a glimpse of what it was like to live in a bothy at 'the muckle toon o Drumdelgie'.

> There's a fairmer up in Cairnie,
> Wha's kent baith faur and wide
> Tae be the great Drumdelgie
> Upon sweet Deveronside.
>
> The fairmer o yon muckle toon
> He is baith hard and sair,
> And the cauldest day that ever blaws,
> His servants get their share.
>
> At five o clock we quickly rise
> An hurry doon the stair;
> It's there to corn our horses,
> Likewise to straik their hair.
>
> Syne, after working half-an-hour,
> Each to the kitchen goes;
> It's there to get our breakfast,
> Which generally is brose…
>
> We've scarcely got our brose weel supt,
> And gi'en our pints a tie,
> When the foreman cries, 'Hallo, my lads!
> The hour is drawing nigh.'
>
> At sax o clock the mull's put on,
> To gie us a strait wark;
> It tak's four o us to mak to her,
> Till ye could wring our sark.
>
> And when the water is put aff,
> We hurry doon the stair,
> To get some quarters through the fan
> Till daylight does appear.

When daylight does begin to peep,
And the sky begins to clear,
The foreman cries out, 'My lads,
Ye'll stay nae langer here!'

'There's sax o you'll gaun tae the ploo,
An twa will drive the neeps,
And the owson they'll be after you
Wi' strae raips roun their queets.'

Sae fareweel, Drumdelgie,
I bid ye a' adieu;
I leave ye as I got ye –
A maist unceevil crew.

14. A Writer long before his time

On 10 December 1824, at 41 Duke Street, Huntly – now a dentist's surgery – a second son was born to the wife of one of the partners in the town's linen and bleaching business. The family were not native to Huntly, in fact they had only lived there since the latter half of the eighteenth century – a matter of a mere 50 years. Nor was it a very auspicious start for the family – the grandfather of this baby had arrived in the town destitute and of no fixed abode. He was also an outlaw and an exile from his own people. His name was Charles Edward MacDonald.

Both his surname and Christian name gave him away. If the former were not enough to label him a foreigner to these parts, and an exile, his Christian name would at once mark him out as a Jacobite and probably an outlaw, for Scotland was still not far away from the abortive attempt in 1745 by Prince Charles Edward Stuart to claim the throne away from the House of Hanover. In fact, MacDonald's family had suffered two evictions from their home. As their name suggests, they were MacDonalds of Glencoe, and in the early morning of 13 February 1692, an event took place which has left one of the most indelible bloodstains on Scots history. Some managed to escape the Campbell bayonets in that infamous massacre in the Glen, including a very young member of the clan named Ronald. He eventually settled in Portsoy, on the opposite side of the country from Glencoe, and here we learn of the first instance of the MacDonald resourcefulness and enterprise. Ronald's son had taken advantage of the local situation and gone into business as a quarrier and polisher of Portsoy marble. The Portsoy marble polisher also had a son – with red hair – called William and he became the Town Piper in Portsoy, waking the townsfolk at five in the

morning, and also telling them that it was time to get ready for bed at eight in the evening.

It was then that the second tragedy struck. True to form, William was one of those who rallied to the call in the Second Jacobite Rising and took his pipes with him to play in the Prince's army, but he was blinded at Culloden in 1746. Again, the Prince's defeat ended in massacre, the Highlanders having their houses burned and their property confiscated. William's wife and three-month old son had gone with him to join up, as women did in those days, and apparently she died when she heard the news of the massacre. However, William managed to escape with his baby son, running the gauntlet of the townsfolk of Nairn, and no doubt other places on the way, and managed to reach Portsoy safely, even though he had to go into hiding until the hue and cry had died down. The Duke of Cumberland's soldiers were ruthless in hunting down anyone with Jacobite tendencies, especially those who had escaped from Culloden.

It will come as no surprise to learn that the baby was Charles Edward MacDonald. Charles Edward had the same resourcefulness and enterprise as his grandfather. He got a job with a linen manufacturer in Huntly, Hugh McVeagh (see Chapter 12), and eventually, when McVeagh died, became owner of the linen business. In 1778 he married a Drumblade woman, Isabella Robertson, who proved to be a great influence on her children and grandchildren and whom her grandson portrayed in one of his novels, *Robert Falconer*. They had ten children, six of whom survived. The eldest son, William, founded the Huntly Brewery, but the other sons, Charles, George and James, joined their father in the linen business. Charles went to America under a cloud and died there in 1836, leaving James and George to run the business. George learned weaving and then took over the thread factory in MacDonald Street until it closed in 1829. He married twice. His first wife was Helen MacKay from Duargbeg in Sutherland and they had six sons, the second of whom was named George, after his father. Helen died of tuberculosis in 1833, and then George married a local girl, Margaret McColl, who lived until she was 102. She bore him three daughters.

In 1826, the MacDonald family built a new house at the farm of Upper Piriesmill which Charles Edward had inherited along with the linen business from Hugh McVeagh. They called it first 'Bleachfield Cottage' but later renamed it 'The Farm' and this name remained with it long after the farm itself had been sold. It changed its name to 'Greenkirtle' when it was bought by Mr and Mrs James T. Black. Mrs Black thought that it should always be accessible to those interested in George MacDonald and the present owners have every intention of continuing the tradition.

George's schooldays were disastrous. He was sent to the so-called Adventure School in Stewart's Lane (where Strathbogie Church stands today). It was certainly an adventure if MacDonald's account in *Alec Forbes of Howglen,* which is thought to be autobiographical, is to be believed. The adventure school also gave him his lifelong aversion to both school and the Shorter Catechism!

Most of the non-Parish Church children went to this school, especially those whose parents went to the Missionar Kirk, as the Congregational Church in Old Road was known. The Missionar Kirk, which is now the Strathbogie Bakery, was established in 1801 under George Cowie who was the minister for 35 years. Those who attended got the nickname 'Missionar' from their support of overseas missionary work and, although it was never meant to be complimentary, they accepted it as such! They were made of stern stuff, these Missionars, however, because although they had no heating in the church, they often sat through a five or six hour service in the depths of winter. MacDonald was very happy in the Congregational Church; he felt it gave him more freedom for his religious views than either the Presbyterian or Anglican Churches, although he did become an Anglican layman later in life.

From school, MacDonald went to Aberdeen University, graduating in 1845. It was here, at King's College, that he sported a bright tartan coat which he always wore with the scarlet undergraduate's gown. He must have been a familiar sight – even if a somewhat gaudy one – on his daily walk from his lodgings at 37 Spittal, down the High Street to King's. It was here, too, at university that he finally threw off the Calvinistic doctrines of the Established Church in Scotland which he had found so objectionable as a young boy. He was then ready to set out on the path towards the ministry of the Congregational Church – only to find that his liberal theological views were no more acceptable here than they would have been in the Church of Scotland; David Strauss and Charles Darwin and the subsequent theological upheaval had not yet hit the Church.

He tutored for a little while after university and was then accepted as a student at Highbury Theological College. It was whilst he was in London that MacDonald met the woman who was to be his wife. Louisa Powell was the sister-in-law of George's cousin, Helen MacKay, to whom he was particularly attached.

From Highbury, MacDonald went to his first and only charge – at Arundel in Sussex. The spring after going to Arundel, George and Louisa married in London and spent their honeymoon in Huntly. Then back to their new home in Sussex, where they were soon expecting the first of their 11 children (see p. 73 for the family tree).

At first, everything seemed to be going fine at the church in Arundel, then, gradually, MacDonald's theological views – normal now, but raising many hackles in the mid-nineteenth century – began to cause problems between himself and the members of his congregation. It was not long before resignation was forced on him, in 1853, only two years after he went there. Not surprisingly, he was never in full-time ministry again, although he did preach in a number of places including the Missionar Kirk in Huntly (when all other kirks in the town closed their doors and went along to hear him) and in Manchester, just after he left Arundel, before his reputation for holding 'unusual' views caught up with him and ministers were reluctant to let him loose on their congregation. He was, therefore, doing less and less in the way of active ministry and more and more in

the way of writing. A sign that his days as a clergyman were over was the letter to his father in Huntly, only three years after he left Arundel, asking him to stop addressing his letters to: 'The Reverend George MacDonald'. It was probably round about this time that he began to show leanings towards the Anglican Church. He became an Anglican layman, and after the move to Bordighera, Italy, he was associated with All Saints' Anglican Church.

It was while he lived in Manchester that he first got into print with a poem called *Within and Without*, published in 1855. This poem got such a favourable review in the press that it was noticed by none other than Lady Byron, the widow of George Gordon, the famous nineteenth-century poet. She befriended the penurious poet and writer and his young wife and family and became his patron as well as his benefactor. Of course, MacDonald and her husband shared North-east connections. Lord Byron was brought up at Gight Castle near Fyvie and also suffered at the hands of the extreme Calvinists, having a Calvinist nurse who often beat him savagely and sexually abused him. Byron, like MacDonald, also turned against Calvinism when he left home and exchanged Aberdeen Grammar School for Harrow.

To mark MacDonald's days in Manchester, a bronze by A. Monro was given to the public library, on 4 March 1926, by his friends and admirers. The inscription read: 'George MacDonald, poet and novelist, preacher 1824–1905, a citizen of Manchester and reader in the public library, 1853–1855'. The Lord Mayor of Manchester presided at the ceremony and an address was given by Cumming Walters, chairman of the memorial committee. He described MacDonald as 'an essayist of a profoundly meditative character, a scholar and novelist... a poet of distinction and a writer of fairy stories who holds a unique position'.

After a brief spell in Huntly, where MacDonald's lungs objected to the climate, they went to Algiers at the behest and expense of Lady Byron, where his lungs could get better. On their return they settled in Hastings and then, eventually, in London, where his serious literary life began in earnest.

There followed a spate of novels, theological works, poetry, fantasy and children's books. In all, 60 works appeared. The best remembered are *The Princess and the Goblin*, *The Princess and the Curdie*, and *At the back of the North Wind* – all fairy stories for children – but his fantasies for adults, *Phantastes* and *Lilith*, have always enjoyed a following and are now regarded as English classics in the field of fantasy writing.

MacDonald's poetry was so highly regarded that he was considered for the post of Poet Laureate on the death of Alfred, Lord Tennyson. He is also the author of 20 novels, many of which are set in Huntly and the surrounding area and some are obviously autobiographical. *David Elginbrod*, *Alex Forbes of Howglen*, *Robert Falconer* and *Ranald Bannerman's Boyhood* contain a great deal of local material and reflect vividly the Huntly of the mid-nineteenth century in which MacDonald grew up. So popular a writer was he, that Queen Victoria gave a copy of *Robert Falconer* to each of her grandsons.

71

It has to be said that, until recently, George MacDonald had been sadly neglected in his home town, for which he always had a high regard. A visit by the George MacDonald Society to Huntly in 1990, Gordon District Council's promotion of a visitor 'trail' around sites associated with him, and the formation of Huntly Heritage have done something to awaken local interest. A spate of new books about him has also generated a great deal of renewed interest, particularly the definitive biography, published in 1987, by Huntly man William Reaper who, sadly, was killed in an air crash in Nepal in 1992. However, if he is not well known in his native town, he is in his adopted town – Bordighera in Northern Italy, a Mediterranean resort formerly much loved by the English, not far from San Remo. It was to Bordighera that the MacDonalds went to live in 1880 to help George's health. Friends clubbed together to build them a house which they named Casa Coraggio and where they spent 20 happy years together. George wrote and lectured, Louisa put on versions of *Pilgrim's Progress* and raised money by doing so to help the family finances. George always took the part of Mr Greatheart.

The last five years of MacDonald's life, however, were dogged by deteriorating health and he hardly spoke to anyone. When Louisa died on 13 January 1902, no one dared to tell him for several days, fearing the effect it would have on him. Nursed by Irene, his daughter, he stayed on at Casa Coraggio, going to live with Irene and her husband Cecil Brewer when they married in 1904. The following year he went to live with another daughter, Winifred, who had married Edward Troup, later Sir Edward, at their home at Ashtead in Surrey. Winifred and Edward went to Italy for three weeks to pack up Casa Coraggio and when they returned it was to find MacDonald drawing near to death. After a bout of pneumonia, he died on 18 September. On 31 September 1905, Edward and Winifred took his ashes to Bordighera and laid them to rest in Louisa's grave after a short service conducted by the chaplain to the English Congregation at All Saints' Church.

In 1946, the Anglo–Ligurian Society held a commemoration service at his grave in Bordighera. The Society, joining with the Mayor and council of the town, unveiled a plaque on the side of Casa Coraggio.

MacDonald's life and work spanned three-quarters of the nineteenth century. C.S. Lewis described him as one of the greatest nineteenth-century writers – but he did not, as you might expect, reflect life in his time. He was primarily a religious writer, which accounts for his enormous popularity then, rather than now, because readers today look for something quite different in religious literature, and it is the fairy tale quality and the fantasy which appeals to them.

His children's books, along with *Phantastes* and *Lilith* – *Lilith* is MacDonald's masterpiece – are being regularly reprinted and there is quite a flourishing interest in MacDonald's writings in America. Many of his novels are condensed and sold in paperback there, and at Wheaton College, Illinois, they have a special interest in MacDonald Studies. His last works were *Lilith,* published in 1895, and *Salted with Fire,* published in 1897.

The MacDonald and Troup Family Tree

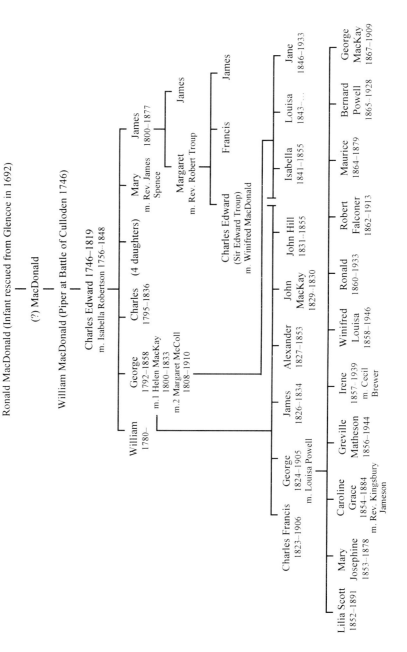

Prior to the 1970s, only one biographical work of MacDonald was published, written by his son, Greville MacDonald, in 1924. What is even more cruel, perhaps, is that he was totally ignored in the place of his birth. The *Huntly Express,* reporting his death on 22 September 1905, was more fulsome. There his life and work were described as a source of lasting pride to his generation, his country and his home town.

'Bleachfield Cottage', 'The Farm', and later 'Greenkirtle' –
home of the MacDonald family

15. Memorial to a Departed Duke

When a duchess laid the foundation stone of her pride and joy on 27 February 1839, in a ceremony impressive as only the Victorians could make it, she created for herself, as much as for her late husband to whom it was dedicated, a memorial with which her name is forever associated.

Elizabeth Brodie was born in London in 1794. She was the daughter of Alexander Brodie, an East India merchant who married a Wemyss of Castle Wemyss, and settled down to run the estate of The Burn, near Fettercairn, in

Kincardine and Deeside, which he bought with the immense fortune he had made out of trading. By strange coincidence, it had been the home of Lord Adam Gordon, son of the 2nd Duke of Gordon, who died in 1801. Having no children by his wife, he left The Burn to a natural daughter, who sold it shortly afterwards to Alexander Brodie, then of Arnhall, Edzell. He was a younger son of the Brodie of Brodie. His wife died when Elizabeth was only six years old and she was brought up by maiden aunts in Elgin. She later went to a boarding-school for orphaned and one-parent-family children in London before returning to live with her father at The Burn.

Relations between the Brodies and the Gordons had been somewhat strained following a none too friendly visit by the 3rd Marquis of Huntly to Brodie in 1653. On that occasion he left with a quantity of Brodie's cattle, so it is not difficult to understand why there was animosity between the families. It was Jane Maxwell who healed the breach and she was a frequent visitor at The Burn, usually breaking her journey between Fochabers or Kinrara and Edinburgh. It was in 1811, on one of her visits, that the idea occurred to her that the attractive 17-year-old Elizabeth, sole heiress to the Brodie fortune, would make the ideal wife for her favourite son, the Marquis, even though he was 25 years older than she. Unfortunately, Jane did not live to see it happen (she died in 1812), but within two years, the 43-year-old Marquis and the pretty 19-year-old were married in Bath Abbey by one of the Marquis's domestic chaplains.

They had a short, but blissfully happy, 23 years together, first travelling all over Europe, before settling at Huntly Lodge until the death, in 1827, of Duke Alexander who, in 1820, had caused the sensation of the century by marrying his first love, Jean Christie, with whom he had been having an affair for 20 years and who had already borne him five children.

The fifth and last bearer of the title, premier duke and largest landowner in Scotland, George Gordon, died on 28 May 1836 – by common consent, the most popular man in the North of Scotland. He was given what amounted to a state funeral, his body being carried from his London home in Belgrave Square to Greenwich, to be put aboard the Government ship, Firebrand, which took him to Speymouth off the Moray Coast. He lay in state at Gordon Castle until his burial in Elgin Cathedral's St Mary's Aisle a week later.

His death was mourned by people far and wide because he was well-known for his honest and courteous attitude to people in all walks of life, something which made him respected and liked even by those who did not agree with his politics. It is small wonder, therefore, that the funeral procession to Elgin consisted of about 50 carriages, a large number of gigs and 70 horsemen.

Although the Duke and his wife had no children, he did have two natural ones, a son and a daughter, by Ann Thomson, one of the castle servants. The first of these was Charles Gordon, later Rear-Admiral, who lived in Castle Street, Huntly, and who gave his name to Admiral's Lane which is now bisected by the East Park Street car park. The affair with the attractive Ann lasted many years and she eventually went to live with friends at Aldunie, Cabrach, where she died

in 1862, just two years before Duchess Elizabeth. The title therefore went to the 5th Duke of Richmond whose grandfather had married Charlotte Gordon, George's sister. He is well known to the people of Huntly because his statue has stood in The Square for well over 100 years. Duke George had willed the estate to him, and the second title of the Marquis of Huntly went to the 76-year-old Charles Gordon, Earl of Aboyne, with whose heirs it still resides today.

After a brief spell in the south of France, the Duchess learned that the tenant of her beloved Huntly Lodge, where she had spent the happy years of her early married life as Marchioness of Huntly, had given up the lease, and she wasted no time in setting up her home there once again. She had reached the ripe old age of 42 and was faced with a very important choice. She was a very religious woman and this would obviously play a part in deciding whether she would continue in public life as the Dowager Duchess of Gordon, or whether she would live a life of obscurity as befitted a Victorian widow. Those who knew her thought she would choose the latter role, which might have suited her inclinations as a woman whose religion meant more to her than it would to many of her station and time. She chose the former, but she was regarded by many as a crank because she had earlier cut herself off from her former aristocratic friends whose way of life she despised. She was highly critical of the immorality in the higher ranks of the so-called 'society' of early Victorian days, and she deplored the way some of them sought honours and secure jobs from the Crown. To her, society was sick.

She was a woman with a cause, who later became prominent in the evangelical revival which spread all over Scotland in the 1850s and which, arguably, had its centre in Huntly. If it had, it was due in no small measure to Elizabeth Brodie and her influence in the new breakaway Free Kirk which she joined following the Disruption of 1843. Immediately following her husband's death, the Duchess wanted to set up an abiding memorial to him. One of the strong passions of her life was education. When she had lived at Huntly Lodge in her early days, she had founded an infant school in the town and later, when she became Duchess, she was one of the prime movers in establishing an infant school in Elgin. When the private chapel of the castle – Gordon Chapel – was built in Fochabers (and it was largely due to her that it was) in 1834, an Episcopalian school went with the package. So it comes as little surprise, with hindsight, that the Duke's memorial should be a school.

She chose a gifted architect, Archibald Simpson, to design it. He might almost have been described as the Gordon's architect-in-residence, as he designed so many of the Gordons' projects. He it was, in the early days of their marriage, who redesigned and refurbished Huntly Lodge for the Marquis and his young Marchioness. Later, when the Duke succeeded to the title, he did an immense amount of work at Gordon Castle, as well as designing and building Gordon Chapel and other buildings in Fochabers, as well as the new Spey Bridge. So it was quite natural that the Duchess should turn to him to design what she regarded as the most important thing she had done. As it turned out, it

The memorial plaque to the 5th Duke of Gordon on the tower of the Simpson Building

was as much a memorial to him as to the Duke, since today it is usually referred to by everyone as the Simpson Building.

There is more than a passing resemblance between the tower and Sir Christopher Wren's Tom Tower at Christ Church, Oxford. Ewen McDonald, in his commemorative booklet for the 150th Anniversary of The Schools, remarks that it might be possible that our distinctive Huntly landmark owes something to the greatest English architect. Since Simpson had worked in London and travelled both at home and abroad, it was more than possible that he was influenced by the design of the buildings in the city of dreaming spires, including Tom Tower. There is also a distinct relationship between the Simpson Building and The Royal Dick Vet College building in Edinburgh, of which Simpson was also the architect. The Simpson Building originally had gates which have long since disappeared.

The white sandstone building was opened in 1841, on the site of the former castle gates, straddling the impressive avenue to the castle and Huntly Lodge, at a cost of £3000. The laying of the foundation stone must have aroused tremendous enthusiasm in the town because the Aberdeen press reported on 6 March 1839 that there was a procession of upwards of 5000 people to Huntly Lodge. The procession was headed by about 400 little girls, neatly dressed, followed by a still greater number of boys. Next in order came the gentlemen of

the town, then the tenantry of the Gordon estates, and a numerous array of 'respectable strangers' (!) bringing up the rear. We shall no doubt never know who the respectable strangers were. The foundation stone laying went off without incident, but when the children began to sing the hymn, which the Duchess had written specially for the ceremony, she broke down in tears.

A time capsule, in the form of a hermetically sealed jar, was put under the stone. It contains a Bible; a copy of the specially composed hymn; the *Aberdeen Almanac*; current coins of the realm; a copy of the *Elgin Courant* which contained an account of the laying of the foundation stone of the Elgin monument – one of three to the Duke; and a parchment, written by the Duchess, stating the aims of the Schools which she was founding, its dedication as a memorial to the Duke, and her views in adding the ceremonial of this founding to the proceedings of the day as a mark of her Grace's respect for the Earl of March. (The date, 27 February 1839, was the day the Earl of March, son of the Duke of Richmond and heir to the Gordon estates, came of age. It was chosen deliberately for the ceremony.)

After the ceremony, everyone went in procession to the Parish Church for a dedication service which, in turn, was followed by a dinner attended by 600 people in a marquee erected in the Square.

The building housed four distinct schools. There was the Parish School, formerly in Church Street. Was this, one wonders, the successor of the school opened in Church Street by Alexander Cheyne after the '45? The second was a school for Dissenters who would not share benches with the Moderates from the Parish School. This was in the days leading up to the Disruption and, after 1843 this became the Free Church School (see Chapter 14). Both these schools were housed on the left hand side of the building as you go through the archway towards the castle. The right hand side of the building housed the Infant School and a completely new concept in education, the Industrial School. Education for girls intended for domestic service, of which there were a very large number, was considered, in the middle of the nineteenth century, to be a waste of time. The Duchess, however, had a different idea. She believed that they should be given a basic elementary education, but she also thought they should be taught their trade. So the Industrial School taught domestic economy – how to scrub, wash, sew and cook. Duchess Elizabeth was also a pioneer of school dinners. The girls were taught how to prepare a dinner – and then they sat down to eat it themselves! The same girls rendered a service to the ladies of the town and district as part of their training. Their sewing lessons included taking in plain sewing and mending – for a small fee. The girls were thus able to do the mending and alterations to the domestic linen when they eventually left school and went into service.

The Industrial School was closed down after the Duchess's death and it was well into the twentieth century before domestic science – or home economics, as it is called today – appeared in The Gordon Schools' timetable again.

The Duchess was a woman of immense character and she applied the same

dedication to her religion as she gave to education. During her time at Huntly Lodge, she maintained the same daily routine. Her fire was lit at 6 a.m. and she was up shortly after. She breakfasted with her mastiff, Sall, at nine, and at 9.30 the whole household, staff and guests, assembled in the library for morning prayers, led by her domestic chaplain. The process was repeated for evening prayers at 9.30 p.m.

Sunday was a fairly cheerless day at the Lodge, and even guests were not allowed to sit around in idle gossip because no fire was lit in the drawing room, even in winter! The servants had to have time off, too. A young man who had been staying at Huntly Lodge – the Duchess always had a vast number of guests staying – wanted to leave on a Sunday morning. He was rebuffed with the remark, 'Oh no. Not on the Sabbath!'

The Duchess continued to worship in the Episcopal Church – the Duchess Chapel in Meadow Street – but found herself disagreeing more and more with its doctrine and was drawn to more evangelical preaching than she got there. It was shortly after much prayer and heart-searching that, after the Disruption, she joined the new Huntly Free Church (now Strathbogie) and became a regular worshipper. She would make pencilled notes of the sermon then expand them later in the day. She never forgot that she was a Duchess of the Realm, even if she was technically retired, and insisted that the minister pray for the Queen and the Royal Family at every service. (She had been chosen, as premier Duchess, to be Mistress of the Robes to Queen Adelaide – William IV's Queen – and visited them many times at Windsor, as she did the young Queen Victoria at Balmoral.)

We are indebted to the late Miss Madge Lobban who recounted what a lady – who remembered the Duchess in church – told her when she (Miss Lobban) was a young girl.

> Just after they were seated in the family pew, the Duchess, followed by her attendants, could be seen walking along the aisle to her seat at the far end of the church, then down the aisle came Adam Hutton, the tied shepherd, tall and dignified with his fine head of white hair. Then down the other aisle came Fairbairn, the coachman, plump and rosy. But the kind face and silvery hair soon passed from our sight, and with the death of Her Grace there came to us all a sense of loss to be followed by a feeling of hope and cheer and the inspiration of a noble and beautiful life.

The Duchess had severe illnesses in 1863, but rallied and found strength to arrange a number of revival meetings and a Christmas treat for the children. There were four Christmas trees and 600 children – everyone receiving a present – at this giant party during the last weeks of her life.

Early in the New Year, she had a relapse and died on the last day of January 1864. After a service at Huntly Lodge, the funeral procession went through the streets lined with children, blinds were drawn, and shops closed – everyone sad at heart at 'the greatest calamity that ever befell this district'. Her coffin was

placed on a train at Huntly station and taken to Elgin to be laid beside that of her husband in the cathedral.

The School buildings were extended in 1886 to cater for 800 pupils. There were then ten teachers besides the Rector. An entirely new secondary building was built in 1896 and, in 1904 the first primary school was built. The assembly hall, dining rooms and science block were added in 1958, later followed by a teaching block, gymnasium and games hall. All three departments – infant, primary and secondary – were under the Rector, but in 1972 it was decided to separate the secondary from the primary and infant departments and appoint a separate, autonomous head, with an infant head responsible to the primary head teacher. The new buildings, opened on 17 April 1972, also included a separate department for those with learning difficulties, known as The Unit. The former primary building, which had served in that capacity for 68 years, was then converted for the use of the community and named the Linden Centre. It now serves as a base for recreational use and community education.

A move by the local authority some 40 years ago to change the name from The Gordon Schools to Huntly Academy – all the schools not so called were to be renamed 'Academy' – was foiled by 'pupil power'. They simply refused to use the new name and the Authority, wisely, allowed the matter to drop and the school to retain its historic title.

On 27 February 1989, staff and pupils from The Gordon Schools went to Elgin Cathedral to lay a wreath in St Mary's Aisle at the grave of 'The Good Duchess' who, 150 years before, had founded their school.

The Founder's Day Hymn

The Founder's Day Hymn now has four verses. They were verses 1, 2, 7, and 8 of the original hymn of nine verses composed to be sung by the children of Huntly on the occasion of the laying of the foundation stone of The Gordon Schools by Elizabeth, Duchess of Gordon.

In its present form, the hymn was first sung at the Founder's Day ceremony on Wednesday 27 February 1957, to a tune called 'Brodie' composed by the late Alexander Keith who was the then Principal Teacher of Music. An annual Founder's Day Ceremony was instituted the previous year.

1. O Lord! Thy Majesty is shown
 By every star that shines on high,
 While round about Thy Glorious Throne,
 Glad Hallelujahs fill the sky.

2. Yet in Thy lofty dwelling place,
 Thou hear'st the feeble suppliant's
 prayer;
 For where the angels see Thy face,
 Jesus, our Advocate, is there.

3. To tell Him, on whom we rest,
 Jesus! the rock on which we build,
 That many a soul may here be blest;
 With light and love, and joy be filled.

4. Through life may we Thy will perform,
 Our various stations wisely fill,
 Thy Gospel in our lives adorn
 And find, in Thine, our only will.

The Gordon Schools' Song

The School Song, dedicated to the pupils of The Gordon Schools was written by a former Rector, Mr D.M.J. James and the music composed by Mr T.E. Wright, a former Principal Teacher of Music.

> By the storied walls of the Gordon's hold,
> By the rivers twain as they wind to the sea.
> Girt all around by the circling hills,
> Is the school of the Tow'r and the Linden Tree.
> Here first we follow'd in learning's train;
> Here first we played in the sun and the rain.
>
> Oh, proud is the fame of the Gordon's name.
> On many a field you shall find their grave,
> And there's many a lad by the Tow'r who played,
> Has pass'd in the splendour that crowns the brave.
> For freedom, for honour, they life resigned.
> Let us harken the message they leave behind.
>
> When the river of time has borne us far,
> And we hear the voice of the calling sea,
> Shall our hearts return in mem'rys hour
> To the school of the Tow'r and the Linden Tree;
> Where first we follow'd in learning's train;
> Where first we played in the sun and the rain.

[Both the Founder's Day Hymn and the School Song are reproduced by kind permission of the Rector of The Gordon Schools.]

16. The Dominie from Grange

Such was the pace in a local farming parish in the 1830s that, even in his wildest dreams, the elderly minister of that parish could never have foreseen the devastating sequence of events which would be unleashed when he died.

The last years of the Reverend William Stronach's life were spent in the Parish of Marnoch, which lies in the picturesque valley of the River Deveron, several miles downstream from Huntly and a few miles inland from the ancient and one-time county town of Banff. The parish lies just inside the former county of Banff, later part of Banff and Buchan District, and now in Aberdeenshire! There, Mr Stronach was assisted in his ministry by the schoolmaster from the neighbouring parish of Grange, John Edwards. Mr Edwards, like so many dominies in Scotland in the nineteenth century, had qualified as a minister of the

Church of Scotland and was awaiting the call which would remove him from the teacher's life of poverty to the comparative affluence of a parish minister.

When William Stronach died in 1837, the patrons of the parish, the Trustees of the Earl of Fife, immediately presented John Edwards as the new minister of Marnoch. They believed – not without some justification – that because he had at one time assisted the old minister, it was only right that he should be asked to succeed him. The congregation had other ideas. The patrons either did not know, or chose to ignore, the fact that Mr Edwards had previously been dismissed by Mr Stronach as his assistant at the request of the congregation. It was therefore unlikely that they would be very keen to have Mr Edwards as their full-time minister. In any case, they were never consulted, and although many stories circulated about Mr Edwards, given subsequent events, the former is more likely to be the reason for the rejection of his name, rather than the latter.

Among the criticism levelled at him, however, were that he was fairly 'right wing' politically, and that in his sermons he denounced the modern liberal tendencies that were springing up, as well as the elders of the kirk for not being committed enough to their duties. Nor was Mrs Edwards neglected either! She got her share of criticism for the things she was reported as saying publicly which, if true, would perhaps have been better left unsaid.

Despite the patronage system, kirk congregations still went through the empty formalities of 'calling a minister' – one whom they had not chosen, and more than likely would not have chosen, and whose name was presented to them by the patron! In Mr Edward's case it turned out that while only one parishioner – the landlord of the inn in Aberchirder (the town known to the locals as 'Foggieloan') – could be found to sign the 'call', 261 heads of families who were eligible to sign it had objected in terms of the Veto Act which had been passed by the General Assembly of the Church of Scotland two years before in 1835.

The Presbytery of Strathbogie took the matter to the General Assembly the following year, and the Assembly was in no doubt as to whose side it was on. They backed the congregation and voted to reject Mr Edwards. Mr Edwards retorted with an action against the Presbytery in the Court of Session. He claimed that it was illegal in Scots Law to reject a minister who had been duly and legally presented by the lawful patrons of the parish. The lawful patrons, meanwhile, seeing that Mr Edwards was not acceptable to the congregation, nor ever would be, accepted the inevitable and nominated a new candidate. He was a Mr David Henry who had succeeded Mr Edwards when he was dismissed.

The Presbytery was in a cleft stick. A similar case at Auchterarder in Perthshire had ended with the Court of Session finding for the patrons and rejecting the minister. There was no doubt that the Presbytery of Strathbogie likewise would be left with egg on its face since the law was on the side of the patrons and it would be a long time before it changed. The Presbytery therefore decided to defy the General Assembly's ruling, and by a majority of seven votes to four, they supported Mr Edward's nomination.

82

This only seemed to aggravate the matter further. Legally, they were right; but they had refused to obey their Church's ruling and their Church carried moral authority, if nothing else. The legal battles continued. Mr Edwards could not get himself ordained as a minister, nor inducted to the parish. At least the Presbytery had the right to decide who should be ordained if not inducted, and since only an ordained minister could be inducted, they had to do it. But since the Presbytery was divided, Mr Edwards waited in vain to be ordained. Even after the Court of Session ordered them to induct him, they found they could get round this by not ordaining him, and it took some time before they eventually complied. At last, on 21 January 1841, despite a split in ranks, and against the wishes of the General Assembly, some of the ministers met at Marnoch Kirk to induct him.

The congregation, however, had appointed a lawyer to read out a formal protest, and after it was read, they walked out, to a man, leaving the ministers to install the new minister on their own. The congregation betook itself to Foggieloan, where temporary premises were rented and David Henry ministered to them.

Two years later, in May 1843, a third of the ministers and many of the elders at the General Assembly of the Church of Scotland walked out and formed the Free Church of Scotland. This is known historically as 'The Disruption'. The reason was the same as that which prompted the Marnoch congregation to walk out more than two years before – the right, in matters of religion, to be free of the control of the State. One of those who played a leading part in the events leading up to the 'walk out' at Marnoch in 1841, and the greater one in Edinburgh in 1843, was the Reverend James Walker, Minister of Huntly. Being one of the Strathbogie Presbytery members who rejected the General Assembly's order not to ordain Mr Edwards, Walker was suspended along with the other six 'rebels'. He was barred from preaching and officiating at baptisms, weddings and funerals. Supply ministers undertook the duties, and things continued at Huntly Parish Church as usual, but without Mr Walker. That is, until he obtained a Court of Session interdict forbidding visiting ministers performing duties in the church of which he was the lawfully inducted minister (he was, legally, if not in the eyes of the Assembly). So the visiting ministers preached and carried out other ministerial duties in the open.

In his book, *The Story of Strathbogie Church*, Ewen McDonald tells the story of a visiting minister who arrived at the Gordon Arms Hotel in Huntly one Saturday afternoon to prepare to take the services on the Sunday. The porter grabbed his bags and tore off the labels indicating the owner's name. 'What are you playing at?' demanded the minister. 'They can't serve an interdict on you personally if they don't know who you are,' was the reply.

It was undoubtedly Walker's stand which precipitated the formation of a new Free Church in Huntly. A group of Huntly Parish Church members who did not agree with Walker's actions in defying the General Assembly and siding with the State, decided to move out and start the new church. Although they had a

preliminary meeting in December 1839, their first gathering was held on 4 January 1840 in what is now the Freemason's Hall in Meadow Street, Huntly. It was then the old Roman Catholic Church, St Margaret's having just been opened in 1835. Eventually, the Duchess of Gordon gave a grant of land to the new Free Church and the General Assembly made a grant of £400 – not without fierce opposition – and the foundation stone was laid on 21 July 1840. The new church was opened by Dr Chalmers, one of the leaders of the Disruption, on 26 February 1841.

Meanwhile, Marnoch Kirk re-established itself in Foggieloan, and for 150 years, the two kirks co-existed. However, on 20 January 1991, the Old Kirk of Marnoch (as it came to be called, since the New Kirk was built in Aberchirder in 1842) closed its doors for the last regular service.

Population shifts and social conditions in the 1990s make two churches unnecessary since the wounds of the Disruption were officially healed in 1929. The New Kirk stands within the main settlement of the district and the decision is a wise one. The Kirk Session still want the Old Kirk to be used for special services like weddings and funerals and it is hoped that, since it stands as the womb, if not the birthplace, of one of the most momentous happenings in the 400-year-old history of the Church of Scotland, it will become an interpretative centre and museum. That remains to be seen and it would be a sad day if something were not done to preserve a building which has played such a significant part in those momentous happenings.

The 'Old' Kirk of Marnoch

17. The Priest who built a Church –
300 years after he died!

It all started with Alexander, Lord Gordon, who was made 1st Earl of Huntly in 1440. He was married three times, the third time to a daughter of the Lord High Chancellor of Scotland, Sir William Crichton. They had three sons and three daughters. The eldest son, George, eventually became the 2nd Earl, but it is the third son, Adam, in which this chapter is interested. Adam Gordon, no doubt called after the Adam de Gordon who received the lands of Strathbogie from King Robert the Bruce (see Chapter 3), became a priest and, eventually, Rector of Pettie and Dean of Caithness.

In fifteenth-century Scotland, priests were not allowed to marry as they had been prior to the eleventh century. That was when the last vestiges of the Celtic Church were erased from the Church in Scotland and it gradually became 'Westernised' following the influence of Queen (later Saint) Margaret, the Queen of King Malcolm III. The Scottish Church finally adopted the customs of the Western (Roman) Church over the next couple of centuries.

Sometimes, rules are kept more in the breach than in the observance, however, and there have been periods, even after 1139 (the date when it became compulsory for clergy to be celibate), when it became commonplace for priests to form relationships. All of which is just to explain why a priest, Adam Gordon, seems to have had such a relationship, and had three sons and a daughter by his 'wife', May or Mariota or Elizabeth Duffus. The blood relationship between the couple seems to have been that of first cousins, because she was the acknowledged illegitimate daughter of Lord Crichton who was, in all probability, not the same person as the one who was Lord High Chancellor of Scotland: Adam's mother being the legal daughter of the Chancellor. Adam's son, George, through the influence of the Cock o the North, George, 4th Earl of Huntly, came into several large estates, one of them being that of Beldorney at Glass, which remained in the family for several hundred years.

The story now moves on 200 years, from the middle of the sixteenth century to the middle of the eighteenth.

In 1731, James Gordon, the 9th Laird of Beldorney, the great grandson many generations removed of Adam Gordon, bought the estate of Kildrummy from James Erskine of Grange and David Erskine of Durn. When he married Mary Gordon, the heiress to the estate of Law and Wardhouse at Kennethmont, they had between them a sizeable estate. They had seven children. John the eldest, succeeded his father in June 1740; their fourth son, Robert Arthur, went to Spain and became a merchant in Cadiz.

John Gordon, the 10th Laird of Beldorney, died in October 1760, aged 36, and was succeeded by his son, Alexander Maria. In 1766, Alexander Maria, through the Duke's influence, got a commission in the 49th Regiment of Foot. On the run from Cork, where the 49th was stationed at the time, following an incident which resulted in the death of a local butcher, Gordon became involved in military espionage. This resulted in his execution as a spy at Brest in October 1769. His brother, Charles Edward, succeeded him to become the last Gordon Laird of Beldorney.

Charles Edward's younger brother, James Arthur, born in 1759, like his namesake great-uncle Arthur before him, was attracted to Spain. He settled at Jerez de la Frontera, on the south-west coast, about ten miles from Cadiz and 60 from Gibraltar. James Arthur bought a vineyard. Founded in 1730, it comprised 60,000 acres and part of it he turned into a farm, built a mansion house, and the remainder he left to grow grapes. Jerez, is of course, famous for its sherry, whose name is a phonetic rendering of the town's name. The Jerez vineyards today cover hundreds of thousands of acres and are a major industry in the south of Spain.

James Arthur seems to have been highly successful in making sherry and received an order to supply the Spanish Royal Family 'to all eternity'. Gordon's fame spread back to Britain when he was visited by Lord Byron in 1809. The famous poet and writer described him as 'a great merchant'.

James married a Spanish lady, Rosa Archimban, daughter of Emmanuel Archimban and Salvadora Campino of Port Royal, and they had one son and nine daughters. He died at Jerez in 1824.

Meanwhile, brother Charles Edward at Beldorney married his first wife Charlotte Boyd. They had three children, the eldest of whom was John David, born in 1774. After Charlotte's death in 1778, Charles Edward married Catherine Mercer in 1781. There were three children from this marriage also. Charles Edward died aged 83 at Gordonhall (Wardhouse) in 1832.

Gordonhall, Wardhouse, was now the family home, and Charles Edward had spent a great deal improving and beautifying it. In 1775 he tried to sell Beldorney, but it did not find a buyer until Thomas Buchan of Auchmacoy, Ellon, purchased it in 1807. He probably used the money from the sale of Beldorney to do the improvements at Wardhouse.

After Charles Edward's marriage to Catherine Mercer, John David and the other two older children went (or perhaps were packed off!) to Spain to join their uncle and cousins at Jerez, and two of them stayed there. John married Maria del Carmen Beigbeder at Jerez in 1805. She died in 1840, he in 1850. They had no children.

The Gordon's of Jerez made such a contribution to the life and economy of their adopted country that they became Counts of Mirasol, but they did not lose their connection with Wardhouse until the 1930s, and not before they had entertained Spanish Royalty there. They entertained King Alphonso XIII and his Queen Ena at Wardhouse during the royal honeymoon in the North-east of

Scotland. If that only raises an 'Oh! really', when you see the labels of the Gonzalez Byass and Domecq Houses on your Sherry bottles, spare a thought that it was the Gordons from Beldorney, Wardhouse and Kildrummy who started it all.

By that roundabout route, the story is linked to Adam Gordon, Dean of Caithness, who lived 300 years before John David Gordon settled in Jerez. It is fitting that the descendent of a priest should have been the one to put a considerable amount of Spanish Sherry money into the building of Huntly's Roman Catholic Church.

The Roman Catholic congregation in Huntly met first in a church in Meadow Street. It was opened about 1760, and is now used as the Freemason's Lodge St

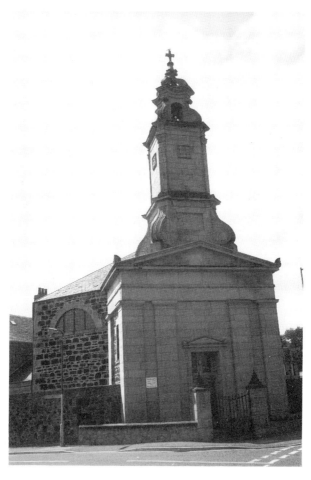

St Margaret's Church, Huntly

87

John. It was actually a swap, because the new church was built on the site of the previous Freemason's Lodge.

The new church was opened on 31 August 1834, and was designed and planned by Bishop Kyle, who preached the sermon at the High Mass which was celebrated at the opening.

The church, dedicated to St Margaret of Scotland, is the first Catholic church in Scotland since the reformation to be built with a bell tower and a bell. Seating 400, the church is octagonal in shape and the vaulted ceiling, façade and tower are much admired. The seven oil paintings in the church were gifts from the Spanish Gordons in 1840.

In 1989, St Margaret's received a £50,000 grant from Historic Buildings and Monuments towards the cost of extensive renovation work, which closed the church for a whole year.

18. 'Cobbie'

In 1775, William Allardice (or Allardes) of Placemill, Forgue, bought the ancient estate of Boynsmill in Forgue. Through the estate runs a burn called Dronac, and it is set in the heart of one of the finest barley growing districts of Scotland. Both these geographical facts are important, because it was here that, 50 years later, William's son, James, along with J.R. Thain of Drumblair (just along the glen), Robert Stuart of Aucharnie and his nephew, William Davidson, a merchant in Aberdeen, began to make whisky.

Mr Allardice used the name of the burn for the title of his distillery – he put 'Glen' in front of it, added an 'h' – and 'Glendronach' was born.

Quite a local character, who collected anecdotes like a fly-paper collects flies – fact, legend and apocryphal – Allardice was known in the district as 'Cobbie', presumably because of his tenancy of the mansion of Cobairdy on the Kinnoir side of Forgue.

The early days of Glendronach had more than their fair share of tragedy – two fires in 1830, and a more serious one in 1837, which just about gutted the distillery buildings. Nor was it really the time to be setting up in the whisky-making business because the oppressive Excise laws of the period made life very difficult and it was never easy to break into a market which was already saturated (so to speak). After the second fire, recovery was so slow that three of the original partners pulled out of Glendronach and Cobbie decided that a bit of aggressive selling was called for if they were to market his product which, he believed, was the equal of any already on the market. So he sent out a salesman, up and down the country, to get orders for it.

❖

For the story about Cobbie and how he sold his early 'Guid Glendronach Whisky', I am indebted to a small book – which must have been published about 100 years ago – lent to me by Mr Morison of Frendraught House some years ago, and entitled *The Kingdom of Forgue.*

"When he returned, the salesman told Cobbie that he had not been able to sell any. 'What for that?' asked Cobbie.

'Because,' replied the salesman, 'everyone is supplied already, and has a connection with other firms.'

'Oh! Well, you'll need to try another district,' said Cobbie, and off went the luckless salesman, returning in a short time with the same disheartening story.

'Why!?' angrily exclaimed Cobbie. 'There is no use for us brewing whisky if it cannot be sold. I'll go myself and sell it!'

So he immediately sent a fair-sized barrel of whisky to Aberdeen with the carrier, and then took a large flagon filled with the spirit alongside him in his gig, and set out for the city.

On the way he called at every public house, inn or whisky shop he came across, but fared no better than the salesman.

He took a bottle of the whisky and a dram glass in his pocket, canvassed every shop and inn in the Granite City, begging them to taste his 'Guid Glendronach whisky.' But the reply was always the same – they had their stock in for the season. They did, however, promise 'to keep him in mind'. This left Cobbie a bit downhearted, but not for long, and he sent the barrel (by sea – the best way to travel in the first half of the nineteenth century) off to Edinburgh, following himself with the flagon, bottle and glass in his gig, not missing a whisky outlet of any kind on his way to the capital.

When he got there, he took a room in one of the best hotels, stowed away his barrel and flagon in the room, and set out with the bottle and glass to canvass the city. After a few days, one or two small shops had placed orders for a gallon or two, but Cobbie knew that this was merely a trickle. He had to sell barrels and puncheons.

At last he found a firm that would take all his stock – at a price which was far too low. Cobbie was not prepared to sell cheaply and the whisky would only improve while it was lying in stock and he decided to wait. The incident, however, disheartened him even more and he thought of packing in and going home to Forgue when, coming up the Canongate, he met two young women who accosted him, asking if he'd buy them a dram.

'A dram?' exclaimed Cobbie. 'Dod, awite I'll gie ye a dram. Come wi me an I'll gie ye a dram o guid Glendronach whisky.' The two women of course wanted him to take them to a pub, but he protested that he had a room of his own in an hotel. 'An whisky o ma ain brewin,' he added. 'So

just ye come awa, for I'm sure ye never tasted better whisky.'

The women went with him but when they saw the hotel they jibbed and said they would not be allowed in. 'Come awa,' said Cobbie, 'I would like to see fa wad haud ye oot. I pay well for my room, and hae the use o't.' The hotel staff demurred, however, asking him if he knew who the women were. 'No,' replied Cobbie, 'I dinna ken onything aboot them, but they are twa bonnie lassies and I'm gaun tae gie em a dram o ma ain brewing.'

The girls agreed that it was good. 'Well tell your friens that ye hae got a dram o the first Glendronach whisky that was ever in Edinburgh.'

'Ye might give us some home wi us to let our friends taste it,' said one of the girls.

Cobbie looked at them for a moment, then rang the bell and asked the waiter for a clean empty bottle. He took it and filled it out of the flask, corked it and gave it to the girls. 'Tak it wi ye,' he said, 'an treat your friens at hame, an tell them it's guid Glendronach whisky. An here's another glass to ye afore ye gang awa.'

The girls drank half, then handed the glass back to Cobbie. 'Tak it wi ye – it's a pity to waste guid Glendronach,' he said.

Two waiters, who had been listening to the conversation from the other side of the door, knew what sort of girls Cobbie's visitors were, and were amused at their Northern guest's ways, but lost no time in telling Mr Allardice what sort of girls he had been entertaining, and that they were not to come back.

The two girls meanwhile, went off home, treated their friends and made fun of the unsophisticated Northern whisky distiller. 'Tak it oot – it's guid Glendronach whisky,' they mocked. The bottle was quickly empty, and their friends pretty far gone, so it was proposed that one of them should go back to the hotel and ask Cobbie for more. But how to get in? Eventually, one of them dressed up as a 'lady', wearing a thick veil over her face, and made her way to the hotel, asking if there was a Mr Allardice, a gentleman from the north, staying there. The waiter was suspicious and asked her business.

'I want to see the gentleman personally,' she told him.

'What name shall I say, madam?'

'Just say a friend,' was the reply. The waiter went and told Cobbie.

'Fa can that be?' wondered Cobbie, 'Bring her in here,' he said to the waiter. The visitor walked in with a 'lady-like' bearing, held out her hand to Cobbie and asked after his welfare, making sure the waiter was out of the earshot before revealing her identity.

'Oh! Mr Allardice,' said the lady, 'I have returned to thank you for the bottle of whisky and ask if you would be kind enough to give us another bottle. Some of our friends are very anxious to taste Glendronach whisky.'

It took only a short time for Cobbie to make up his mind, but at first he was not at all certain that this lady was one of the previous day's visitors. Eventually, he gave her the flagon and all that was left in it as he intended returning home the following day.

The lady took it, fair weight that it was, and soon there was a certain street in Edinburgh which was seething with drunken women going about holding a dram in their hand, saying, 'Tak it oot – it's guid Glendronach whisky.'

The result was that when anyone went into a pub, they asked for Glendronach whisky!

Cobbie did not go home the next day, nor the next, but he did sell all his stock before he left Edinburgh, and for many a year after that, placards could be seen in every pub window in the Royal Mile, and in many of the streets for a long way around it, bearing the words 'GUID GLENDRONACH WHISKY'"

Cobbie was apparently a good friend of the last Duke and Duchess of Gordon, and was, indeed, a regular visitor both at Huntly Lodge, and later at Gordon Castle, Fochabers. One of the stories circulating about Cobbie concerns an evening at the castle when he drank rather deeply of a certain Speyside whisky. In the course of the visit, he complimented the Duchess in a rather exaggerated manner, somewhat to her disgust, she being rather straight-laced. Next morning, Cobbie heard from the Duke that she was displeased with his conduct and is reputed to have replied: 'Well, your Grace, it was just the trash from —' (naming the Speyside distillery in question) 'that you gave me yesterday that did not agree with me. Now if it had been my ain guid Glendronach, I would not have been ony the waur.' It is reported that the Duke ordered a cask of Glendronach on the spot!

During another stay at Gordon Castle, Cobbie, who was an early riser, wanted to go out before his boots had arrived at his bedroom door. Seeing a bell-rope in the passage, he rang it, only to discover that, in a few moments, he had more servants than he needed. It was the fire-bell. When asked where was the fire, he replied, 'I was jist wantin' ma beets!'

On another occasion, Cobbie was invited to a dance given by the Duke. The Duke complimented him on his dancing and asked him who had been his dancing teacher. 'I never had one,' replied Cobbie. 'I just imitate your Grace.'

The *Banffshire Journal* of 10 February 1920 tells the story of one of Cobbie's frequent visits to London. On this occasion he was recounting the visit to a neighbour. 'When in London, I called on His Grace the Duke of Gordon, and left my ticketty (visiting card) with him. And I soon had an invitation from His Grace to dine with him, and sic a fine company, none but Earls and Lords; and sic fine hearty chiels as they waur. When the tae guffaw of lauchin' was dune, the tither began; and as for the chiels ahint oor chairs (the footmen), they just snickered and leuch.'

One day, Cobbie was dining with the Factor of the Bognie Estates at Bognie Brae, after the half-yearly audit, and there was champagne at dinner. The servant being mindful of his master's interests, poured out the champagne so high that it frothed to excess, and the result was but a meagre supply of Cobbie's favourite beverage. The next time the servant brought round the champagne, Cobbie held out his glass and the servant again raised the bottle, Cobbie's glass followed it, but the result was still meagre. Cobbie could not restrain his admiration. 'Eh, Mr Blaikie, what a capital servant you have got; ye surely pay him good wages, for I never saw ane gar a bottle of champagne gang farer!'

Very reduced in circumstances and bankrupt in the financial crisis of 1847, and troubled with worldly affairs, he turned to the Book of Job for comfort! Seeing the problems which surrounded the long-suffering and patient Job, he remarked: 'Ay, Ay, Job, man. Ye had mony troubles in your day, but I doubt ye never had the trouble of a bill protested at the bank!'

A wag to the last, Cobbie died in 1849, but the name of the founder lives on. On every cask coming out of Glendronach is stamped, in large black capitals, the first two letters of the Allardice (Allardes) name – AL.

After the second fire at the distillery in 1837, and three of the original partners had resigned, a Mr Walter Scott, who had considerable experience in the distilling business, was brought in as a partner and effectively managed Glendronach.

General view of Glendronach Distillery

Following Cobbie's death, and various changes of interest, Mr Scott became the sole proprietor of the distillery in 1860. During his time, he embarked on schemes for the enlargement of the premises and expanded the business and became, himself, almost as much of a legend, though in a different way, as the founder. He was renowned throughout the agricultural community as a breeder of Shorthorn cattle and gained over 60 gold and silver medals as well as silver cups and other trophies at shows all over Scotland. In recognition of his work and interest, he was made a director of the Highland and Agricultural Society, and for 30 years was a member of the Board of the Aberdeen and London Steam Shipping Company. A local benefactor, he gave an organ to Forgue Parish Church, one of the first 'kist of whistles' to be installed in a Presbyterian Church in the North. He was also responsible for building a parish hall in the village at a cost of £2000.

The distillery was purchased in 1960 by William Teacher and Sons Ltd and for the next ten years, the bulk of its whisky production was needed for Teacher's famous Highland Cream blend. Sufficient stocks, however, had been set aside to allow for the re-introduction of an eight-year-old Glendronach, and this was made available to the home market and certain export markets in 1968. Now it is available generally.

When The Gordon Schools celebrated their 150th anniversary in 1989, William Teachers labelled a commemorative 12-year-old malt and a 12-year-old matured-in-a-sherry-cask malt for sale at £15 a bottle, which created considerable interest. The writer has been advised by Mr F. Massey, Distillery Manager, at Glendronach, that the company now markets a 15-year-old malt, matured in a sherry cask. This is at present the only Glendronach Malt marketed by Allied Distillers Ltd.

The other distillery in the Strathbogie area is Ardmore at Kennethmont. Not as old as Glendronach, it was founded in 1898, but seemingly not by such a character as 'Cobbie'! It, too, is owned by Allied Distillers Ltd.

19. Pioneer of Eventide Homes

It is difficult to be completely unaware of Craibstone, even today, as you travel the main road from Aberdeen to Inverness. Its entrance is dominated, to some extent, by the roundabout where you turn off for Aberdeen Airport and the Kirkhill Industrial Estate, but it is still difficult to miss the large sign which indicates that this is part of the SAC – the Scottish Agricultural College.

Craibstone mansion house, which still forms the centre of the college complex, was itself probably no less difficult to see from outside its extensive grounds 160 years ago, than it is today, lying, as it does, about 400 metres from

the main road. Then, it was a private house in the country, a mile or so from the centre of Bucksburn village. It was here, at Bucksburn, that a man lived who was to have one of the most important and long-lasting influences on Strathbogie in recent times, for Craibstone was the home of Dr Alexander Scott, one of Huntly's greatest benefactors.

Alexander Scott was the son of a Huntly linen manufacturer. He studied medicine at university and probably was in general practice in his home town before joining the army as a surgeon. During his service he appears to have spent a long time in the Far East.

When he retired from the army he bought the estate of Craibstone, together with adjacent farms, and lived there until his death. He also owned a half-tenement and dwelling house in Huntly, which, in all probability, had belonged to his father.

Scott died on 10 June 1833. Nine years before he died, on 8 June 1824, he had executed a Trust Deed in favour of six trustees who were to be responsible for disposing of his property and carrying out his wishes for his (considerable) estate at a later date. In any event, that was to be after the death of his wife, Catherine Forbes – who died on 21 January 1855 – for she had the life-rent of the mansion house, garden, offices and Mains farm of Craibstone.

The surviving Trustees of Alexander Scott's estate lost no time in 'denuding' themselves of the residue and remainder of the estate in the terms of his Trust Disposition and Deed of Settlement and conveying the estate to another group of Trustees and Managers whom Dr Scott had named in his original Deed.

The whole of this intricate legal exercise was 'for the purpose of erecting, establishing and endowing, an Hospital or Receptacle (hereinafter called "the Hospital") for the maintenance, aliment, clothing and lodging of old men and old women in the said town of Huntly... and which Hospital or Receptacle was to be known, styled, and called by the title of 'Alexander Scott's Hospital'.

It was a revolutionary concept. Previously, the only place where indigent old people could find refuge was in the workhouse, and it is a pity that, in course of time, Dr Scott's noble concept was inevitably ever-so-slightly tarnished by local people (and even the early Trustees, in their 'Rules and Regulations') referring to it as 'th' Institution'. Many still do, even though eventide homes have been an ever-growing part of every local scene at least since the Second World War.

Dr Scott left no loose ends to dangle. The Trustees who would carry out his wishes and administer his considerable estate to give the elderly, poor people of Huntly an eventide home were: The Scottish Episcopal Bishop of Moray, the Moderator of the Presbytery of Strathbogie, the Sheriff Depute of Aberdeenshire, the Established Minister in the Parish of Huntly, and the Scottish Episcopal Minister at Huntly. They and their successors in office, were to be Trustees perpetually 'for the management and direction of the hospital', and Alexander Scott even made provision for every eventuality.

For example, if it should happen that the Episcopal Minister at Huntly should

also be Bishop of Moray at the same time, then it was laid down that the Episcopal Bishop of the Diocese of Aberdeen 'should and might be a Trustee and Manager of the hospital during the time that the Bishop of the Diocese of Moray was Episcopal Minister at Huntly'. He also provided that 'the Moderator of the Presbytery of Turriff should and might be a Trustee and Manager during the time that the Minister at Huntly happened to be Moderator of the Presbytery of Strathbogie'.

To these Trustees and Managers of the hospital, Dr Scott left his 'town and lands of Craibstone in the Parish of Newhills and Sheriffdom of Aberdeen', as well as the whole of the mosslands and lands of Fairniewreaths contiguous with the lands of Craibstone, and three pieces of ground lying within the Burgh of Huntly, together with all the hospital buildings erected on them. Just to make sure that the administration of the trust should be finally and irrevocably secure, he laid down that the Trustees should be incorporated by Act of Parliament, as should also any additional Trustees and Managers who might in future be appointed. Following the passing of the Police and Improvement (Scotland) Act, 1862, which brought the office of the Chief Magistrate to the Burgh, Alexander Stewart was the first to be elected to the office (see Chapter 20). He quickly succeeded in getting the Alexander Scott's Hospital Act, 1868, amended to include the Chief Magistrate *ex-officio* as a Trustee. He was later to become Provost (see Chapter 26).

The Alexander Scott's Hospital Act was passed in the Parliamentary Session of 1868, 1 & 32 Victoria. The Trustees and Managers had little discretion in the Act of Incorporation as to who should be admitted to the hospital. That, too, Dr Scott tied up very tightly, and restricted it to people who were:

Poor persons of good character;

Not under 50 years of age;

Widowers, bachelors, widows or old maids;

Born in Huntly and/or children of feuars of the Town, or have been born in Huntly and lived there for the ten years continuously before the date of the application for admission;

Free from disease at the time of admission;

Having no children surviving, or only adult children surviving who are not able to maintain them, the latter being removable from the Hospital, at the discretion of the Trustees, if and when any children subsequently become able to maintain them.

In 1949, a further Act of Parliament raised by the Trustees at the time extended the qualifications and are those under which the Trustees operate at the present time.

Principally, these special qualifications include grandchildren of feuars born in the Burgh of Huntly; children or grandchildren of feuars, born elsewhere; persons born in the Burgh and having resided for the five years previous to

application for admission; persons having carried on business in the Burgh for ten years and resided five before application.

A new qualification was one which Dr Scott could not have envisaged and was consequent on the gift of a new wing for the hospital by Alexander Morison of Bognie and Larghan. Mr Morison commissioned Mr A. Marshall Mackenzie, designer of the frontage of Marischal College, to design a new wing, which he never saw as the building did not begin until after his death. The wing and the impressive frontage which made the hospital into the building it is today was handed over to the Trustees in October 1900, together with an endowment of £60,000.

Following Alexander Morison's bequest, the qualifications for admission to the hospital were extended to include a fifth class – those who are or have been agricultural tenants (including, in the case of a widow, one whose husband was a

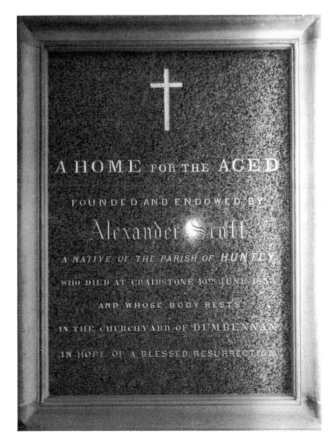

Memorial tablet dedicated to Alexander Scott,
situated at the main entrance of Alexander Scott's Hospital

tenant) on the Estate of Bognie, and who have held their land on a lease for not less than ten years, direct from the proprietor of the Estate. Children of such tenants also qualify for admission. Bognie Estate is defined as the entailed lands and estate as it existed when Mr Morison had it at the end of December, 1879.

Others who now qualify for admission are those who have resided in the Burgh and Parish of Huntly for 15 years immediately prior to their application, and others who were born in Gartly, Drumblade, Forgue, Cairnie, Glass, Rhynie, Kennethmont and Clatt, and who have resided there for 15 years consecutively before their application for admission. Thus the spirit in which Alexander Scott made his original bequest is still the motivating force when the Trustees are considering applications for admission.

There is one notable departure from Dr Scott's original intention, which is not really a departure; rather a response on the part of the Trustees to social conditions which he could not have envisaged. Over the last quarter of the twentieth century, social and financial circumstances of elderly people in the area, as elsewhere, have changed considerably. At the same time, the cost of 'maintenance, aliment, clothing and lodging' of even one elderly person increased to such an extent that it far exceeded the state pension, less the agreed personal allowance given to each person. For many years, the pension (if that was all the income the resident had) was supplemented to an agreed figure by the Social Work Department of Grampian Regional Council. If the resident had income of such an amount that the shortfall (over and above the amount of the state pension) could be made up from that, the Social Work Department would make no payment. Thus, inevitably, a situation has been reached where some of the residents still pay only their state pension, others pay all or part of the additional amount required to reach the current cost per week – an amount reviewed annually by the Trustees.

Each resident has his or her own room in the hospital, which they often furnish with treasured items from the old home. Most have their own radio/television, as well as heating additional to the 70°F maintained by the hospital's central heating.

The hospital opened for the first residents on 1 August 1855, but it was only ten years old when it was burned to the ground. Nowadays, if the smoke alarm sounds, Huntly's firemen are on the spot within minutes. The story is told that one resident had them there on one occasion even before he had finished getting his pipe going properly! In the middle of the nineteenth century, Huntly had no such efficient fire brigade but, thanks to the speed of the local people, there was no loss of life and most of the furnishings were saved. Buckets of water were passed along a chain from the River Bogie, and it was largely due to them that only the building needed replacing. Which it was, and reopened the following year.

One of the most interesting documents to read, 150 years after the opening of the hospital, is the book of 'Rules and Regulations for the Management and

Direction of Alexander Scott's Hospital'. The document bears the stamp of Lumsden & Davidson, Advocates, 15 Dee Street, Aberdeen; Mr Henry Lumsden being Clerk to the Trustees immediately before Mr William Murdoch, whose name headed the Huntly law firm of Murdoch, McMath & Mitchell. Mr John A. Christie, the present senior partner, and his firm are still Clerks to the Trustees. Examples of these old Rules include:

9. The female inmates shall, so far as able to do so, make up their beds, and assist in cleaning the Hospital, and generally in all such work as the Medical Officer of the Institution shall consider them capable of performing.

10. The fire-places shall be cleaned out, and fires put on in the public rooms by half-past 7 o'clock a.m., and the rooms and passages shall be swept every day and washed every week...

11. The male inmates may, if in the opinion of the Medical Officer they are able for such work, be employed in keeping the grounds and walks clean, and in order; in assisting in cultivating and labouring the part of the ground set apart for the growth of vegetables, and in assisting in carrying the linens to and from the laundry, and in using the mangle.

13. All the inmates shall take their meals at one table, and none shall be excused...

17. All the inmates shall be in the Hospital grounds by 8 p.m....

18. The outer gates and doors of the Hospital Buildings shall be locked by the House Steward at 10 p.m.

19. The whole inmates will be required to attend Divine Service... every Sunday.

20. They shall also be expected to attend every morning at half-past 8 o'clock for family worship, when the House Steward will read a prayer and portion of Scripture.

22. If any of the inmates be found guilty of improper conduct, such as drunkenness, profane swearing, frequent absence from public worship, quarrelling, fighting, Sabbath breaking, or the like, or of disobedience of the directions of the Clerk and treasurer, or House Steward, or neglect of the work appointed them, or any of the duties entrusted to their charge, such inmate or inmates may, at a meeting of the Trustees and Managers thereafter, be either reproved or removed from the Hospital, as in the circumstances may seem meet.

23. The inmates shall be supplied with good, substantial warm clothing...

26. The Medical Officer, when there is no sickness, shall visit the inmates at least once a week...

The 'House Steward' was replaced many years ago by the 'Matron', a fully-qualified and registered nurse, and all the care staff are referred to as 'nurse' whether they are or not. The Medical Officer no longer calls once a week, unless someone is in the sick ward, for most are looked after by their own GP. 'Inmates' are now called residents, nor are they required to carry out any domestic, horticultural or labouring duties, the hospital having a fully-competent

and qualified staff for work in the kitchen, living quarters and garden.

Residents now attend Divine Service on a Sunday only if they wish, and if they are able, physically, to do so; nor does the Matron lead morning and evening 'family' prayers and read a portion of Scripture. Ministers of all denominations are regular visitors and minister to members of their own 'flock' as need arises.

The hospital continues to meet the changing needs of local people and has the resources to go on doing this, hopefully for many years. It was a remarkable piece of foresight on Dr Scott's part to make sure that, although the future would mean changes in his hospital, the Trustees would have recourse to Act of Parliament before they could effect anything of major importance. Lesser benefactors would simply have left them the money and let them get on with it – this way showed the measure of his greatness.

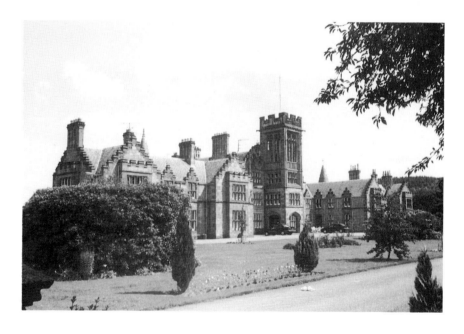

A general view of Scott's Hospital from the entrance in Gladstone Road

20. *The Man who gave a Town House to Huntly*

For several years at the beginning of the second half of the nineteenth century, it had been known that the chief citizen of Huntly was going to leave a sum of money for the building of a Town House for the burgh. Perhaps no one could have foreseen that the bequest would have been so munificent for, when his will was read, Alexander Stewart, Jnr., Chief Magistrate of Huntly, had left his entire estate – something in excess of £10,000, less one single bequest of £200 – to five trustees. Had his two sisters not predeceased him, the sum would have been rather less.

The will directed that the trustees were to realise his entire property and to erect, when and where they may think proper, a Town House for Huntly. With the residue, if any, they were to 'improve and beautify' the town of Huntly in such a way as may to them seem proper.

Mr Stewart placed certain restrictions on the use of the proposed 'Stewart's Hall', as it came to be called even before it was opened. It was supposed that it would certainly be used for lectures and addresses – so beloved of the Victorians – but anti-Popery lectures were prohibited, as were addresses calculated to promote religious strife. There was also a ban on 'peripatetic lecturers' – equally beloved of the Victorians – 'who pretend to be wiser and more learned than ordinary people'! There would seem to be some ambiguity about that prohibition, although there is no doubt that it would be understood and interpreted correctly by the Trustees who, to a man, knew the mind of the late Alexander Stewart very well indeed.

They called him 'The Lairdie' in Huntly, for the simple reason that, for many years, he was at the 'the head and front of things' in the town. If there was to be a celebration, Stewart was immediately thought of. If there was a public meeting to be called, who would call it but Stewart? If Huntly was to move in a public way, there needed to be consultation at Stewart's office, which was situated not far from where Stewart's Hall now stands. There, throned on his high chair, he would express his own opinions, and usually the wise men who came to 'consult' with him 'gathered greater wisdom at the feet of our local Gamaliel' and made up their minds to 'say as Mr Stewart said'. This, of course, was a compliment to Stewart, and the journalist who wrote the report at the opening of Stewart's Hall in the *Huntly Express* in December 1875, said that even the boys of the town looked on Stewart as the embodiment of everything that was great. 'They would not even light a bonfire on the Market Muir, or fire crackers in the Square, without first securing the consent of the Lairdie', he wrote. Despite what were described in his somewhat 'acrid answers' to the young folk, he had a great deal of sympathy with them and they were never afraid to put up a deputation 'to

go and see the lairdie', as they put it. Yet Stewart represented the end of an era and, before he died, he saw the erosion of some of his autocratic power. For a long time – he was born in 1795 – he had ruled as a sort of benevolent despot and had a hand not only in, but on, everything that went on in the town. It came as a great surprise – a shock, even – when a newspaper was started in the town in 1863. Apparently he viewed the start of the *Huntly Express* in much the same way as he would have viewed the office boy putting a firecracker under his chair, because he must have seen in it the first stirring of independent opinion which occurred outside his, Stewart's, office and therefore would not be allowed! So he carried on a small war with the editor, Adam Dunbar, for several years – in its columns, of course. Local dignitaries often suffer at the hands of the press and Stewart was no exception. It was to be a long time before he could accept the new experience of an opinion being expressed by Dunbar one week, contrary to his own expressed the previous week. Gradually and eventually, he did come to accept, in part at least, that he was living in a new and more democratic age, and that other people might possibly have an opinion which he did not share. It was then that he began to use the local newspaper and its editor as an ally and not an enemy.

The adoption of the Police and Improvement (Scotland) Act, 1862, brought a new order to Huntly, and Alexander Stewart was elected as Chief Magistrate – a token of the esteem and regard in which he was held, and the highest honour which his fellow townsmen could confer on him. It was notably more important in his case, since he was a Roman Catholic and believed to be the first one in Scotland to hold such an office. As the writer of his obituary in the *Huntly Express* said, 'he was never understood to be one of the strictest of his sect, and his desire was to live at peace with all men. He was very careful with his money but was always ready with his neighbours to give a subscription for any public purpose. And as an instance of his kindly feelings towards other religious communities, he gave a subscription of £10 towards the building of Huntly Free Church'.

One of Alexander Stewart's chief concerns in the town was Alexander Scott's Hospital. It was he who got the Act of Parliament incorporating the Trust altered to include the Chief Magistrate of Huntly for the time as one of the Trustees. Doubtless, with his foresight, Stewart saw that the predominance of the clerical members on the Board (see previous chapter) could cause problems. The Chief Magistrate remained a Trustee *ex-officio* until the reorganisation of local government in 1975 ended the office and his place was taken on the Board of 'Scott's' by an elected member of Gordon District Council, appointed by the council. Stewart devoted a great deal of his time and energy to the well-being and extension of 'Scott's', then, of course, only half the size it is today, the second wing not being built until the turn of the century.

Alexander Stewart died on 4 November 1871 and Stewart's Hall was opened in December 1875 with – one might have guessed, knowing the Victorian proclivity for them – a lecture! This was given by Sheriff Comrie Thomson on

the subject of 'Life Assurance'. Not, one may say, without a few caustic letters in the local press, describing having the lecture as 'a joke' and 'a disappointment'. Does one detect the stirrings of a little disenchantment even with such a well-established Victorian custom as 'the lecture'?

Unfortunately, Stewart's Hall burnt down only 11 years after its opening, but was rebuilt in 1887 in the form in which we see it today.

When local government was reorganised in 1975, Huntly Burgh Council ceased to be the 'local authority'. Its successor was Gordon District Council and Huntly was represented by one council member and one member of the new Grampian Regional Council, which replaced the former County Councils of Aberdeen, Banff, Kincardine and Moray. The ownership of Stewart's Hall passed, along with all the other property in the name of Huntly Burgh Council,

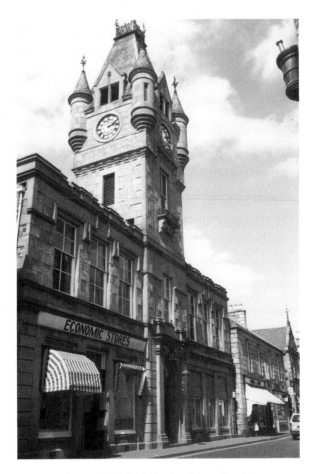

Stewart's Hall in Gordon Street, Huntly

to Gordon District Council. They, in their turn, were good custodians, and in 1987, to mark the centenary of the rebuilding after the fire, did a complete refurbishment, putting in a new kitchen and new toilets, as well as redecorating throughout.

Although it has always been known through the years as 'Stewart's Hall', it is, as Stewart intended, a Town House for Huntly, and formerly it housed the Burgh Council meetings, presided over by the chief magistrate or provost. Since 1989, other elected and representative bodies for the town and district, the community councils for both Huntly and Strathbogie, sit in the former council chamber, with no teeth but a voracious appetite for discussing anything and everything pertaining to the affairs of both town and rural area.

The police court, however, is no longer held in the adjacent room. Nothing more offensive than the strains of the chanter is heard there as the young members of the Pipe Band practice their fingering. Petty offenders have to travel to the District Court held at Inverurie, presently the principal town of Gordon and administrative headquarters for the district. More serious offenders are dealt with in the Sheriff Court in Aberdeen.

21. A Man from Portsmouth

Just over halfway through the nineteenth century, Adam Dunbar, a native of Portsmouth, with little money and equally little experience of journalism, launched a local newspaper. He called it *Huntly Express*. The people of Huntly were able to buy its four pages of tabloid (A3) size, for just one penny, for the first time on 15 August 1863. What began as a monthly paper soon began to appear every week and now more than 6,000 issues have been published. It has enjoyed unbroken publication for more that 130 years, which is possibly a record for any local newspaper.

Adam Dunbar was born in 1814. His parents apparently only had a very slight connection with the North-east of Scotland before they moved to Portsmouth, but, after Adam was born, they came back and settled in Elgin. It was there that the young Dunbar grew up, but it was under the shadow of a tragedy which altered his life to some extent, because his father lost his life in a blizzard, along with two other men. Naturally, the boy's education had to be cut short because he had to go out and support the family as soon as possible. After a very short time at a dame school, Adam began working as an apprentice weaver, at the tender age of nine. Later, as a young man, he worked for a time, presumably at his trade, at the Haugh of Glass. This no doubt familiarised him with the countryside in Strathbogie, which he came to know and love so well, but it was also the start of the major work of his life because, while he was there,

103

he wrote his first article for a newspaper. Although he often recalled the incident in later life, he never said which newspaper published it. Soon after this, his work took him to Galashiels when the textile industry – not for the last time – went into decline in the North-east, and there he stayed for the next 25 years, marrying and settling down in the town.

Like many others, the call of the North-east brought him back when the opportunity came. In 1861, he came to Huntly and bought a bookseller's shop at 5 The Square, although it was his son Robert who ran the business for a year until the family were able to move from Galashiels. It is believed that part of the same premises were at that time occupied by a Miss Ann Cruickshank. Known in Huntly as 'Aunty Ann', she was a time-served printer and, as far as is known, is believed to be the only woman printer in Scotland in those days. She learned the business from her brother and, when he died, carried it on until she sold it to Adam Dunbar in 1862. Miss Cruickshank died in 1867.

1863 was a good time to start a newspaper, the duty on paper having been lifted and the compulsory Stamp abolished, and Dunbar simply rode the tide of the time. There was a need, however. The *Aberdeen Journal* and *Aberdeen Herald*, both Conservative newspapers, and the *Aberdeen Free Press*, a Liberal, were well established. So was the *Banffshire Journal* – also supporting the Tories – and the *People's Journal*, supporting the Liberals. What was needed was a newspaper which contained local news, as opposed to national, and which was more independent in character.

Dunbar supplied these needs. He set out the aims of the paper in the very first issue:

> "There are many towns and districts in Scotland of seemingly no greater importance and extent than this, which have long enjoyed the advantages that a properly conducted weekly journal confers; and to all appearance those weekly papers have become something more than remunerative to the publishers.
>
> If a career of prosperity and usefulness is before us our position will not be attained by crawling in the earth or singing chorus at the bidding of the great. We shall not keep silent when the truth is in abeyance or unprofitable. We shall maintain the rightful privileges of the poor. At the risk of loss, we shall stand by our working population, should they ever have to oppose the iniquitous aggressions of their employers and those great in power. But we will not pander to the prejudices of the moment. Regardless of popular offence, we shall maintain the just prerogatives of the rich. Preferring rectitude to gain, and trusting more to common sense than metaphysics, we will never try to make right and wrong co-mingle, nor with type and darkness create a hazy twilight that might either please or puzzle.
>
> In the columns of the *Express*, prominent attention will be given to all matter of local interest, and every possible exertion will be made by the

employment of staff of able and trustworthy correspondents and otherwise – to obtain early and correct notices of everything of importance occurring in the district. It will be our pleasant duty to lend a helping hand to every movement having for its object the moral and social well-being of the community..."

It was a brave brief which Adam Dunbar proposed for himself but he carried it out, and so have his successors in the proprietor's chair, to the best of their ability.

In 1882, Dunbar bought 18 and 20 Duke Street, and moved the print shop to these premises which they occupied until 1984 when they moved to a site on the Industrial Estate, leaving only the retail shop and small printing work at Duke Street. Six years after moving to Duke Street, Dunbar retired and left his youngest son, Joseph, to continue the business.

Brought up and educated in Huntly, Joe Dunbar was a 'local' man, a gifted journalist, speaker and musician. It was his social gifts, however, which were more prominent, unlike his father, and he had a wide circle of friends from every social group. Unlike his father, too, he was no crusader and the newspaper lost much of the fire which had marked it out in Adam's day.

Adam died in 1892, and Joe continued his work until he, too, retired in 1918. It was his nephew, and a grandson of the founder, Charles Hunter, who had come up through the business as a time-served printer, who then became the owner. Not only did Charles inherit the business, he also inherited his grandfather's way with words, and he knew the local folk, having lived and worked with them all his life.

Joe Dunbar died in 1937, just before the outbreak of the Second World War, and although Charles Hunter was not in his first youth, he carried on with reduced staff, reduced supplies, and all the other deprivations which the War brought, until he could put the business on the market when peace came again. He finally sold it in 1947, when he was 82, although he lived another ten years in retirement, dying in December 1957.

On Hogmanay 1946, the Dunbar family ceased to own the *Huntly Express*, having done so for 83 years, and on New Year's Day 1947, it passed into the ownership of the second of only four families to have owned it. George Dunsmore was a journalist from Glasgow who had just completed war service in the RAF. It was George Dunsmore's wife's niece, Margaret, and her husband Ian Carnegie, a consultant chemical engineer then living in Merseyside, who succeeded George when he retired in 1971.

With Ian Carnegie, who was also a native of Glasgow, though not a journalist, there began a new practice of having an editor who was not also the proprietor. This continued under the next owners, a family concern, headed by Peter Grossi, who also ran a chain of retail shops from Elgin to Arbroath under the name of Recent Events. It is still a family concern. The fourth family to own it are the Johnstons of Buckie who for many years published another title, the

Banffshire Advertiser.

In 1973, Ian Carnegie also bought the *Banffshire Herald* from John Mitchell & Sons. This newspaper had been serving Keith and district since 1892 and became part of Mid Grampian Journals Ltd., the company which Ian and Margaret Carnegie founded. Jack and Michael Johnston formed a new company, J&M Publishing, to continue the publication of the *Huntly Express.*

George Dunsmore summed up the spirit of local newspapers, writing in the Centenary edition of the *Huntly Express* on 16 August 1963:

> **"**You will find no sensationalism in its pages. While the outside world is enthralled about landing a man on the moon, the *Huntly Express* is more concerned about who is on the local town council's housing list. When the big daily newspapers hurl at you sordid details of scandal in high places, the *Huntly Express* is quietly printing the item from the Women's Rural Institute or the Church Woman's Guild. Tragedy, too, in its pages is a personal affair to be recorded with a degree of reluctance.
>
> For the *Huntly Express* is a family affair, containing news as personal and engrossing as a personal letter. It will turn no deaf ear in certain genuine cases of appeal for assistance through its columns. Time and again it has helped to build up a struggling local and district organisation following upon a diplomatic approach. For its very essence is personal. Why, perhaps, is it often nicknamed *The Two Minutes' Silence, The Squeak,* or the *Huntly.* But no local newspaper need be a wishy-washy spineless sheet of sweetness. The spurious, the sly, the flatterers – they get short shrift here. Only the genuine are catered for. Or, as someone else said, 'Journalism is the first draft of history'.**"**

22. *The Lady with the Starched Cap and Voluminous Gown*

No one called her anything but 'Miss Barclay'. No one would have dared call her anything but 'Miss Barclay'.

It was on 23 September 1888, that Miss Barclay was appointed to be the first Matron of Huntly's month-old and newly-opened Jubilee Hospital, at a salary of £35 a year (it was raised to £40 in 1896), a post that she held for the next 20 years. Miss Barclay, in the words of Dr Patrick McBoyle, to whom Huntly is indebted for a great deal of the 'Jubilee's' history, 'donned her well starched cap and voluminous gown the appointed day, and the hospital opened its doors...' She was required to enter upon her duties not later than 1 November 1888 and to be responsible for the care of the 'sick and suffering' of Huntly, Drumblade,

Gartly, Glass and Cairnie, but not of Forgue, who had their own cottage hospital, although it was not long before they came in as well when they saw the benefits of a well-run modern hospital. 'Paid-for-paupers' – those who were supported by the local parochial boards – were also to be cared for at the Jubilee. Eighteen months before that, Mr Wilson of Castle Park had had a preliminary sortie to Keith to have a look at the Turner Memorial Hospital and how it was run, and at the end of January 1887, he called a meeting in Huntly. Eighteen of the local citizens of Huntly and Strathbogie met in the Brander Library and, says Dr McBoyle, 'in an atmosphere of strong tobacco, steam from strong wet broadcloth, strong smoke from paraffin heater and lamps, and the strong glow of sensible far-seeing faces, the project was born and waxed strong'.

Mr Wilson told the meeting that he thought it would be possible, in view of the great fall in the price of labour, to build the hospital in Huntly for something like £1000 – much less than the cost of the Turner Memorial in Keith. The local worthies discussed the idea, liked it, and went on to discuss how they could raise the money. They agreed that one of the best ways was for the local ministers to ask from the pulpit for public subscriptions. By May 1887, they were ready to go ahead and contracts had been agreed for the sum of £1257.10s. The work was completed and all was ready in August the following year, so they arranged a two-day bazaar and invited the Duke of Richmond and Gordon to come and open the Huntly Jubilee Cottage Hospital. His Grace made a donation of £20 per annum towards the upkeep of the hospital and many other people subscribed to its maintenance.

Because of the large numbers of people who subscribed, a vast governing body came into existence. Fortunately, it was pruned down to a management committee of only 16, four of whom were to run the hospital as a house committee. In addition, there was also a medical committee composed of four general practitioners from the town – Dr Wilson, Dr J.O. Wilson, Dr Garson and Dr Thomson – one of whom was to act as medical superintendent. This practice still continues today and the hospital is still run by the local GPs. In 1926, Dr Peter Philip joined the staff and introduced the practice of the GPs doing surgery, a practice which continued until it was decided that those carrying out surgery had to be fully qualified Fellows of the Royal College of Surgeons. Mr Crum was the Jubilee's first official surgeon to occupy this new post in 1959.

Miss Barclay's first assistant at the Jubilee is described in the hospital records as 'the girl Jessiman'. She received the amazing sum of £6 a year which – although worth a great deal more than £6 is today – was, nevertheless, a starvation wage. A good thing that COHSE was not in existence in 1888! 'The Jessiman girl' did not have long to enjoy her fortune, however – she died in 1890. This seems to have been the sad consequence for most of the assistants who never seemed to last very long, going down like ninepins after falling sick of the latest scourge to hit the hospital, of which there were many!

Of the eight deaths which were recorded in the medical superintendent's first report, covering the ten months to October 1890, two were from TB and one was

due to a haemorrhage from typhoid fever, and over the early years it was a similar story. Deaths from typhoid fever, diphtheria, phthisis – a wasting disease, i.e. tuberculosis – and abscesses caused by scarlet fever[1] were the main causes of death at the Jubilee. Scarlet fever was the main scourge for many years and Dr McBoyle remarks that the uproar which was caused in the hospital during the process of disinfestation after each fresh outbreak must have been prodigious! 'The *scarlatina* bug was attacked with fanatical fury and driven forth from the portals at regular intervals,' he says. 'One can picture matron on her hands and knees shouting triumphantly, "Take that – and that!" as she fired her spray gun at the bed springs with the same venom in her soul as had Lord Emsworth [Blandings novels, P.G. Wodehouse] when he attacked the thrips on his roses.'

It was the 1897 outbreak of scarlet fever which prompted the management committee to think of extending the hospital, but even when the First World War broke out in 1914, this still had not materialised.

Miss Barclay, who had borne the burden and heat of the day – and survived many onslaughts of virulent bugs, as well as jaundice – contracted blood poisoning from a septic finger and died, having given 20 years devoted service to the Jubilee. Dr McBoyle wonders just how many hours a week she worked!

Miss Barclay was just one of many. Miss Bayne, Miss Gordon and Miss Gilchrist followed in quick succession until the arrival of Miss Spittal in 1920. 'She "handled" the Board with amazing dexterity,' says Dr McBoyle, 'and by various threats and manoeuvres eventually succeeding in raising her original salary from £70 to £170 per annum by 1941.'

It was during her time (in 1924) that the operating theatre was rebuilt and 57 major operations were performed in 1926 by surgeons from Aberdeen. Dr Falconer said that he remembered administering anaesthetics in the new theatre with a coal fire burning cheerily at his back! Out of the 219 cases treated at the Jubilee in 1927, 153 were surgical cases – 56 major ones (unspecified) and 25 appendectomies. 1927 was also the year when the new isolation block was opened with local authority/public health authority backing. The block was separate from the main building, as you would expect it to be. From 1945, it served as the maternity unit, with Sister Alexander as the first 'Hatcher-in-Chief', but has now ceased to be so. The sunparlour or day room of the general block was built in 1928, the hospital's Jubilee year, for the sum of £450. A day room for the Emergency – the old scarlet fever block – was built in 1965. Although it was of a similar size to the main block day room, it now cost £4500.

The Second World War saw the Jubilee again on an emergency footing and, in fact, the old scarlet fever block became the emergency block (later it housed Wards 5 & 6 for the chronic sick – old and not so old). Miss Spittal retired during the War and, like Miss Barclay, her long and devoted service warranted a plaque in the entrance hall. She was succeeded by Miss Dunnett, at a time when

[1] According to articles in the *British Medical Journal and Practitioners* of 1889, scarlet fever could produce abscesses anywhere.

the work was expanding at a tremendous rate, and it was then that the Management Committee decided to drop the 'Cottage' from its title and style it simply, 'Huntly Jubilee Hospital'.

In 1948, the Management Committee ceased to be and the hospital was handed over to the National Health Service which came into being that year. It was, however, a very successful year – there were 539 in-patients, and out-patient attendances numbered 1307, and there was a gradual increase in work for the hospital.

As an epitaph to the first – but no means the last – phase of the Jubilee's life, it is worthwhile recording the statement read on the occasion of handing over by Ex-Provost Christie, dated 26 October 1948:

"The passing of these accounts for the period 1st January 1848 to 4th July 1948, finishes the business of Huntly Jubilee Hospital Management Committee.

Our hospital was built and equipped to commemorate the Golden Jubilee of Her Most Gracious Majesty, Queen Victoria, by the men and women of the Burgh of Huntly, and the Parishes of Huntly, Gartly, Cairnie, Glass and Drumblade. For over 60 years the Hospital has been administered by a representative Committee from the Burgh of Huntly and these surrounding parishes along with two trustees from the Scott's Hospital Trust. The Scott's Trustees were appointed in virtue of the generosity of the Scott Trust to the Hospital.

On 5th July this year the Government took over our Hospital, well-equipped in every way: in fact, I think it was as well equipped as any hospital of its size in the county. In addition to this, they took over all our Assets – a total sum in Invested Funds of £27,204. and if you add to this the value of our Hospital Buildings and equipment at a conservative estimate of £20,000. we, the Management Committee, handed over to the Government from the people of Huntly and the surrounding parishes no less than £47,204.

We are led to believe that the £27,204. of Investment Funds will be earmarked for the benefit of Huntly Hospital.

As Chairman of the Hospital Committee for 21 years, I think it is my duty to thank the members of the committee, both past and present, for the good service they rendered to the Hospital, and for their assistance to me at all times. Some of our members have given, not only devoted service, but have served on the Committee many years. Canon Smith has been a member of the Committee for 42 years: I have been a Member for 27 years, and Mr James Innes has been a Member for 19 years.

Our Hospital Committee has been most fortunate in having had most admirable service from our Secretary and Treasurer. This most important office was filled by the late Mr John Dickson and then by his son, Mr George Dickson. The late Mr John Dickson was appointed Secretary and

Huntly Jubilee Hospital from the forecourt of the long-stay unit, 'Rothieden'

Treasurer on the 14th August 1901, and retired in October 1935, when Mr George Dickson was unanimously appointed to succeed him. All that these two, father and son, have done for the Hospital is difficult for me to define or assess, but what a record! 47 years between father and son! It was my proud privilege to serve on the Committee with both, and their long and devoted service has been of enormous benefit to the Hospital. The people of Huntly and the surrounding Parishes owe a deep debt of gratitude to the late Mr John Dickson, and to Mr George Dickson, for all they have done for the Hospital. We are glad to think that Mr George Dickson is carrying on, and the new Committee is very fortunate in securing his services.

And so, Gentlemen, with regret we finish our work for the Hospital. We will always take an interest in it and we look forward with hope and the full knowledge that it will continue to prosper under the new regime."

It did. Maternity work occupied a large part of the time and 217 babies were born in the post-war boom of 1948.

In 1965, the new health centre was added to the hospital, together with a new waiting area, office accommodation, out-patient department with two treatment rooms and casualty theatre, an X-ray therapy department with up-to-date

equipment, a gymnasium and nurse training schoolroom. In addition to this, the other facilities have gradually been modernised.

Since Miss Spittal's retirement during the Second World War, matrons have come and gone – Miss Gordon, Miss Webster, Miss Gow, Miss Johnston and Mrs Kennedy – until Miss Low brought up the rear (so to speak) because the matron became known for the first time as the Chief Nursing Officer, and Mrs Thomson (hopefully) is still there, at least as the proofs of this book are read! With the title have gone the starched cap and voluminous gown!

Eventually, the West Aberdeenshire Board, which administered the local Health Service, gave way to the Banffshire Board of management in 1964. Now Grampian Health Board is a great administrative machine and the board members are appointees of – or at least approved by – the Government. Many of the larger hospital units have already opted for trust status in the National Health Service. This seems not to belong to the spirit of the Health Service to which the local management committee entrusted the Jubilee Hospital in 1948. Then it was assumed that, no matter what it cost, the Government would 'fund' the NHS; something the Government in 1991, and for the decade previously, seemed reluctant to do.

All this has meant severe stringency measures. This has not prevented them going ahead with a much-needed project at the Jubilee – a 30-bed long-stay unit which has been given the name of 'Rothieden', the name used for Huntly in George MacDonald's novels.

The Scottish Office has now allowed Huntly Jubilee to become part of Grampian Healthcare (NHS) Trust. It remains to be seen what changes lie in the future.

Huntly and District Nursing Association

The 90-year-old Huntly and District Nursing Association, which few people know about – although it has helped virtually thousands of people – has now ceased to exist.

It was at 'Huntly, on Monday the 23rd day of December, 1901', that the announcement was made, in those terms, of the birth of the Huntly and District Nursing Association. There was no National Health Service and certainly no nurse 'on the district', in 1901, although the Cottage Hospital had been built some ten years previously. This association was begun specifically, however, to provide money to support a district nurse for the town and district. Its first ventures were largely financial. A group of ladies, under the chairmanship of Mrs Wilson of Castle Park, had already been meeting and the inaugural meeting of the new Association regularised them as 'promoters of the Scheme', suggesting that they meet and form a committee of '30 or thereby, consisting of both ladies and gentlemen, whose duty it would be to start this scheme in a business way'.

So it began, and by the end of January 1902 they were ready to invite the

secretary of the Scottish branch of Queen Victoria's Jubilee Institute for Nurses, a Miss Guthrie Wright, to meet with them and discuss their plans. At the same time, they were busy raising money through a collection in the town to help finance the project.

Following Miss Guthrie's visit, the association elected their first president, Lady Caroline Gordon Lennox, with Mrs Bisset of Lessendrum as vice-president, and Mr Sellar as chairman. On 19 May 1902, the first district nurse, Nurse Farquhar, started work on a salary of £12 a year. By the annual meeting she was able to tell members that she had already paid 3610 visits and Mr J.R. McMath, who was the treasurer, told them that the cost, much as expected, had been just £70.

At the end of the First World War, Huntly Town Council and the Nursing Association jointly agreed on a Child Welfare Scheme, to be operated by the district nurse who, by 1919, had 73 children on her books and had made 319 child welfare visits. It was, however, a time when district nurses were not always the most popular visitors, being regarded as 'prying' into things that were not their business.

Despite this, between the Wars the nurse's duties were extended to the care of children at school and the local education authority made grants available for carrying out inspections regularly, as they did for the care of tubercular patients. It also resulted in the nurse's qualifications being approved by the local authority when an appointment was being made by the Association. As her duties escalated, so did her salary, and she was paid £159 a year in 1925, plus a free furnished house. By 1934, the services were being provided for the landward area around Huntly.

It was the 1938 Maternity Act, rather than the National Health Service (Scotland) Act which came into operation on 5 July 1948, which began to erode the local Nursing Association's control over nursing services. The nurse's work then came under the control of the supervisor of maternity services, but it was three years after the NHS was established that county councils began to employ the district nurses. Money was no longer required to be raised after the county councils took over the paying of the nurses and all costs of running the service. The chairman at the time, the Reverend D.I. Cowan, told the collectors they were now 'honourably discharged'.

That was not the end of the story, however. For another 43 years the Huntly and District Nursing Association continued to exist, though with an entirely different function. Every year they met at least once and, in many years, several times. They still had a certain amount of money invested and this they used to support the district nurses, allowing them to buy 'comforts' for their patients not available under the NHS. In addition, they were able to provide capital sums to buy special types of equipment for patients' needs, again not available through the NHS. Donations continued to come in and so the investments have increased and among the many things they have provided for the sick and disabled of the town have been wheelchairs, a bath hoist, ripple beds, a turning bed, and other

smaller items which have filled a need. The local eventide home, Alexander Scott's Hospital, has been the beneficiary of a number of items over the years (see Chapter 19).

Eventually they felt their usefulness had come to an end and, progressively, sold their investments and disbursed the money principally to reinforce the work of the district nurses and other local 'needs'.

At the association's last annual meeting in 1981, the last chairman, Mr Charles Mackintosh, discharged the members, thanking the secretary, Mrs Barbara Murray, and treasurer, Mr Roy Anderson, for their work.

The last remaining sum of money was to be drawn on by the district nurses over the year, and when the balance dropped below £50, what remained was handed over to the Jubilee Hospital welfare fund.

The curtain had come down on an important century of service given to the people of Huntly and district.

23. The Man who sent a present from America

The Castle Park lay immediately through the Gordon Schools' archway, at the entrance to what were, in the middle of the nineteenth century, the grounds of Huntly Castle and Lodge. The Dowager 5th Duchess of Gordon was still alive at the time, and she generously allowed the townspeople to enjoy a walk, even games, in the spacious grounds which made up the Castle Parks. However, since her 'conversion' and subsequent joining of the new Huntly Free Kirk (now Strathbogie) following the Disruption of 1843, the Duchess had a great passion for evangelical Christianity. In 1860, she accepted with enthusiasm a suggestion that there should be a great assembly for prayer and preaching over two or three successive days held in the Castle Park. She personally wrote invitations to ministers and lay-people of all denominations all over England and Scotland, and in July they came. Hundreds of them. Huntly Lodge, where the Duchess now lived, was full of people, as were the surrounding houses, and most of those in the town. Nearly everyone seemed to be exercising a large hospitality to the hundreds of people who thronged the town and the Castle Park. The Gordon Schools were filled with stores of food and there were tents erected to sell tea, coffee and food to the vast crowd.

On 15 August 1863, the first edition of the newly-launched *Huntly Express* newspaper carried the prize list of the Strathbogie Farmers' Club's annual exhibition of livestock and dairy produce held in the Castle Park. Entries included 155 cattle and horses, and there were also swine, sheep and poultry.

These are two examples of how the Duchess liked the Castle Park to be used for the benefit of the town and district. She believed in a sound body to house a

sound mind, and she made sure that the pupils of her new schools had every opportunity for physical development by giving them the Castle Park on the left side of the Avenue as their playing fields. There is little doubt that it was also the Duchess's lead that encouraged the development of the Castle Park as a concentrated games/recreation area which is the envy of many towns. Few can boast a complex which includes school playing fields, tennis courts, putting greens, a children's play area, golf course, cricket ground, swimming pool, football ground, rifle range, Nordic ski centre, community centre and picnic and play area – all within the same area.

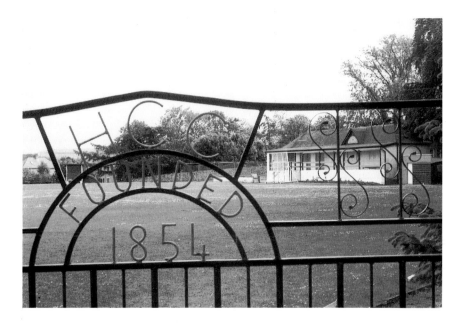

Huntly Cricket Club ground at Castle Park

When the Duchess died in 1864, ownership of Huntly Lodge and Castle Park passed to the Duke of Richmond and Gordon, but the people of Huntly continued to regard it as their place of recreation. The Duke was only too ready to allow them to use it as such whenever they asked. In 1889, for instance, he allowed Huntly Cricket Club the use, as a tenant, of one of the parks on which to play – a pitch they still occupy a century later.

This was not, however, the beginning of cricket in Huntly. As early as the 1840s, several local teams had been formed, and were already playing competitive cricket. The main team was Strathbogie Cricket Club, which amalgamated with the others in 1854 to form the Huntly Cricket Club.

There was actually a tradition (apparently unfounded) that the Duchess of Gordon was the founder of the club, but it was the day of perhaps the most famous cricketer of all time, W.G. Grace, so perhaps 'Her Grace' got mixed up with W.G. Grace! However, the founder of the *Huntly Express,* Adam Dunbar, who was one of the notable Huntly players in the 1860s, did, on one occasion, play against 'W.G.'.

The club was, by 1854, playing 'away' matches, travelling to and from Huntly in a horse-drawn omnibus, owned by Mr Grant, the licensee of the Strathbogie Hotel. However, it was not until 1890 that it joined the Aberdeenshire Cricket Association. In 1933, they became members of the North of Scotland Cricket Association which celebrated its centenary in 1993.

Having played on the Castle Park for 35 years, the club bought their ground from the Richmond and Gordon Estates in 1924 for a nominal sum.

Huntly golfers began to look at the remaining four parks as a possible golf course. The Duke was very pleased to let them have it – but only in the winter months! – at a rent which the *Huntly Express* rather sniffily thought at the time to be 'practically nothing'. A club was formed with the Duke as president, and the only hiccup was a blizzard on 18 March 1893 which prevented the first competition being held. The 'winter months only' play was necessarily frustrating and by the turn of the century, the members were beginning to wish for an all-year course, and a lease on the four parks on the east side of the Castle Avenue was negotiated with the Duke at a rent which, this time, seemed not to attract any derisive comments from the *Huntly Express*!

The popularity of golf, in the district, as a recreation went on apace until the 1914–18 War. The course was ploughed up to grow crops and was not restored to being a golf course until 1923. In that year, the Burgh Council rented the Castle Parks from the Richmond and Gordon Estates, and sub-let them to the Golf Club. Provost Christie proposed that the council should buy the Parks from the Estates, but at £3000 it was too expensive. The Duke eventually agreed to £2750 but, by then, the folk in Huntly wanted a referendum and by nearly 100 votes decided that it was too costly.

A syndicate was formed by the minority who had voted in favour of it and they bought it from the Duke with the proviso that they would offer to sell it to the Burgh Council by November the following year. This they did, and the council decided to buy it for the town and opened a list for public subscriptions. £1000 was quickly raised, and then a number of ratepayers who felt it was too costly asked for another democratic vote. This time the 'againsts' were in the minority and lost by almost 200 votes. The council proposed to borrow £1500 and embarked on plans for a putting green and a quoits pitch which would be opened immediately in the Castle Parks Public Park.

Enter 'The Man from America'. Alexander Cooper, however, was not American; he was born in Huntly, the son of Robert and Amelia Cooper.

Cooper attended Mrs Robertson's school in McVeagh Street, the Meadow School, Gartly Parish School and The Gordon Schools in Huntly. He became a journalist and went to South Africa to become a reporter first with the *Kaffrarian Watchman* and then with the *Cape Mercury*. When he returned to Scotland, he became a reporter with the (now defunct) *Crieff Journal* and *Perth Constitutional*, as well as local correspondent of the *Scotsman*. While in Crieff, he also taught shorthand to pupils at Morrison's Academy.

It was not long before he was off abroad again, this time to Jamaica in the West Indies to become assistant editor of a Kingston newspaper. Finally, he probably achieved his goal when he got a job on *The Day Star*, a New York daily, and he spent the rest of his life in the USA.

He wrote stories and poetry for the expatriate newspapers, the *New York Scotsman* and *The Caledonian* as well as for other journals. He then launched his own newspaper, the *Suburban Herald*, and eventually ran his own school of shorthand. Whether at the same time or later, he went into the New York Department of Public Works, rising to the top clerical post in the department.

Cooper knew what was going on in his native town and, in fact, never lost touch with it and its affairs. He was already a contributor to Provost Christie's 'subscription list' for the purchase of the Castle Parks, and there was £200 against his name, when a letter arrived on the desk of the Editor of the *Huntly Express*. The letter read:

> Room 2039
> Municipal Building,
> NEW YORK.
> April 16th 1925

Joseph Dunbar, Esq..
Editor
HUNTLY EXPRESS.

Dear Mr Dunbar,

Referring to Provost Christie's lucid address in the *Express* on April 3rd, I hereby offer, through you, to pay the balance of the purchase price of the Castle Parks (£1500), upon condition that the name shall be changed to Cooper Parks.

Yours truly,

Alexander Cooper

Mr Dunbar published the letter in the *Huntly Express* on 1 May 1925, with the comment: 'It will afford readers unqualified satisfaction to peruse the following letter which reached our office on Tuesday morning.'

Naturally, it caused a stir, not least in the sacred precincts of Stewart's Hall, in the bosom of the Burgh Council. Provost Christie immediately called a meeting of the council to consider it and proposed that the generous offer be

accepted. The council was unanimous and a cable was sent off to Mr Cooper accepting his most generous offer and agreeing to his condition. His reply was short, and to the point:

Town Clerk, Huntly. Good. Draft in 30 days. COOPER

Although Alexander Cooper's gift of £1500 may not seem such a vast sum to Huntly folk nearly three quarters of a century later, if you add a couple of noughts to the figure, the resulting amount will give a truer picture of its real value in 1925. The *Huntly Express* carried an appreciation of the gift in verse by a local rhymer, John Hood.

The official opening of Cooper Park was performed by Capt. Murray Bisset of Lessendrum and among the invited guests were Alexander Cooper's two sisters.

This was not quite the end of the story, however. In 1930, Alexander Cooper returned to his native town for the first time in 25 years and visited many of the places he had known as a boy. Although he was by then 70, he climbed Clashmach as well as visiting the Cooper Park, and was guest of honour at a civic dinner presided over by Provost Christie. He died in 1932, aged 73, in New York. Six months later, Mrs Adeline Cooper brought her husband's ashes home to Huntly to be buried in Huntly Cemetery, following a service in the Parish Church. As a mark of respect to the town's benefactor, the Stewart's Hall flag flew at half mast, businesses closed and houses drew their curtains.

After bequests to his widow, Mr Cooper left the residue of his estate to The Gordon Schools' Former Pupils Association to provide prizes and bursaries for pupils who had marked ability, especially the sons and daughters of poor parents, attending the Schools.

Mrs Cooper gifted gates to Cooper Park in memory of her husband, which were handed over by her sister-in-law – as she could not be present – on 16 August 1934.

After the reorganisation of local government in 1975, all Huntly's 'common property' passed into the custodianship of Gordon District Council. As inheritors of the property vested in the former Town Council, they indicated that they were willing to sell that part of the Cooper Park which was the Golf Club. After some considerable time, and not without a number of misgivings on the part of the Golf Club, they eventually entered into ownership of their own course on 15 May 1987. They immediately built a new clubhouse, which resulted in a new interest in the game, which it still enjoys.

The remainder of the Cooper Park is still in the ownership of the town of Huntly, vested in the local authority.

One of Huntly's more prominent sports did not start in the Castle Park/Cooper Park complex; in fact, it was not until after the First World War that it moved its playing ground to (nearly) the Castle Park. Like the Rugby Club and the Boy's

Huntly Golf Club's new clubhouse

League Football, soccer was first played on the Market Muir pitch. The game seems to have started originally among workers at Sellar's iron works in Granary Street/Church Street and the Strathbogie Boot and Shoe Works in the Square. It quickly expanded its popularity until there were three teams playing on the Market Muir – Huntly, Gordons and Rovers. Eventually the three merged to become Huntly United and celebrated their union by winning three cups in the season 1909–10. There were problems, naturally, during the First World War, and when things got going again afterwards, the name 'United' was dropped in 1921 when Huntly Football Club came into being. They played their first game as Huntly FC against Keith on 3 September 1921 which Huntly won 3–2. When they joined the Aberdeenshire League they were handicapped by not being able to charge admission to the Market Muir ground and began to look around for a ground of their own. It was Provost Alex Christie who bought and gifted a field in East Park Street which became, and still is, the Huntly FC ground. It was originally called Strathbogie Park and the first game was played there on 9 November 1926. The name was later changed to Christie Park as a tribute to the donor.

Here is how the *Huntly Express* reported the meeting between the Provost and the Club President and members of the Committee:

"HUNTLY FOOTBALL CLUB

Park Presented by Provost Christie

Our worthy Provost has always taken a keen and generous interest in the Huntly Football Club, and has done much to help it get on the proper rails. On Tuesday evening Provost Christie asked the Management Committee of the Club to meet him in the Council Chamber, where he was accompanied by Mr Alex Mitchell, town clerk depute. The Committee with Mr Jack Murray, president, were all in attendance.

The Provost in the course of some complimentary remarks about the manner in which the Club was being conducted, said he had long been desirous that the Club should have a field of their own for practice and for competitions. He had pleasure in intimating that he had acquired the Strathbogie Park – where they now played – and he proposed to hand it over to the Club on condition that the Club should be continued as an amateur one. He was glad to know that the Huntly Club was held in high respect among other clubs in the north of Scotland, and he trusted this would long continue to be so. He hoped members of the Club would always strive to play the game as true sportsmen, and in a manner worthy of themselves and of the town to which they belonged. It gave him very much pleasure to ask the president, Mr Murray, to accept the park on behalf of the Club, and he wished its members ever-increasing success.

Mr Murray said it was no easy task to thank Provost Christie for the splendid gift with which he had not only honoured – but considerably surprised – the Club. That was not by any means the first occasion on which the Provost had proved a good friend to the Club. Only the management knew, perhaps, in how many ways Provost Christie had extended a helping hand. The Management had always been desirous of getting a field for the Club and had considered the probability of shouldering the burden of it. Now, however, this had been generously done by the Provost, and on behalf of the Management, and of every member of the Club he asked the Provost to accept of their grateful thanks. A gift like that would greatly encourage 'the boys' to do better than they had ever done before. In conclusion he would ask the Provost's permission that, in future, the field would now be designated the 'Christie Park'. It has to be added that all in the community who take interest in manly and healthy recreations are very much gratified with what Provost Christie has just done. As readers know the park is an ideal park and is so conveniently situated to the town. Adjoining the Gordon Schools avenue and sharing in the shelter of the belt of trees, it is also in close proximity to the cricket field and golf course which are just 'over the garden wall'."

In 1928, the club was promoted to the Highland League, playing their first game against Inverness Thistle on 21 August that year. Thistle won, 2–1. It was also in 1928 that the club agreed its first constitution.

One incident which had a disastrous effect on the club, occurred in 1975 and resulted in the ground being closed for two months at the beginning of 1976. At the end of a league game with Rothes at Christie Park on 25 October 1975, the referee, George Macrae, in his first season on the Highland League list, had occasion to book three Huntly players for dissent and one Rothes player for foul play. Rothes won, 2–1. At the end of the game, the referee called over one of the booked Huntly players to speak to him. A number of the spectators, crossing the pitch on their way out of the ground, surrounded the referee and the player, and listened in. Suddenly, the referee fell forward because, as he later said in his report, he had been hit on the head and rendered unconscious. The club denied this, saying that, although they admitted he had been assaulted, he was not hit on the head but tripped from behind. When the matter went to the Scottish Football Association, it emerged that the club had not arranged policing for the game. The SFA's sentence was closure of the ground during January and February the following year, plus a fine of £100, and an order that all home games in future be policed. On appeal, the SFA said they were not satisfied that Huntly had made every effort to protect the officials in what amounted to, as they put it, 'something close to a riot situation'.

It took a long time for Huntly to recover their fortunes, especially since they had just begun to get back on their feet following a decline. They did not begin to turn the corner until 1979, when a group of business men led by Forbes Shand, the now managing director of R.B. Farquhar Ltd, put the club on a sound financial footing. Not only are they now financially sound, but they also won their third league cup and their first Qualifying Cup in 1992. Mr Shand continued as chairman until 1996, when he was succeeded by Mr Mike Hendry, Head of Hendry Hydraulics, Elgin.

Incidentally, the club appealed for the person who struck (or tripped) the referee to come forward and own up.

Rifle Clubs were founded to assist in the defence of the realm and in promoting the security of the nation – a sort of early Home Guard. As such they attracted 'charitable status'. However, in 1994, the Charity Commissioners for England and Wales looked again at the relevant law. They formed the opinion that rifle and pistol clubs, although having a historical reason for their charitable status, had very little connection any longer – and that only indirectly – with the armed services, either in terms of training or type of weapons used. Any decision made by the Commissioners for England and Wales, although it has no bearing directly in Scotland, will still have its effect. There is no formal registration of charities in Scotland although they do have the same status as in England for tax purposes.

Huntly's Rifle Club was formed about 1911 and now has about 20 keen

members from as young as 14 (occasionally younger) to those of more mature years. The members meet twice a week and the guns are provided by the club, but they pay for ammunition.

The Rifle Club premises are within the area occupied by Huntly's recreational facilities complex and are situated adjacent to the swimming pool.

An even later arrival in Huntly than the Football Club was the Rugby Club. The first person to conceive the idea of playing rugby in Huntly, rather than going elsewhere to get a game, was Mr John Boyd. It was to be several years, however, before a club was formed. The first meeting was held in the Castle Hotel in 1966 and Dr Patrick McBoyle was elected first president, Ian McKay, secretary, and John Boyd, captain. They played, as they continue to do at the time of writing, not on the Castle Park complex, but on the Market Muir, except for a short time when the council re-seeded the Muir pitch and they used a pitch in the cricket park. The first game after formation of the club was played against Peterhead on the Blue Toon's recreation ground.

When the Highland League system started, Huntly joined the league and this opened up new fields for them with Moray, Aberdeen Wanderers, Highland 2nd, Gordonians 2nd or 3rd, Caithness and Glenrothes. They never actually won the Highland League Cup but were runners-up one year. Now they play in the Aberdeenshire League and have several players playing for Alford.

The Club have the distinction of knowing that several of those who began their Rugby career playing on the Market Muir have gone on to play with first class teams, among them Andy Godden with North Midlands; Ian McRitchie also with North Midlands, who then went on to Highland; and John Lockhart, who played for Boroughmuir.

A newcomer to the sporting complex of the Castle Park in recent years has been the provision of the Nordic Ski Centre by Gordon District Council at the Hill o Haugh, close by the castle and, more recently, Castle Caravan Park at Meadow Farm. (Incidentally, it is believed that the Hill o Haugh was the former Gallows Hill for the execution of those whom the Gordon Laird deemed worthy of such a punishment.)

No one really knows when The Huntly Boy's League actually started, but it was more than 30 years ago, and it is still going strong. It is another club which does not play at the Castle Park, but on the Market Muir; in fact, it was money raised locally by members and friends – and their physical labour – which built the Market Muir pavilion. When it was finished, they handed it over to the town to be used by anyone who plays on the Market Muir.

Huntly was the first town in the North-east to start a boys' league and it was Alfie Nicol, Huntly's 'Mr Football', and Roddy Rice who were responsible for its success and turned it into what it is today. Over the years, there have never been less than 250 players in the league and it is one of the continual regrets that

they have never produced a really big football star, although some have gone on to play in Highland League teams and two have been coaches with Aberdeen FC, with whom they have always had very close connections.

It continues to maintain its original purpose, however, and that was to give boys an interest in soccer and to get them playing the game.

Other clubs which do not play their particular game at the Castle Park are the Huntly Bowling Club, who have a splendid modern clubhouse and first class green at Victoria Road, and the Huntly Curling Club, whose activities, inevitably, are subject to the weather. They meet at the curling pond in Lennox Terrace.

24. The Man who Hi-jacked the Trade

Early in the nineteenth century, there were eight carriers' carts going from Huntly to Aberdeen and back every week: Strathbogie was sending leather, cloth, pork, butter, eggs, cheese and whisky; in return, the carriers brought back lint, iron and merchant goods. There were also three stage coaches every day, there and back. These carried some light goods, as well as 20 or 30 passengers between them.

Apart from textiles, which were beginning to move out of the 'cottage industry' stage into the mills, many industries in the town during this period were meal mills; at Nether Piriesmill, Mill of Cocklarachy and Mill of Huntly. The Bogie, rather than the Deveron, was used to turn the mill-wheels, which is why they were all on the east and south of the town. There were also two tanneries, two candle-making works, a tobacco factory (mostly staffed by young boys, apparently!), three turners, two wheelwrights and three nailmakers. There were also, of course, blacksmiths (farriers), brass-smiths, tinplate workers and shoemakers.

There was a price to pay for transporting both goods and passengers, however. Carriers of both had to pay a heavy toll, and evidence of this are the toll houses that still survive at both east and west entries to Huntly. In the town, there were a number of people in the transport business, most of them carrying stone for the ever-increasing building business as the town grew in industry and population. A few of these carters went regularly to the Banff coast for fish supplies – predecessors, no doubt, of the number of vans which still come regularly from the coast and sell their fish in the Square and round the town. There is no evidence that the carters themselves retailed their fish; more likely, they sold it to fishmongers in the town. Although many people obviously travelled by 'public' transport – the stage coach – to get them from place to

place, horseback was still the mode of transport for a good many others, who either owned their own horse, or hired one from one of the licensed stables in the town.

In 1854, the railway came to Huntly! The Great North of Scotland Railway planned to go all the way to Elgin via Keith and Dufftown, in due course, and extending the line to Huntly was the first stage. It started in 1854 as a single track with passing places at Kintore, Inverurie and Insch. In recent years, the line has reverted to that, having been completed as a double track all the way to Keith Junction when it became single-line via Keith Town Station to Dufftown.

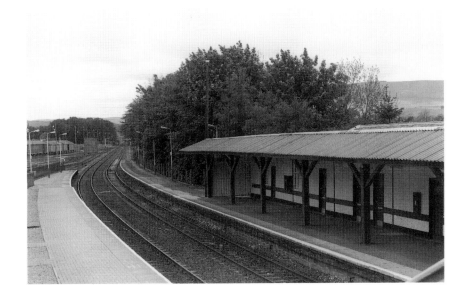

Huntly Railway Station

Goods traffic began on 12 September 1854, and the railway officially opened for passenger traffic on 19 September. A special train of 25 coaches, double headed (that is, two engines) carrying about 400 passengers, left Kittybrewster station in Aberdeen (now closed) at 11 a.m. It arrived at Huntly at 1.12 p.m. by which time the number of passengers had increased to nearer 650, many having boarded the train at the intermediate stations on the way. Huntly was ready for it; shops had closed for the day as people gathered at the station to await the arrival of the first passenger train. They were looking forward to being able to travel to Aberdeen in just two hours, and by 20 September, the GNSR were running three passenger trains and one goods train in each direction. The passenger trains

stopped at all 12 stations en route and took two hours to complete the 39 mile journey. The stations (for those readers who do not remember more than the present three! – if, indeed, there are even three by the time you read this) were Kittybrewster, Dyce, Kintore, Inverurie, Inveramsay, Pitcaple, Oyne, Insch, Wardhouse, Kennethmont, Gartly and Huntly. The 12½ mile extension to Keith was opened just over two years later, on 10 October 1856, with stations at Rothiemay and Grange. Cairnie Junction was added in 1898, Cairnie and Grange being the junctions for the connections with the coast line via Tillynaught Junction. To railway enthusiasts, these are now simply romantic names from the past as all of them are closed, as is the coast line.

There is no doubt that the coming of the railway changed the way of life in Huntly, as in so many other towns. Industry, particularly, benefited, but it also altered the horizons of the lives of all those who had regarded Strathbogie as a quiet backwater. It was that no longer, although it took nearly a century for the people of Huntly to think of their town as an industrial centre. It is also difficult, even now, to find them particularly interested in thinking of it as a 'tourist' town, but that is another story.

By the end of the nineteenth century, Huntly was bidding to becoming a busy little market town and shopping centre as well as an industrial centre. There were five textile mills as well as Sellar's flourishing implement manufacturing business. Despite two World Wars, as late as the 1960s Huntly's Industrial Estate was little more than a few fields on the south side of the town, adjacent to the Market Muir. King George V Avenue was the relatively quiet A97 to Rhynie which joined the A96 Aberdeen–Inverness road in the Square, the main road being through the town centre, and two way into the bargain. It is difficult to remember those days of the sixties before the inner ring road for westbound traffic via Gladstone Road, Bleachfield Street, Market Street and King Street, and certainly before the A96 bypassed the town completely, as it does today. Now the A96 and A97 still meet, but at the roundabout outside the town. At the same time, a staggered junction was made for the A920, Dufftown–Ellon road, which shares the A96's bed for ten miles between Huntly and Colpy. In 1994, Duke Street was improved, thus lessening the dangers to both traffic and pedestrians.

The A96 by-pass circumscribed an area of land which has now been filled completely by the Industrial Estate, and the beginnings of increased sprawl towards the line of the A920 are evident. Recently, the Huntly Auction Mart has been built on the side of the by-pass further away from Huntly (see Chapter 13), although there are no plans for immediate further industrial development on that side of the road. Residential development now fills the angle on the east side of King George V Avenue and the A96.

One of the early arrivals on the Industrial Estate was R.B. Farquhar Ltd. Their story begins at the end of the Second World War when Bob Farquhar, a Rhynie loon, was demobbed from the Royal Navy in 1947 after service which

View of Huntly's Industrial Estate taken from the lower slopes of Clashmach Hill

took him to many parts of the world, including India and the Mediterranean. The story actually started in 1943, when he was cutting wood on Lary Hill at Ballater; he applied for exemption for the members of his small workforce, but not for himself! So, in 1943, he was called up. Four years later he came back, accompanied by a constantly-recurring dose of malaria, and he and his wife, Elsie, moved into a tenement in Rhynie. Bob put his £65 gratuity into a second-hand lorry; Elsie put her savings into buying wood which, together, they sawed up and Bob delivered in the lorry in an ever-widening circle from Rhynie. Elsie said that she was at the end of a cross-cut saw many a day, and sometimes it was 11 o'clock at night before they had the load ready for the next day's deliveries.

1953 put an end to that business. It was in the late winter that year that the big 'wind blow' happened. Thousands of trees all over the North-east were felled like skittles by the hurricane-force winds. That winter, Bob Farquhar hardly worked because he was ill both with ulcers and the measles. It was not long, however, before he had turned the estate's misfortune, of having too much felled timber, to his own advantage, and he established a chain of sawmills from Cabrach to Burghead, Moray having suffered worse than most from the effects of the hurricane. Soon, the embryo of today's multi-million pound business had begun to develop in Rhynie, where Bob and his small, but growing workforce began to turn the timber into boards and the boards into sheds and other items of joinery. The jobs became bigger and the 5000 square feet of the joiners' shop in

125

Rhynie soon became too small.

In the 1970s, R.B. Farquhar moved to the infant Industrial Estate in Huntly. 'I can remember standing in the middle of the new, empty factory,' said Mrs Farquhar. 'Bob said, have we done the right thing?' He had; and they never looked back. Mobile offices, multi-purpose blocks, chalets, temporary classrooms, houses, mobile homes, accommodation units – all came off the production line. 'We build anything that is required,' Bob said, and people did require them. Farquhar accommodation units – particularly their specialities Hi-Jaks, Sea-Jaks, Steel-Jaks – were soon becoming a familiar sight from one end of Britain to the other, as well as abroad and in the North Sea. The oil-boom was an ideal opportunity to supply the oil rigs in the 1970s and 1980s, as was the Channel Tunnel in the 1990s.

More recent ventures have been in permanent housing developments springing up all over the north-east – which looks like being a growth industry for the future – hotels and the King George V Garden Centre which, to so many people, is Huntly.

Sadly, the man whom visitors to the Deveronside Works often failed to recognise as the boss, with his dry, ready humour, his friendly manner and his local speech, is no longer there to see the firm – now the largest employer in Huntly – developing into ever newer fields. The man who said that although he had not been able to have the education he would have liked, but wanted to 'get on', would certainly approve of the direction in which the firm is going. His widow, Elsie, is still the Company Chairperson and his nephew, Forbes Shand, the managing director. The business grew and changed, but Bob stayed the same. 'Change,' he once said. 'I couldna change.'

Another business which has grown from a 'kitchen' industry to a world-wide supplier, is Dean's Shortbread – a product which is readily available in most supermarkets. Helen Dean started making shortbread for her family, then her friends and neighbours, and eventually for the whole of Huntly. From home kitchen, to a bakery in Deveron Street, it now occupies the fine imposing building of the former Banffshire Egg Packer's factory in Depot Road.

Alexander Dey Ltd. (now taken over by R & M Engineering, who had premises already on the Estate) – which was founded in 1910 specialising in distillery installations – and Highland Fuels, which was once Gordon & Innes, were both early arrivals. Aardvark and Black Gold have been there for some time, as have George Sellar & Son (see Chapter 13). Newcomers are North Eastern Farmers and Towns and Carnie Ltd. (both in the same business); Huntly Builders; SCOOP (Subsea Continental and Offshore Providers Ltd.); Grampian Food Ingredients; and RAM Environmental Services. Fraser's Car Spares rubs shoulders with G.T. Tyres and A & A Ross (Agricultural Engineers); whilst a new expansion takes in Johnson & Carmichael in new custom-built offices.

25. Ones who got away!

Huntly Folk who made their name furth of Huntly

James Legge

James Legge was born at his parents' home in Huntly Square in the year of the Battle of Waterloo, 1815. He was a remarkable man, in that he was a Chinese scholar, perhaps as rare then in a Westerner as it is today. He nearly did not make it. In his early years at Huntly, he nearly drowned in the River Deveron; then, as a student in Aberdeen, he was injured when a platform collapsed as he was listening to arguments about the Reform Bill of 1832. As if that was not enough, he nearly fell prey to typhoons at sea, and to robbers on land when he had to drive them away from his house with a loaded rifle!

Legge was the youngest son of a Huntly draper, educated at Aberdeen Grammar School and the University, where he had a brilliant career in languages. In 1870, his old University conferred on him an honorary Doctorate of Laws degree.

The principal influence in his career had to be the so-called 'Missionar Kirk' in Huntly, of which his family, like that of his contemporary, George MacDonald, were members. The Kirk was rather contemptuously so-called locally because of the members' devotion to the London Missionary Society which had been founded in 1795 by a group of Congregationalists, Anglicans, Presbyterians and Wesleyan Methodists to promote overseas missions. Local contempt turned to pride as local people saw many missionaries from the Church going to work all over the world. In later years, the work of the LMS (as it is now known) was continued almost exclusively by the Congregational Church and operates in China, India, SE Asia, the South Sea Islands and Africa.

It was to this Society that James Legge offered himself for work overseas and, after a brief (no doubt because of his aptitude for learning languages) course of Chinese, he was sent to Malacca, in Malaya, to become Principal of the English School for young Chinese students there. He continued his study of the language and travelled throughout the Singapore/Sumatra area. He was known for his eccentricity and kept a young crocodile in his bath!

Legge was sent by the LMS to Hong Kong in 1843, and spent the next 30 years in the colony, returning to Britain for leave only three times during that period. While in Hong Kong, Legge was pastor of the expatriate and native congregation of Union Chapel, and he also compiled his major work: a translation into English of the Chinese classics – the works of Confucius and Mencius – published between 1861 and 1866. The cost of the publication was met by a fellow Scot, a member of the famous Jardine Matheson firm. Legge's

daughter tells how, a few years after his arrival in Hong Kong, a native Chinese said to her: 'He speak more better Chinese than me!'

When he returned to Huntly for his first leave from China, Legge brought with him three Chinese youths who attended The Gordon Schools in Huntly. He also had the honour of being presented, along with the boys, to Queen Victoria and Prince Albert in London.

An amusing sideline to the Huntly Missionar Kirk's support and the London Missionary Society involvement with missions in China is that, as a result, Old Road in Huntly, where the Church was built, came to be called 'Chinatown' during the nineteenth century. This seems to be because returning missionaries to Huntly from China were in the habit of bringing Chinese visitors home with them, much in the way that Professor Legge had brought the Chinese boys.

In 1875, a group of businessmen, mainly in Hong Kong, began to raise funds to establish a Chair of Chinese at Oxford. Paris had had such a chair for more than 50 years. Their fund-raising was based on the understanding that Legge would be the first occupant of the post, and the University accepted this, and in 1876, Legge became the first Professor of Chinese at Oxford, and the first non-Anglican to hold a professorship in the University. He stayed there until his death in 1897, when his translation work was continued by Professor Max Muller.

Legge's daughter, Dominica, said that he never got used to the modern life of a century ago. When he went to London, it was always an event and long remembered by the staff at Oxford Railway Station who were all mobilised to see that Professor Legge was put safely on the train!

Mr Ewen McDonald, to whom we are indebted for the research done into the life of James Legge – a much neglected son of Huntly – says that 'he was a leader, both in transmitting the history and values of the West to the Chinese, and in interpreting China with depth and sensitivity to the West.'

Not long ago, an assistant professor from Beijing visited Huntly and was very interested to see the countryside which had influenced the great translator of Confucius and Mencius. In 1997, Aberdeen University's Chinese Studies' Group hosted a four-day Conference of International Scholars from as far afield as the USA, China, and Hong Kong, as well as the UK, on 'James Legge: The Heritage of China and the West'. The Conference was formally opened by the University's Chancellor, Lord Wilson, who is a former Governor of Hong Kong, and at least one of James Legge's descendants was present.

During the Conference, members visited Huntly where they were welcomed at Stewart's Hall by Councillor William Anderson, the local member, on behalf of Aberdeenshire Council. They saw the site of the house in the Square where Professor Legge was born and visited the family burial place in Dunbennan Churchyard.

Alexander M. Mackay

Alexander M. Mackay (he never told anyone what the 'M' was, except that it was the name of an old Celtic ancestor!) was born in Rhynie in 1849, the son of the Free Church Minister. Until he was 14, he never went to school, being educated by his father who was, by all accounts, an excellent teacher. He joined his father at cottage prayer-meetings and 'catechising' throughout the parish. They gathered botanical specimens, took tea with the elders and on the way home learned astronomy from the night sky.

The inspiration for Mackay's missionary leanings, however, came from his mother, Margaret Lillie, who was high-principled, prudent, tactful and thrifty. She taught him to pray for the evangelisation of the whole world and encouraged him to discover if he had a missionary vocation.

In 1864, Mackay began attendance at Aberdeen Grammar School but, shortly afterwards his mother died and his father decided to move to Edinburgh. In the capital, the young Mackay spent four years at the University studying engineering and sciences, and two years at the Free Church Teacher Training College. 1873 saw Mackay setting sail from Leith bound for Hamburg, where his intention was to learn German and qualify as an engineer. On a cold night just before Christmas 1875, Mackay had just finished reading Stanley's *How I found Livingstone*. Laying down the book, his eye caught some words in an old copy of the *Edinburgh Daily Review* lying on the table: 'Henry Wright, Hon. Sec. Church Missionary Society'. It was the bottom of an advertisement from one of the leading missionary societies of the Church of England for men to offer themselves as missionaries in Uganda. Although it was after midnight, Mackay thereupon wrote a letter to the CMS, and early in January was called to London for an interview and was accepted.

He sailed for Zanzibar on 27 April and gave his short life to the people of Uganda. He died on 8 February 1890, aged only 41, but in that time he left an indelible stamp on the country and in the annals of the Church Missionary Society. His title, 'Mackay of Uganda', says it all.

James Stuart

James Stuart was born in 1813 in Forgue. He was an antiquary and author of *Sculptured Stones of Scotland*, which was published in 1856. He held the post of secretary of the Society of Antiquaries of Scotland from 1855 to his death in 1877.

George Findlater

Another native of Forgue, and a hero of the local regiment, was Pipe-Major George Findlater VC, who was born in the town in 1873.

On joining the Gordon Highlanders, he was posted to the 1st Battalion. This later became part of the Tireh Expeditionary Force on the North–West Frontier

in India from October 1897 to April 1898. The British force was faced with some 12,000 Indian troops but, despite this, the 6000-foot high ridge known as Dargar Heights had to be taken before any advance could be made.

The attack began on 20 October, and Gurkhas, Dorsetshires and Devonshires led the field but were unable to make much progress. Then the 1st Battalion of the Gordons, under their Commanding Officer Lt-Colonel Mathias, was ordered to take it.

They did, and their success was partly due to Findlater who, although shot through both feet and unable to stand up, sat up and played the Gordons' regimental march, *The Cock o the North,* to give the regiment fresh heart. For his bravery in the face of the enemy and against all odds, he was gazetted for the Victoria Cross in May, 1898.

When the Gordons returned home, it was to a heroes' welcome. Such was the popular acclaim that Queen Victoria took the unusual step of presenting their decorations (having instituted the Victoria Cross herself, of course) to Findlater and Private Vickery on 14 May, six days before the citation even appeared in *The London Gazette*!

Returning to his native north-east, Findlater retired from the Army to farm at Cairnhill, Forglen; but then rejoined his old regiment at the start of the First World War in 1914. Once again he was wounded, this time at Loos in 1915, and invalided out of the Army. Back in Forglen, he farmed almost until his death, at the age of 70, on 4 March 1942.

He would no doubt have been delighted to have known, that only a year after he died, his old Pipe Band of the 1st Battalion, The Gordon Highlanders, was playing *The Cock o The North* as it led the regiment into Tripoli after its capture from the Germans in the North African Campaign of the Second World War.

John Morrison

John Morrison (or Morison, if the *Church Hymnary*, revised edn, 1929, is to be the authority) was born at Whitehill, Cairnie on 18 September 1746. Again, the *Church Hymnary* has a different opinion – it claims he was born in 1750. In the *Church Hymnary III*, however, John Morison disappears altogether without trace! Only some of his works remain, with the ascription: 'As in Scottish Paraphrases 1781'. However, a plaque to his memory in St Martin's Kirk at Cairnie declares that 1746 was the year of his birth, and this we must accept as the true one.

On 26 September 1780, Morrison was ordained and inducted to the Parish of Canisbay in Caithness, and there he remained until his death just 18 years later on 12 June 1798. In those 52 years, however, he had left an indelible mark on Scottish hymnody. No less than seven of the 67 Scottish Paraphrases, published in 1781, are his work, many of them, becoming almost household words:

> Come let us to the Lord our God
> with contrite hearts return;

Our God is gracious, nor will leave
the desolate to mourn.
(Paraphrase 30)

The race that long in darkness pin'd
have seen a glorious light;
The people dwell in day, who dwelt
in death's surrounding night.
(Paraphrase 19)

Mr John Philip, who was brought up at Avochie Cottage in Rothiemay, remembers walking up the fields from Rothiemay Station and looking at the thatched cottage where Morrison was born, lived and worked. The cottage was pulled down in the late 1920s and a cottar house built on the site. It has recently been restored.

Plaque to John Morrison in Cairnie Kirk

William Brander

Little is known about the early life of William Brander except that he received his training in the Union Bank, Huntly, and later became a successful stockbroker in London where he seems to have carried on business at 5 Draper's

131

Gardens in the City. His home address was Huntly Lodge, Crouch Hill, Middlesex.

On 20 September 1882, William Brander became the Andrew Carnegie of Huntly when he executed a 'Declaration of Trust' relating to the setting up of a foundation for educational purposes in the town and district. What he did, in effect, was set aside in Trust the sum of £6000, vested in seven named trustees, including himself, to 'provide, in or near Huntly, a building suitable for a Library, Reading Rooms, Class Rooms and other necessary apartments'. He stipulated, however, that the cost should not exceed £2000. They were also to supply books for the said library at a cost of not more than £500, as well as a suitable remuneration for a librarian and a caretaker. In addition, they were to pay for additional books for the library, as far as the Trust funds allowed. He was taking no chances, either! 'It is hereby specially provided and declared that

William Brander: portrait in the Brander Library, Huntly

all the books in said library shall be thoroughly sound in their moral tone and religious tendency and be fitted to instruct, elevate and improve the readers.' Presumably the trustees were to be arbiters of the 'moral tone and religious tendency' of the books.

He then left the library and instructed the trustees, from the revenue of the remainder of the Trust funds, after all necessary expenses have been paid, to provide 'nine bursaries for boys and three bursaries for girls', each tenable for three years, and the money set aside for these was not to be applied to any other purpose. The Trustees, however, did have the power to alter the number and value of the bursaries, as well as withhold them in the light of a candidate's 'irregular attendance, idleness, improper conduct, or on any other account which tends to frustrate the object for which the bursaries are given'.

Any balance of revenue, after all these things had been provided, would be devoted to encouraging the establishment of evening classes in any branch of useful knowledge, by adding to the teacher's salary, giving prizes or in any other way the Trustees might decide.

The 'intellectual, moral and spiritual advancement of the town and neighbourhood of Huntly' seems to have been Mr Brander's aim, in common with so many Victorian benefactors. It is curious how this paternalistic factor dominated the Victorian scene: we saw it in the Duchess of Gordon and in so many others who benefited local and national society of the time. It was not so surprising, therefore, that the twentieth century saw the revolt against this paternalism and the rise of socialism, the suffragettes, trades unions, and, in Scotland, the demand for independence. The 'nanny state' of socialism in the second half of the twentieth century has been criticised for making people dependant on the state (and other people) but this is vastly different from the Victorian benefactions which always had strings attached. They were obsessed with 'improving the poor', either morally, spiritually or educationally.

In 1934, the Trustees of the Brander Library and the Education Committee of Aberdeenshire County Council joined forces, and on 18 October 1934 the library re-opened under the new agreed conditions. As Provost Christie said on the day, 'Both bodies set to work with one end in view; what is best for the community at large'. The ceremony was performed by Colonel J.M. Mitchell, secretary of the United Kingdom Carnegie Trust. He said that 'a well-organised library service was the most potent educational agency that existed outside the schools'.

James Hastings

James Hastings was born in Huntly in 1852. Like James Legge, he was educated at Aberdeen Grammar School and Aberdeen University and then achieved his fame outside his native town. He had a conventional, copy book education for the sons of reasonably well off parents of the time; and then, because his leanings were towards the Church's ministry, he went to Aberdeen Free Church Divinity College. He was ordained to the Free Church ministry in 1884, as minister of Kineff Free Church in Kincardineshire. After 13 years there he was

invited to be minister of Willison Church in Dundee, but, four years later, he was heading up the coast again to Kincardineshire, to the United Free Church at St Cyrus. He stayed there until moving to Aberdeen in 1911 to continue the work for which he is known and renowned, the world over.

On moving to Aberdeen, he founded the monthly journal *The Expository Times*, which used to be the handbook of expository preachers, in denominations even beyond Presbyterian pulpits. This he edited himself until his death in 1922.

Hasting's monumental work, however – at one time found on the shelves of most ministers of all Christian denominations – is his *Dictionary of the Bible,* published in five volumes from 1898 until 1904, followed by the one-volume edition in 1909. Side by side with the *Dictionary,* in the period 1908–12, Hastings was compiling the 12-volume *Encyclopaedia of Religion and Ethics.* An index to the *Encyclopaedia* was published in 1926, after his death. Two other works of not quite such monumental proportions are *A Dictionary of Christ and the Gospels,* published in two volumes in 1906 and 1908, and two volumes of *A Dictionary of the Apostolic Church* (1915–18).

James Ferguson

A self-educated man (he only had three months of formal education, either by accident or design), James Ferguson became a noted maker of astronomical instruments. Born in Rothiemay in 1710, Ferguson taught himself the rudiments of surveying, astronomy and clock-making so thoroughly that, when he moved to London, he quickly made his mark and acquired a well-deserved reputation for making the best time-keepers and the most reliable astronomical models. He was also a writer of popular science books and his work attracted the notice and patronage of King George III.

Ferguson died in 1776 at the comparatively ripe (for that time) old age of 66.

26. The Last Provost

Huntly does not appear to have been such a law abiding place in the eighteenth and nineteenth centuries as it is in the closing years of the twentieth. Theft, usually of a minor nature, was rife, because few people in Huntly had much in the way of wealth. The constable used to use a means called 'dackering' to find the culprit. He and his party would search all the houses in the locality, along with that of the suspect, so that if it turned out that he was innocent he would not lose his reputation!

Smuggling was more a sport than anything else in the early days of the Excise Laws. Mr George Gray, in a talk to the Huntly Field Club at the end of

the nineteenth century, told the members that, some 70 years before, not only was evasion of the law thought to be neither immoral nor disreputable, it was positively approved and even encouraged. In fact, he said, there were few who did not smuggle or abet those who did, and it was a good game to out-do the 'gauger' (as the Excise man was known).

Not only did a lot of distillation take place – certainly in the rural areas – but a good many were prosecuted for both making and selling it. As well as salt, malt for home-brewed ale, though not illegal, was taxable, and therefore open to fraud. The salt found in the bottoms of the fish-wives' creels, however, was duty-free and this they sold illegally!

Even tallow candles carried a tax, so one can imagine that only the better off were able to afford them. The substitute for lighting the houses was the candle fir, and a supply of fir candles had to be laid in for the season at the Charles Fair. The fir came from the Abernethy Forest on Speyside and 20 or so little carts would be lined up in the Square at the Fair containing pieces of fir.

This was also the signal for small boys to work a 'racket' of their own. The small, shaggy, long-tailed Highland ponies that were tied up in their carts in the Square were the target for the town 'nickums'. There is no need to ask how the loons got their name when you discover that what they were doing was 'nicking' the hair from the ponies' tails to make fishing lines!

Law and order is, however, an important factor in any organised society and it has always been something of a game to outwit the law and the ones whose job it is to preserve it and enforce it. Small theft, vagrancy, breaches of the peace and other petty crimes were always (then as now) dealt with by the local bailies or magistrates and justices of the peace. More serious crime was the business of the Sheriff Court, while the most serious cases were dealt with by the High Court. The bailies and justices functioned in the burgh court and met in the burgh concerned, usually on a weekly, sometimes on a daily basis. The more important courts met in the county town – Aberdeen, Banff, Elgin, and so on.

Since 1975, with the reorganisation of local government, the burgh courts have been replaced by district courts, bailies have become extinct species and the justices have widened their horizons and become 'district' people, dealing with offenders not as well-known to them as they were before.

Chief among the local bailies was the Provost (or Lord Provost, if it was a city). In 1975, the burghs or towns, with their councils, were replaced by districts and district councils. Similarly, the former counties and their county councils were replaced by regions and regional councils. This meant that, when the burgh and burgh councils went, so did the provosts, although in many instances the title of provost was revived by the district councils as the title of their civic head (as in Gordon), though not for the regional chairperson who was known as 'convenor'. In one or two instances, the title never lapsed, as in the major city councils which became city district councils. They retained the title provost or lord provost, from the outset, and of course, have now reverted to their original city status.

The provost and bailies were supported as 'the local authority' by the town sergeants, often also the sheriff officers and constables, and the messenger-at-arms (the equivalent of those who 'rode shot-gun' on the stage coach in the days of the developing American 'West').

The town-crier, in the days before newspapers and local radio, was an important means of communication and a vital part of burgh life. Twice or three times a day, the town crier would deliver the 'skries', and there were three or four notices to be delivered. He was also the town's 'knocker-up' on working days, between 5 and 6 in the morning, and 'bedtime announcer' in the evening between 8 and 9 o'clock. He also followed the same route, beating a lively march as he went, so that people could tell the time by him in those pre-clock and watch days when even the Stewart's Hall clock was not there. By the time it was built (Chapter 21), education was well under way in Huntly (Chapter 14), and the local newspaper was being published (Chapter 20).

The last Provost of Huntly, before the reorganisation of local government in 1975, was Reid Flory. Mr Flory was a respected and well-liked pharmacist with his own business in Duke Street. He was a man typical of those men and women who were less party politicians than people who wished simply to do a job for the community in which they lived and from which they had chosen to derive their livelihood. In Mr Flory's case, he admits that, 'some have greatness thrust upon them,' and when he signed his nomination form it was in the belief that he was signing a completely different document!

Characteristically, he took it in his stride and in the belief that he might manage to achieve something, which he did in the 14 years he served on the Burgh Council as councillor, bailie and then provost. His last duty was to preside over the winding up of the Burgh Council when it became absorbed into Gordon District. He still regrets the demise of the local town councils, because they brought democracy within the grasp of the ordinary citizen – he knew who his local representatives were because they were all from the same town. In turn, Mr Flory also regrets the passing of the districts in 1996. 'It makes democracy seem that much more remote,' he feels.

Author's Epilogue

Like Adam de Gordon and his family, to whom King Robert I gave 'the lands of Strathbogie', I, too, am an incomer, and just as much a Sassenach as he was, in the true sense of the word. For the popular term, used so often now, quite wrongly, to describe 'the English', properly means 'English-speaking', and was originally used by the Highlanders to describe the Lowlanders – any one to the south and east of the Great Glen – and in fact anyone who spoke the Doric or any form of Scots dialect, and not the Gaelic.

Having said that, I can claim Celtic blood, but I can no more lay claim to being a Highlander than Adam de Gordon, King Robert the Bruce or, for that matter, most of the folk who live in Strathbogie.

Like the Gordons, and their subsequently more than 150 recorded offshoots, I look to Huntly and Strathbogie as the country of my adoption, because I have spent most of my adult life in the North-east of Scotland, and in Gordon country. Like them, I have come to love this country, this gently-rolling land which lies astride the two rivers, and I am grateful. As the writer of Psalm 16 wrote, centuries ago: 'The share that has fallen to me is in pleasant places; indeed, I am well-content with my inheritance.'

In these pages we have looked at many people who have made the history of this Gordon country. It is history which shapes a people – the things they were, the decisions they made, the actions they took, the roads which, for better or worse, they chose to travel.

I believe that every one of us, from the forebears of Rhynie man, searching for a place to settle and live in peace, down to the latest arrival, following the Klondyke trail which leads to an oil-rig in the North Sea or the North Atlantic, or even the latest refugee seeking peace from the rat-race and looking for a derelict croft to transform – whoever it is, we are all, and have been, incomers, settlers, at some time or other.

True, some of us have been here longer than others, but not one of us can claim that his ancestors did not come from elsewhere to stake a claim, like Adam de Gordon's family. We may be 'Huntly born and bred', but somewhere down the line, our ancestors journeyed overland, or took a ship from mainland Europe, or Ireland, or, even now, much further afield, and put down their roots in this 'pleasant place'.

One day, the children of today's arrivals, like those of hundreds of years ago, will not only claim that they are Huntly loons and quines 'born and bred', but they, too, will be shaping the history and geography of 'the lands of Strathbogie'. For, whoever we are, and wherever we came from to settle here, this is our country, our heritage and our future.

Let us be proud of it.